The Lifeboat Serv

Scotland

station by station

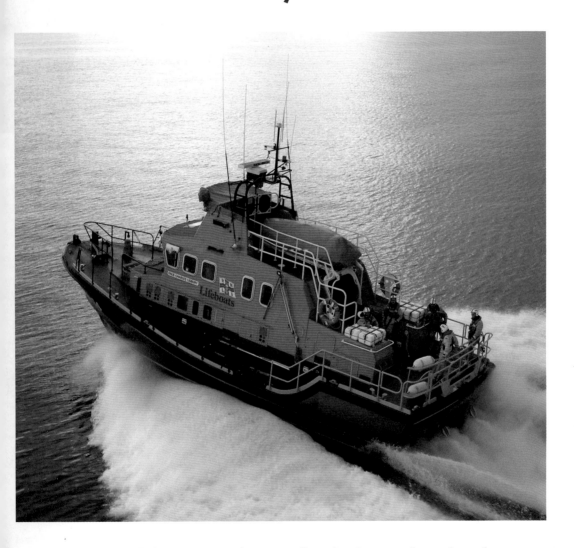

The Lifeboat Stations of Britain and Ireland

NICHOLAS LEACH

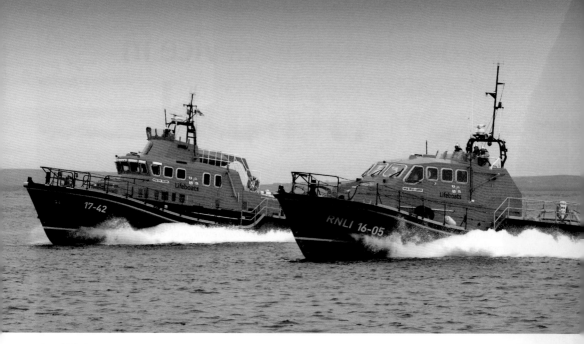

First published 2013
ISBN 978 14456 1339 0
Amberley Publishing
The Hill
Stroud
Gloucestershire GL5 4EP
www.amberley-books.com

Copyright © NICHOLAS LEACH 2013

Typesetting and layout by Nicholas Leach.
All images by Nicholas Leach unless stated.
Printed in the UK.

Cover Relief 17m Severn Margaret Joan and Fred Nye (ON.1279) on exercise off Lochinver.

Page 1 Aith lifeboat Charles Lidbury (ON.1232) heads north from Shetland.

This page Thurso lifeboat The Taylors (ON.1273) and Longhope lifeboat Helen Comrie (ON.1284) on exercise in the Pentland Firth.

Acknowledgements

Many people have assisted with this book, and I am very grateful to them all. Andy Anderson, of Wick, supplied numerous photographs from the north; John Harrop provided some unusual and rare old postcards illustrating aspects of nineteenth century lifeboat work; and Cliff Crone supplied various photos of modern lifeboats.

Around the coast, numerous lifeboat crew members and station personnel have assisted, and I am grateful to the many people who have made me so welcome at Scotland's lifeboat stations; the following are just a few: Hylton Henry at Aith, Adam Robertson at Buckie, John Stewart at Campbeltown, Gary Fairbairn at Dunbar, Bing Collin at Eyemouth, Victor Sutherland at Fraserburgh, Stewart Moffat at Girvan, Johnny Macrae at Kyle of Lochalsh, David MacAskill and Stuart Gudgeon at Lochinver, Kevin Kirkpatrick at Longhope, Michael Ian Currie at Mallaig, Scott Murray at Montrose, Rod Macdonald at Stonehaven, Martin Murray at Stornoway, William Munro at Thurso, Donald Clark at Tighnabruaich, John Wilshire of Tobermory, Ian Johnson at Troon, and Ian Cormack at Wick.

At the RNLI Headquarters in Poole, I am grateful to Barry Cox and Elise Chainey at the RNLI Heritage Trust for facilitating my research and answering many questions at various times; also, to Nathan Williams for supplying photographs for possible inclusion; and finally, at the RNLI's Scotland Base, Media Manager Richard Smith has kept me informed of the latest developments and happenings in Scotland.

CONTENTS

Map of lifeboat stations in Scotland 4
Part One • Scotland's Lifeboat Heritage 5

Part Two • Scotland's Lifeboat Stations 57

Bibliography 190
Lifeboat types serving in Scotland 191
Index 192

Lifeboat stations in Scotland

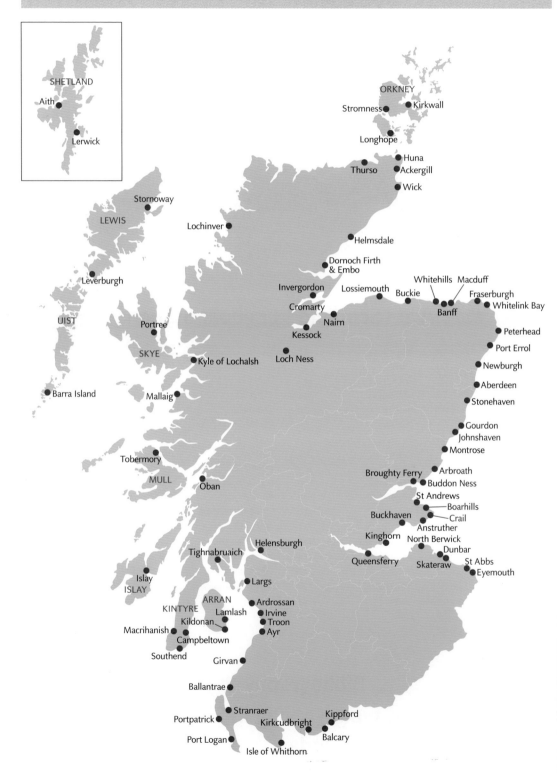

SHETLAND
Aith
Lerwick

ORKNEY
Stromness Kirkwall
Longhope
Huna
Thurso Ackergill
Wick

Stornoway
LEWIS Lochinver
Helmsdale
Dornoch Firth & Embo
Leverburgh Invergordon Lossiemouth Buckie Whitehills Macduff
Cromarty Fraserburgh
Nairn Banff Whitelink Bay
UIST Kessock Peterhead
Portree Port Errol
SKYE Kyle of Lochalsh Loch Ness Newburgh
Aberdeen
Barra Island Mallaig Stonehaven

Gourdon
Johnshaven
Montrose
Tobermory Broughty Ferry Arbroath
MULL Buddon Ness
Oban St Andrews
Boarhills
Buckhaven Crail
Anstruther
Kinghorn North Berwick
Helensburgh Dunbar
Tighnabruaich Queensferry Skateraw St Abbs
Eyemouth
Islay Largs
ISLAY ARRAN Ardrossan
KINTYRE Lamlash Irvine
Kildonan Troon
Macrihanish Ayr
Campbeltown
Southend Girvan

Ballantrae

Stranraer Kippford
Portpatrick Kirkcudbright
Port Logan Balcary
Isle of Whithorn

4

Scotland's Lifeboat Heritage

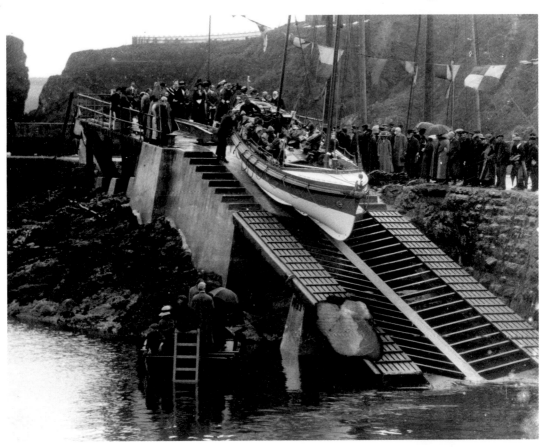

The lifeboat stations of Scotland are operated by the Royal National Lifeboat Institution (RNLI), which was founded in 1824 and today maintains a network of 235 stations around the coasts of the United Kingdom and Ireland. While the literature of the lifeboat covers almost every aspect of lifeboats and sea rescue, little has been published specifically about the lifeboat service in Scotland, so this book redresses that balance.

The book is divided into two parts; the first part gives an overview of lifeboat history in Scotland, how sea rescue developed around the country, and describes some of the most notable rescues that the country's volunteer lifeboat crews have undertaken; the second part provides brief histories of each lifeboat station, past and present.

The earliest lifeboats in Scotland were among the first anywhere in the British Isles, with Montrose, Aberdeen and St Andrews being some of the oldest lifeboat stations anywhere. Today's RNLI lifeboat fleet in Scotland, where there are forty-seven operational stations, is made up of fast inshore and all-weather lifeboats, which provide a network of search and rescue cover. The aim is to reach any point fifty miles from the coastline within three hours in fair weather, and ninety-five per cent of total casualties within thirty minutes.

above 38ft Watson motor Helen Smitton (ON.603) on the slipway at St Abbs during her inauguration ceremony on 25 April 1911. Helen Smitton was one of the RNLI's first motor lifeboats and operated from St Abbs for thirty-five years, saving thirty-seven lives. She was powered by a single 34hp Wolseley petrol engine. (From an old photograph supplied by Andy Anderson)

The first lifeboats in Scotland

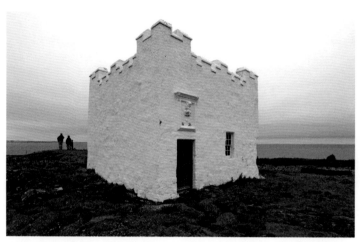

above The coal-fired beacon on the Isle of May was established in 1635 by James Maxwell of Innerwick, and John and Alexander Cunningham, who charged shipping a tonnage-based fee; it was one of Scotland's earliest navigation lights.

below An engraving depicting a North Country type lifeboat, as built by the South Shields boatbuilder Henry Greathead. Several Greathead-built North Country type lifeboats, with steering oars at both ends, served Scotland's first lifeboat stations in the early years of the nineteenth century.

For shipping in the seventeenth and eighteenth centuries, avoiding the many and various hazards of Scotland's long coastline was difficult. The islands of the west coast were particularly challenging for early navigators, and, although the east coast was a little more straightforward, the Orkney and Shetland archipelagos were not. Islands at the entrances to the rivers leading to the country's major ports of Glasgow and Edinburgh presented further tests.

The first efforts to improve matters for the mariner saw the building of lighthouses to guide ships into the country's major ports. On the east coast near Edinburgh the Isle of May, at the mouth of the Firth of Forth, was first marked by a light in 1635, when a coal-fired beacon was established. Further north, lights at Buddon Ness were built to mark the entrance to the river Tay and the port of Dundee in 1687, while on the west coast lighthouses were built at Cumbrae (1757) and Mull of Kintyre (1788) at guide ships into the Clyde.

The country's first lifeboat stations were established along the east coast, mainly at ports between the cities of Aberdeen and Edinburgh. Fishing boats were the main casualties, as most coastal towns and villages had their own fleets, but with trade expanding in the eighteenth and nineteenth centuries large numbers of coasting vessels were also being wrecked.

A prolonged hurricane in January 1800, which caused thirty shipwrecks in just one week, was the impetus to establish lifeboats at St Andrews and Aberdeen. Over eighty Aberdeen seamen lost their lives in what was the worst maritime disaster in the harbour's history. The subsequent donations that were expected by the organisers of the public subscription failed to materialise, and in the end Alexander Baxter, an Aberdeen-born merchant resident in London, donated the lifeboat to his native city.

The lifeboat at the historic town of St Andrews was organised in a similar way. The sloop *Janet*, of Macduff, went aground on the East Sands about 300 yards from the shore during the 1800 storms and John Honey, a student, waded into the surf to help the stricken vessel, managing to save the casualty's five crew. These events prompted local man Cathcart Dempster to set up a subscription to pay for a lifeboat.

The St Andrews and Aberdeen lifeboats were among more than thirty built by Henry Greathead at South Shields, on the river Tyne. In 1790 he completed the first boat designed

specifically for life-saving, which was 28ft 6in in length and 9ft 6in in breadth with a curved or rockered keel. This boat was operated from South Shields for several decades, supplemented by a second boat Greathead built in 1798, and stationed at North Shields on the river's opposite shore.

The Greathead-built lifeboats were used extensively, not only in Scotland but along England's east and south coasts. Although funding and management at a local level was important to the success of the early lifeboat ventures, they were given a boost by Lloyd's insurance agency in London, which, to counter ship losses during the first decade of the nineteenth century, set up a fund for the building and operating of lifeboats. This fund provided an impetus to early lifeboat building, and helped pay for almost thirty lifeboats down to the 1820s, including several in Scotland.

As well as Aberdeen and St Andrews, other places in Scotland to acquire lifeboats built by Greathead were Montrose, Arbroath and Ayr. The Montrose station can lay claim to be the oldest in the country, as its boat, funded by local collections, arrived in 1800. At Ayr, Provost George Charles was the driving force behind getting a Greathead boat to the town, which thus became the first lifeboat on the west coast.

Another lifeboat on the east coast was established at Arbroath in 1803, where a lifeboat committee was set up under the chairmanship of Provost William Mill and a public subscription opened. A Greathead-built boat measuring 25ft by 9ft arrived at the small port on 25 August 1803.

Further south, at Leith, the port which serves Edinburgh, a lifeboat was in service from 1805 until about 1825, working under the auspices of a local committee. The boat was another of those built by Henry Greathead and was kept at Newhaven, the town's fishing village. This boat did perform at least one rescue during her time, saving at least ten from the vessel Liberty of Kirkcaldy. She was also mentioned in the First Annual Report of the Royal National Institution for the Preservation of Life from Shipwreck in 1825, but was also found to be too heavy and cumbersome to launch.

above The north bank of the river South Esk at Montrose with, to the right, the RNLI lifeboat house built in 1869-70. The white building to the right of that is the original lifeboat house given to the RNLI in 1869 when the station was taken over from the Town Council. This historic site was where Scotland's first lifeboat was operated, and the white boathouse may date from 1800, when the first boat was placed here, or from 1818 when the Town Council took over from the original lifeboat committee.

below The same site, pictured in June 1973, with the two RNLI boathouses which were built in 1901-2. Despite being listed buildings, they were demolished in the 1990s and no trace of them remains.

Scotland's first lifeboat stations

Year	Funding	Stations	Served until
1800	Cathcart Dempster, plus Lloyds contribution	St Andrews	Circa 1824
1800	Local collections, plus Lloyds contribution	Montrose	1834
1802	Alexander Baxter	Aberdeen	1820
1802	Provost George Charles, plus Lloyds contribution	Ayr	Circa 1819
1803	Local subscriptions, plus Lloyds contribution	Arbroath	1866
1805	Local subscriptions, plus Lloyds contribution	Newhaven (Leith)	Circa 1825
1806	Sir William Forbes	Fraserburgh	1831
1807	Local subscriptions	Montrose (second)	1834
1808	Local subscriptions	Dunbar	1821

The RNLI takes over

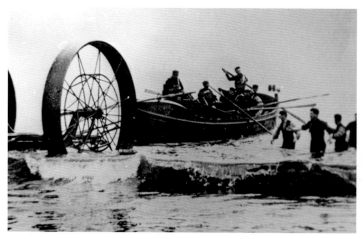

above The Aberdeen lifeboat Bon Accord No.1 being launched off the beach. This boat, built by Forrestt at Limehouse in 1853, was operated by the Aberdeen Harbour Commissioners independently of the RNLI. She was a 30ft ten-oared Peake type self-righting lifeboat and served at Aberdeen until 1925, when the station was taken over by the RNLI. (Grahame Farr, by courtesy of the RNLI)

Northumberland Report

The Northumberland Report, which was published in 1851 and included a survey of existing lifeboat provision, described the situation in Scotland; 'with a seaboard of 1,500 miles, there are eight life-boats: at St. Andrews, the Tay, Arbroath, Montrose, Aberdeen, Wick, Ardrossan, and Irvine. Some of these boats are in tolerable repair: that at Wick is quite new, others are quite unserviceable. The boats at Aberdeen, Montrose, and St. Andrews, have been the means of saving 83 lives. There are Manby's mortars at ten stations, and rockets at eight stations; the latter have been instrumental in saving 68 lives. Orkney and Shetland are without any provision for saving life; and with the exception of Port Logan, in Wigtonshire, where there is a mortar, the whole of the west coast of Scotland, from Cape Wrath to the Solway Firth (an extent of 900 miles, without including the islands), is in the same state.'

The success of lifeboat operations in Scotland during the first decades of the nineteenth century was somewhat questionable, but the Arbroath and St Andrews lifeboats, described above, remained operational for several decades, and a number of other stations were established through local initiatives. A station on the west coast, in addition to Ayr, was established at Ardrossan in 1807 to cover the approaches to the First of Clyde, with the Earl of Eglinton providing the necessary funds. The following year the harbour authority at Dunbar, east of Edinburgh, paid £372 to purchase a Greathead-built lifeboat.

These early lifeboats were built before a national organisation for life-saving had been established, although even when the Royal National Institution for the Preservation of Life from Shipwreck (RNIPLS) came into being in 1824 its influence on Scottish lifeboat matters was limited. In the first half of the eighteenth century it was only involved at one station, River Ythan (Newburgh), where a Coastguard boat was converted to the plans of George Palmer, a member of the central committee of the RNIPLS. This boat was altered in February 1828 at a cost of £25, paid from Scottish contributions to the Institution. This lack of direct

involvement could have been because, with its headquarters in London, the RNIPLS focussed on England and Wales simply because they were closer.

So independently operated lifeboats remained the norm in Scotland until the 1850s and, despite a national organisation for sea rescue being in existence, the only new lifeboats built for service at Scottish stations were all funded independently. A lifeboat at Buddon Ness to cover the river Tay was provided in the 1830s, along with lifeboats for Irvine in 1834 and another at Wick in 1848. The Irvine lifeboat was operated by the local Harbour Trust, while at Wick the station was established by the British Fishery Society, who provided three lifeboats between 1848 and 1895.

In the two decades after its founding, the RNIPLS funded and operated several lifeboat stations, but it was not a truly national organisation mainly due to a lack of funds. As these dwindled in the 1840s, and few worthwhile public appeals were made, the Institution was at its lowest ebb by 1850. A disaster at the mouth of the river Tyne in 1849, when one of the local Society's lifeboats capsized with the loss of twenty out of twenty-four on board, in sight of land, highlighted the need for better lifeboats and in the 1850s the RNIPLS was reformed, reorganised and renamed, becoming the Royal National Lifeboat Institution (RNLI) in 1854.

With a new secretary at its head and a new managing committee providing greater dynamism, the RNLI raised funds on a far greater scale than previously and considerably expanded its operations. The national economy prospered in the latter half of the century, and causes such as life-saving at sea gained a national prominence they had not before enjoyed.

Perhaps the most significant advance came with the introduction of a new

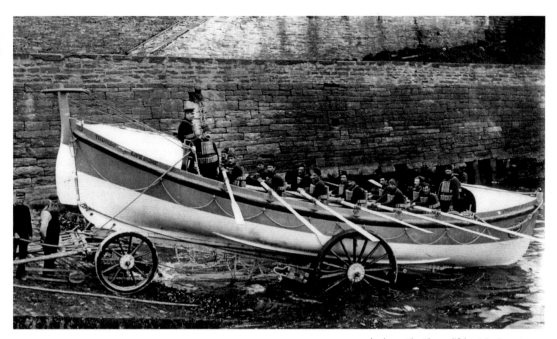

design of lifeboat: the self-righter. This was primarily a rowing boat, 34ft or 35ft in length, with high end-boxes and a narrow beam that enabled it to come upright in the event of a capsize. Self-righting lifeboats were used at all of the new stations that were established in Scotland in the latter half of the nineteenth century, and were usually launched from a carriage off a beach.

New stations were clearly needed, and the RNLI wasted no time in expanding its operations north of the border. A lifeboat was sent to Lossiemouth in 1859 and the following year to Banff and Buckie on the same coast, with North Berwick receiving a lifeboat at the same time. On the north coast, Thurso was the fourth new station opened by the RNLI in 1860 as its position 'on the south shore of the Pentland Firth, through which channel numerous vessels pass every year, makes it a very desirable station for a lifeboat.' The pulling lifeboat at Thurso proved to be very busy, unlike

above The Thurso lifeboat Co-Operator No.3 (ON.282) being launched down the slipway into Scrabster harbour. This 37ft self-righting type lifeboat served the station from 1890 to 1909 and saved twenty-four lives. Thurso was one of several lifeboat stations that were established on the coasts of Caithness and Sutherland during the latter half of the nineteenth century. Others were at Huna, Ackergill, Wick and Dornoch. (From an old photograph supplied by Andy Anderson)

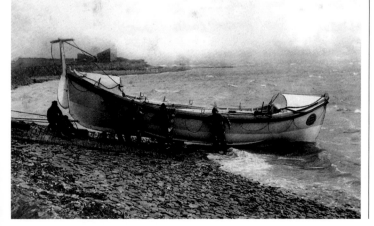

left The first Stromness lifeboat Saltaire (ON.286) being launched on 8 March 1884 to search for a missing fishing boat. Saltaire, a 33ft self-righter, served her Orkney station from 1867 to 1891, during which time she performed only three effective services. She was kept in a boathouse which was very exposed, and not only was launching from there difficult, but so was getting to sea and thus reaching the casualty.

The RNLI takes over

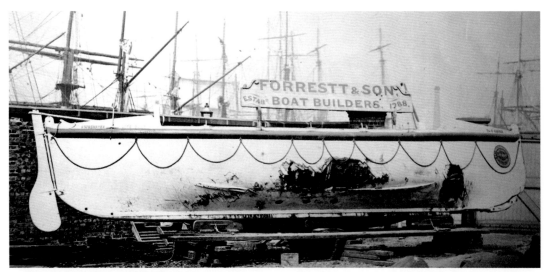

above The Stonehaven lifeboat St George at Forrestt's boatyard in London in 1874 where she was taken after capsizing on service on 27 February. She overturned when returning from service to the barque Grace Darling, of Blyth, which had in fact not needed her assistance. The lifeboat, which had been built in 1867, was wrecked among rocks at the back of Aberdeen Pier with twelve on board, of whom four were drowned. (By courtesy of the RNLI)

Medal winners

Even though the RNIPLS was little involved in lifeboat matters in Scotland before the 1850s, the Institution did award medals for outstanding acts of bravery, and the following is a small selection from the 1830s.

THURSO January 1830 • HM Coastguard Chief Boatman John Morgan saved the master, mate and three seamen from the brig Mary, of Stornoway, which had gone ashore at Thurso in a storm on 11 January. With two other coastguardsmen, Morgan rigged a rope and brought them ashore. The survivors had been in the rigging for more than seven hours.

MONTROSE March 1832 • Thirty lives were saved from the vessels Annie, Sophia and Ann on 25 March. Three of the rescuers were master mariners who manned the independently operated lifeboat, and six were the crew of a salmon coble. Following this rescue, silver medals were awarded to John Nichol, David Edwards, Robert Mearns (Jnr), Alexander Coul, Robert Japp, Charles Coul, William Finlay, John Peart and Alexander Watt.

right The 33ft self-righter Wallace on her launching carriage at Dunbar. (RNLI)

the lifeboats at stations operating in the more remote parts of Scotland. She spent eleven years at Thurso and saved almost fifty lives, with a particularly busy spell in February 1869, helping four different schooner in the space of a fortnight, and saving more than twenty men in the process. The vessels had been caught out in heavy gales in Scrabster Roads, and the lifeboat was able to reach them to render assistance.

On the west coast, stations were opened at Campbeltown in 1861, Kirkcudbright in 1862, Girvan in 1865 and Port Logan in 1866, while in the east lifeboats were placed at Anstruther

and Peterhead in 1865 and Stonehaven in 1868. All the new stations had new boathouses built and were supplied with launching carriages. However, no lifeboats were sent to Orkney or Shetland until the 33ft self-righter *Saltaire* went to Stromness in 1867.

Not only did the RNLI establish new lifeboat stations, but it also took over existing stations from local organisations and renovated them with new lifeboats and boathouses, starting in 1861 with the important stations at Broughty Ferry and Buddon Ness, near Dundee, which covered the entrance to the busy river Tay.

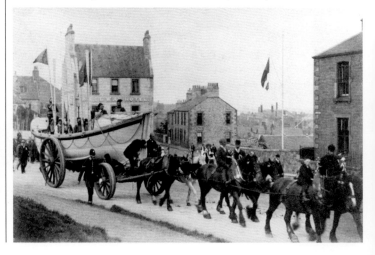

Nineteenth century lifeboat work

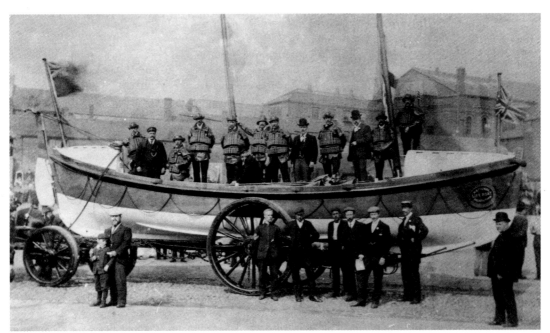

The expansion of lifeboat stations in Scotland was quite rapid from the 1860s, with many new stations opened. A number of lifeboats were placed on the south-west coasts between the Clyde and the Solway Firth, with stations being established at Kirkcudbright in 1862, Girvan in 1865, Port Logan in 1866, Ballantrae and Troon in 1871 and Portpatrick in 1877. On the Mull of Kintyre a station at Southend was opened in 1869, and on the nearby Isle of Arran the small village of Kildonan received a small 32ft lifeboat the following year.

None of the Hebridean islands were supplied with lifeboats in the nineteenth century. This was because the frequency of wrecks was so low, locations where suitable crews could be found were few and far between, and the range of the self-righting lifeboat type was so limited that its use in the heavy seas characteristic of Scotland's west coast would have been ineffective. But another station, along with that at Stromness, was opened in Orkney in 1874, at Longhope, on Hoy.

More stations were established during the 1870s, with no fewer than eight opened between 1876 and 1878, including two on the country's north coast, at Huna in 1877 and Ackergill in 1878, to cover the notorious Pentland Firth. By 1880 the RNLI was operating thirty-eight lifeboats in Scotland, all of which were standard self-righters between 30ft and 33ft in length, apart from the 37ft boat at Longhope.

The stations opened during the 1860s and 1870s were equipped with

above The Irvine lifeboat Busbie (ON.168) in Coventry on lifeboat flag day, 11 May 1901. A typical 34ft self-righter, Busbie served at Irvine from 1887 to 1898 and was then used as reserve lifeboat and for display purposes, hence her visit to Coventry. (By courtesy of Jeff Morris)

below The naming ceremony of the Banff lifeboat Help for the Helpless (ON.150), another 34ft self-righter which served from 1888 to 1901. The boat was funded from from a legacy bequeathed to the RNLI by the late Mrs Elizabeth Blain, of Blairlogie.

Nineteenth century lifeboat work

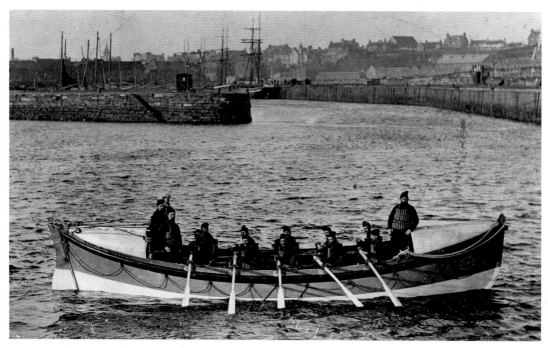

above The standard 34ft self-righter John Avins (ON.385) afloat in the harbour at Wick. Built in 1895, she was the first RNLI lifeboat to serve at Wick, where she stayed for ten years and saved eleven lives. (By courtesy of Andy Anderson)

below The 38ft Watson pulling lifeboat John Fortune (ON.523) on her carriage outside the boathouse at Port Errol. She was the last lifeboat to serve the station, which closed when she was withdrawn.

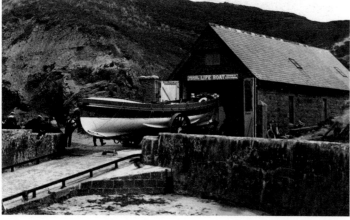

self-righting type lifeboats, which were usually carriage-launched. Although the self-righter had its faults, it was the best available design for much of the nineteenth century and many notable services were performed by lifeboat crews. A fine rescue was carried out by the Montrose crew using their self-righting lifeboat, the 33ft 1869-built *Mincing Lane,* on 21 December 1872. The lifeboat launched and was rowed through the harbour mouth and across the dangerous Annat Bank to go to the brig *Henriette,* of Memel, which had gone aground in a south-easterly gale three-quarters of a mile north

During the rescue, the coxswain and three crew were washed out in the heavy seas, but the strong waves also pushed the lifeboat close enough to the wreck so that six men were able to throw themselves from it into the lifeboat, which then picked up those crewmembers who had been washed out. The station's No.2 lifeboat *Roman Governor of Caer Hun,* a North Country type, was also launched to help and took the three remaining survivors from the wreck, including a small boy. *The Lifeboat* journal described this as 'one of the most gallant Life-boat services ever rendered on the Scotch coast', and Silver medals were awarded to the coxswains of the two lifeboats.

Despite being used for many rescues and used throughout the country, the self-righter had its drawbacks. In order to right in the event of a capsize, it had a relatively narrow beam, but this

Nineteenth century lifeboat work

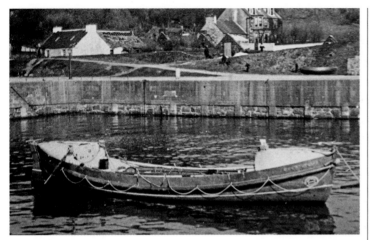

made it less stable than a non-self-righting lifeboat and more prone to capsize in the first place. And a number of accidents occurred during the late nineteenth century involving this type, many of which were fatal.

At Fraserburgh, on 16 February 1876, the lifeboat was driven onto rocks and her crew had to be taken off by shore boats during a service to the schooner *Augusta,* of Sunderland. On 28 October 1884, at the same station, the lifeboat *Cosmo and Charles* launched during a hurricane to the fishing boat *Gratitude,* but when she got among the rocks very heavy seas overwhelmed the lifeboat and she was capsized. All the crew were thrown into the sea, but luckily

they managed to regain the boat, while those on the smack were rescued by lifelines from the shore.

In the 1880s, to improve matters, a new design was introduced; it was developed following a tragedy off the north-west coast of England in which more than twenty-five lifeboat men lost their lives when the lifeboats at St Annes and Southport capsized. The new design, which became known as the Watson type after its designer George Lennox Watson, was larger, steadier and less likely to capsize than the self-righting type, although was itself not self-righting. Two types were built to his specifications: one was a large sailing boat and the other a

Medal winners

MONTROSE December 1872 • Silver Medals were awarded to the station's two Coxswains, William Mearns (No.1 lifeboat) and William Mearns Jnr (No.2 lifeboat), for the service to the brig Henrietta, of Memel. Unfortunately one of the lifeboat men, Alexander Paton, died a few days after from the effects of exposure.

LONGHOPE March 1891 • Silver medal was awarded to Coxswain Benjamin Stout in recognition of his gallantry when rescuing twenty-two men from the steamship Victoria, of Sunderland, which was sinking in the Pentland Firth on 3 March 1891. Eleven of the rescued crew were Germans and the Emperor of Germany presented a gold watch to the coxswain and £24 to the crew of the lifeboat.

left The Lossiemouth lifeboat James Finlayson (ON.541) on her launching carriage at the head of the harbour, which is busy with fishing boats. James Finlayson was a 35ft Watson sailing lifeboats, one of only two such craft to serve in Scotland. She was stationed at Lossiemouth.

below The unusual independent lifeboat at Helmsdale pictured on the day of her christening on 7 October 1909. The boat served until 1939 and was sold after the war. (By courtesy of Andy Anderson)

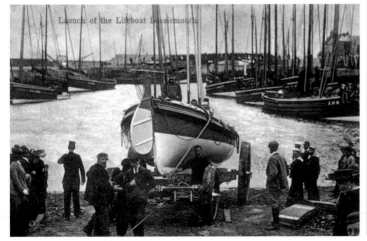

Launch of the Lifeboat Lossiemouth

Nineteenth century lifeboat work

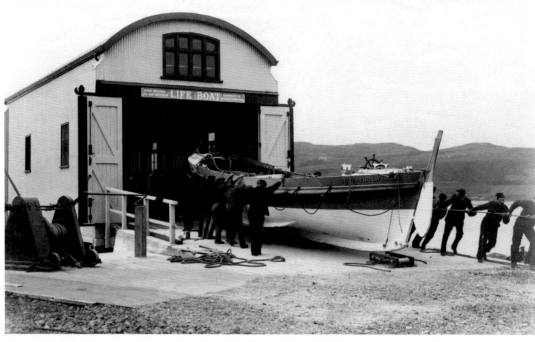

above A fine photograph of the Southend lifeboat John R. Ker (ON.529) being hauled back into her boathouse. A 38ft Watson, she was launched down a slipway at the other side of the house to that pictured, and was recovered through the rear of the house by being hauled over the beach, a somewhat labourious process. (By courtesy of the RNLI).

smaller pulling boat, neither of which was self-righting. The boat primarily designed for sailing measured 43ft by 12ft 6in, carried twelve oars, and weighed almost eleven tons. The smaller type was 38ft in length with a beam of 9ft 4in.

The Watson designed as a sailing boat had a greater range than its pulling counterpart. Although this

was important for many stations in Scotland, only two 43ft Watson sailing lifeboats were operated, from Cromarty and Longhope, where a long range was needed to cover the Cromarty and Pentland Firths respectively. The smaller version of the design, measuring 35ft to 38ft in length and intended largely as a pulling lifeboat, served at Anstruther and Lossiemouth.

above Longhope's 43ft Watson class lifeboat Anne Miles (ON.550) under oars, with her crew kitted out in cork life-jackets and, somewhat unusually, her masts lowered. (Orkney Photographic Archives)

right The lifeboat house and slipway built at Thurso in 1906-09 at the end of the Harbour Quay. This boathouse was typical of the lifeboat stations being built during the early years of the twentieth century. (By courtesy of Andy Anderson)

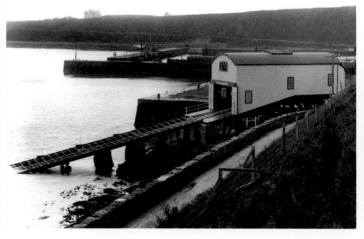

Nineteenth century lifeboat work

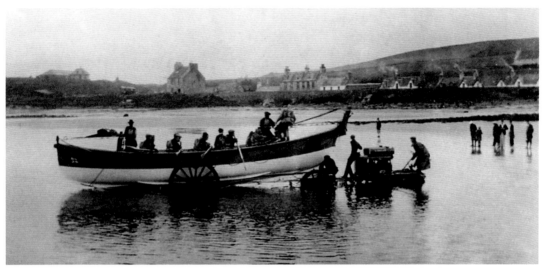

Another non-self-righting type, the Liverpool class which measured 35ft by 10ft, was also introduced at this time and was similar in many ways to the Watson design, but was more beamy and was fitted with four separate water-ballast tanks. The use of Liverpools was more widespread in Scotland, with seven stations operating boats of this type, including Girvan, Ayr and Ardrossan on the west coast, and Skateraw and Dunbar in the east, all built between 1898 and the outbreak of the First World War. Dunbar's he 35ft Liverpool, *William Arthur Millward* (ON.443), was involved in a fine service on 13 October 1905 when she saved the crew of six from the steamship

King Ja Ja, of Swansea, which was in difficulties and eventually wrecked near Thorntonloch, in a north-westerly gale.

However, despite the introduction of the larger lifeboats, the standard self-righter remained the predominant type. By the turn of the century, the RNLI was operating forty-five lifeboat stations around the coasts of Scotland, the great majority of which were using self-righters which were carriage launched, and this remained the case until after the First World War.

Another significant development was the construction of lifeboat stations with launching slipways. This method launching enabled larger lifeboats to be operated, as launching down

Medal winners

DUNBAR October 1905 • The Silver medal was awarded to Coxswain Walter Fairbairn for saving the crew of the steamship King Ja Ja The lifeboat William Arthur Millward stood by the casualty in a northerly gale for over four hours while attempts were made to repair the vessel's machinery. She then returned to station, but was called out an hour later as the steamer was again in trouble. The lifeboat reached the casualty, ten miles off Dunbar, and took the crew off using lines in an operation that took an hour. The return to Dunbar, in heavy seas and strong winds, took three hours.

NEWBURGH October 1923 • The Newburgh lifeboat James Stevens No.19 was dragged seven miles along the soft sandy beaches to assist the Aberdeen trawler Imperial Prince, which was ashore at Belhevie, north of Aberdeen. The Aberdeen private lifeboat was unable to assist, but the Newburgh boat was launched three times to save a total of seven men in what was an exhausting operation for the lifeboatmen. The Silver medal was awarded to Coxswain John Innes and the Bronze medal to Bowman James Innes for their considerable efforts during this rescue.

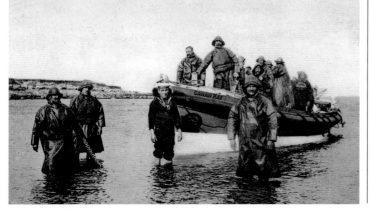

left The Skateraw lifeboat Sarah Kay (ON.569) was built in 1907 and remained in service until well into the Second World War. She was one of several 35ft Liverpool class lifeboats to serve in Scotland.

Nineteenth century lifeboat work

above The 35ft twelve-oared Liverpool lifeboat William Arthur Millward (ON.443) pictured under sail off Dunbar; she served the station from 1901 to 1931 and saved thirty-four lives. (By courtesy of the RNLI)

right Girvan lifeboat James Stevens No.18 (ON.452) being launched across the beach. Built in 1901, she served at Girvan for thirty years. (From an old postcard supplied by John Harrop)

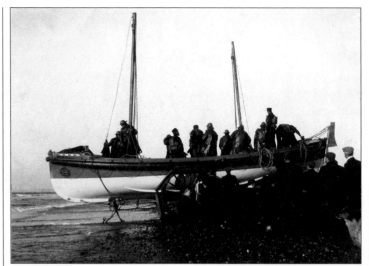

below The Stonehaven lifeboat Joseph Ridgway (ON.652) being recovered in the harbour. A 35ft Rubie self-righter, which was a lighter version of the standard self-righter, she was the last pulling lifeboat built for service in Scotland and served at Stonehaven until 1934, launching just four times in the eighteen years she spent there. When she was withdrawn, the RNLI closed the station. (From an old postcard supplied by John Harrop)

a slipway was easier and faster than using a carriage, on which the boat was pulled to a launch site. New boathouses with slipways were built at many of Scotland's lifeboat stations, starting with Kirkcudbright in 1892-3, where the new house was built a couple of miles out of the town and so launching was far easier than it had been before.

Further slipways were built at Stromness (1901), Southend (1904), Thurso (1906), Longhope (1906), St Abbs (1909), Broughty Ferry (1909), Stronsay (1911), Macrihanish (1911), Peterhead (1911), Fraserburgh (1913) and Wick (1916), enabling larger lifeboats to be operated. Slipway launching became the norm at this time, and most of these boathouses were used for many years, being able to accommodate the motor lifeboats that were subsequently built for the stations.

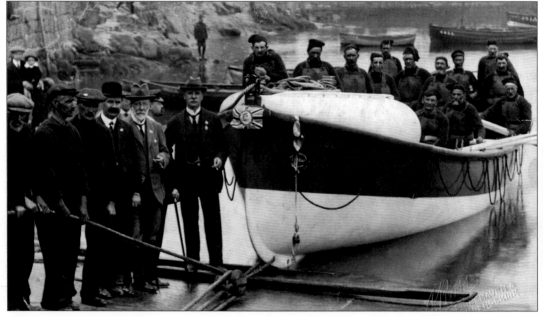

Nineteenth century lifeboat work

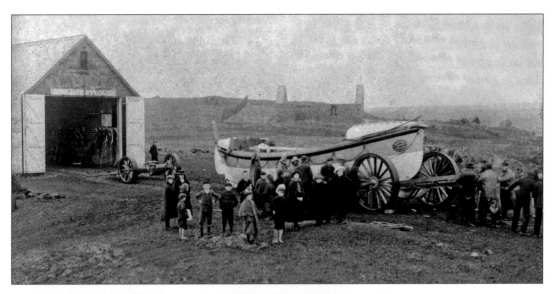

Three images showing nineteenth century lifeboat work at stations which are no longer operational.

above The Isle of Whithorn lifeboat George and Margaret (ON.476) being recovered onto her carriage. This station, at one of the most southerly villages in Wigtownshire, was operational for fifty years. George and Margaret, a 35ft self-righter, was the last lifeboat to serve and she launched just six times on service during her eighteen years of service.

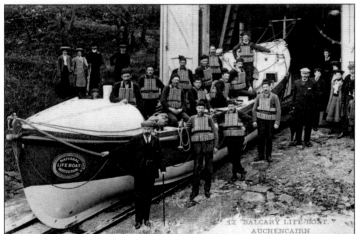

left The Balcary lifeboat David Hay (ON.84) was the first of two lifeboats to serve this station, which covered Auchencairn Bay. She was on station from 1884 to 1914 and is pictured just outside the lifeboat house, from which she was launched down a steep slipway.

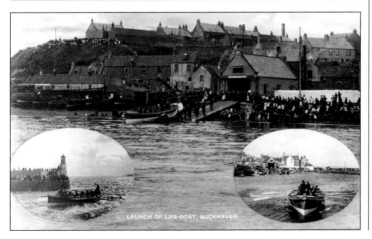

left The Buckhaven lifeboat Isabella (ON.441) being launched in 1900 from her new lifeboat house and taken to sea for what was probably the inauguration of the station. This fine lifeboat house, which was used from 1900 to 1932, has been demolished and no trace of this short-lived station exists. (Images on this page from old postcards supplied by John Harrop)

Early motor lifeboats

An epic journey

The two new motor lifeboats for Orkney, John A. Hay (ON.561) and John Ryburn (ON.565), were taken to their stations from London by sea in April 1909. Hitherto, new lifeboats had been delivered to their station by steamship or railway, so such a long journey was a major undertaking and intended as a proving test for the new motor lifeboats.

15-19 April • Left London Docks at 8.50am on 15 April and reached Scarborough four days later after overnight stops at Harwich, Gorleston and Grimsby Dock

20-25 April • The boats continued north, calling at Hartlepool, Tynemouth and Blyth, then reaching Dundee on 25 April, covering 111 miles on the last leg to reach the river Tay

25-30 April • From Dundee, the lifeboats made for Aberdeen, and stopped overnight at Fraserburgh, Wick and Thurso, before a final passage across the Pentland Firth on 30 April

During the epic journey, which took seventeen days, the Stromness lifeboat covered 768 miles, while the Stronsay boat covered 808 miles and arriving at her station on 1 May.

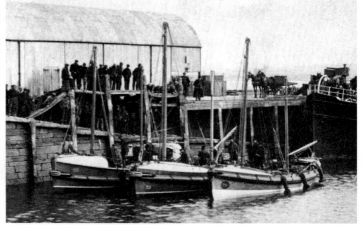

above right The flotilla of lifeboats at Thurso in April 1909, nearing the end of their epic journey north from London. The Stromness lifeboat John A. Hay (ON.561) is on the left, nearest the quayside, with the Stronsay boat John Ryburn (ON.565) in the middle. On the outside is the Thurso lifeboat Sarah Austin (ON.585), a twelve-oared Watson sailing type. (RNLI)

right A crowd of well-wishers admire the new motor lifeboat John Ryburn (ON.565) alongside at the Old Harbour, Kirkwall. She visited Orkney's capital for her naming ceremony in September 1909, when she was formally christened by Mrs Balfour. (Orkney Photographic Archives)

below John Ryburn inside the lifeboat house during her short service career at Stronsay. (Orkney Photographic Archives)

During the nineteenth century lifeboat men using the pulling and sailing lifeboats often performed remarkable feats of life-saving. However, powered lifeboats would have distinct advantages over lifeboats relying on sails, oars or a combination of the two, and the earliest powered lifeboats were steam driven. The first steam-powered lifeboat, *Duke of Northumberland* (ON.231), was launched from her builder's yard on the Thames in 1890 and, over the next decade, the RNLI had a further five steam lifeboats built for service around the British Isles, but none served at stations in Scotland.

Although steam was better than rowing and sailing as a means of powering lifeboats, it was not ideal, and by the opening of the twentieth century it was clear to the RNLI's designers that the internal combustion engine, developed during the second half of the nineteenth century, offered a better alternative. So in 1904 a lifeboat was fitted with an engine for the first time and, once numerous setbacks and technical difficulties had been solved, lifeboats powered by the internal combustion engine pointed the way ahead and Scotland was at the forefront of the early lifeboat development.

Initially, the RNLI fitted lifeboats already in service with an engine, using the boats for a series of trials to assess the suitability of motor power. As the trials with the first converted pulling boat, *J. McConnel Hussey* (ON.343), proved so successful, the RNLI's Committee of Management ordered

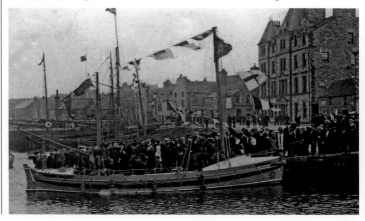

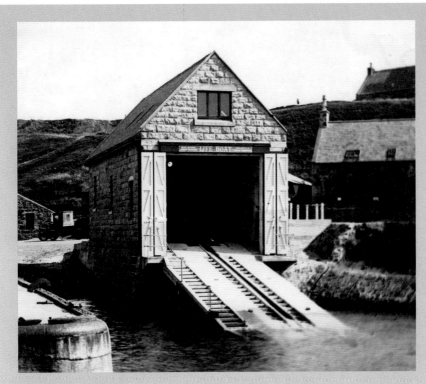

left The lifeboat house and slipway built at Whitehills in 1933 and used until the station was closed in 1969. The lifeboat to cover this part of the coast was transferred here in 1924, and this boathouse accommodated a series of motor lifeboats, starting with the 35ft 6in self-righting motor Civil Service No.4 (ON.756). This photograph dates from the 1930s, soon after the house had been completed. (By courtesy of the RNLI)

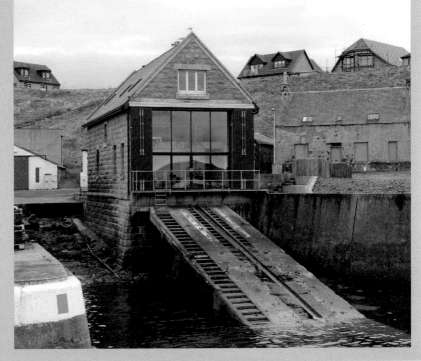

right The boathouse at Whitehills was used for the lifeboat until May 1969, when the last boat to use it, the 47ft Watson motor Helen Wycherley (ON.959), was removed and the station was closed. The building was used as a store during the 1980s and 1990s, but in 2008 it was extensively modernised and converted into a private house, with as much of the original interiors preserved.

Early motor lifeboats

Inaugural launch of the Peterhead 45ft Watson motor lifeboat Duke of Connaught (ON.668) on 28 August 1922, watched by supporters from the boathouse, with trawlers gathered in the harbour. (By courtesy of the RNLI)

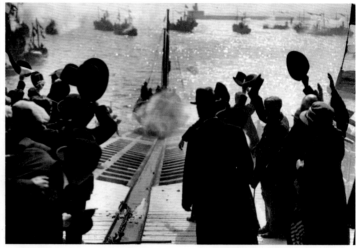

Peterhead tragedy

On 26 December 1914 the motor lifeboat Alexander Tulloch (ON.622) went to assist the Hull trawler Tom Tit, which had gone ashore in a fierce southerly gale. Before the lifeboat could get to the casualty, a huge sea caught her, carried her westwards, and smashed her upon rocks which were being swept by mountainous seas, watched by hundreds of people on shore. When the boat hit the rocks, John Strachan, Robert Slessor, and Andrew Geddes jumped clear and, with the assistance of onlookers who had clambered over the rocks, were hauled to safety, but the other nine members of the crew were washed out of the boat. Second Coxswain James Geddes and crew members Thomas Geddes and David Strachan lost their lives, although the rest of the crew were saved thanks to the efforts of those on shore. The crew of Tom Tit were brought ashore by the breeches buoy, but the motor lifeboat was smashed to pieces. The motor was salved and renovated, and the machinery, air cases and other valuable parts were also saved, but the disaster cast a long shadow over the fishing community of Peterhead.

three engines to be used to convert three lifeboats then being built and, of these three, two were allocated to serve in Scotland, at Stromness and Stronsay, the latter a new station in Orkney. The lifeboats had already been ordered from the London boatyard of Thames Ironworks along with a boat for Thurso, *Sarah Austin* (ON.585), which in the end was not fitted with an engine.

The new Stromness lifeboat, *John A.*

Hay (ON.561), was a self-righting type, 42ft in length and fitted with a Tylor four-cylinder engine of 30bhp. During her trials, she reached a speed of almost seven knots. The boat for Stronsay, *John Ryburn* (ON.565), was a 43ft Watson type powered by a Blake four-cylinder engine of 40bhp, which gave her a speed of just over seven knots during her trials. These boats were taken to their stations by sea, and the massive

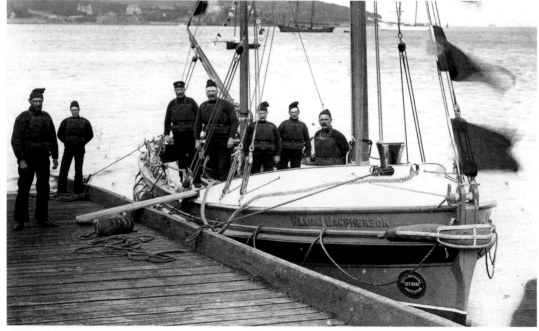

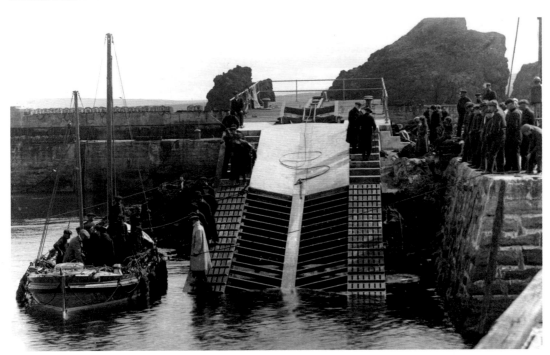

journey from the Thames to Orkney was used by the RNLI to prove the viability of motor power in lifeboats.

Further motor lifeboats were built before the outbreak of war in 1914, and a good number went to Scottish stations. In October 1910 the 40ft Watson *Maria* (ON.560) arrived at Broughty Ferry to cover the dangerous waters of the river Tay. In April 1911 one of the smaller motor lifeboats to be built, the 38ft Watson *Helen Smitton* (ON.603), was

sent to St Abbs, where a new station was established with a slipway specially built for the new motor craft.

In July 1912 another Watson motor lifeboat, this one measuring 43ft by 12ft 6in and named *William MacPherson* (ON.620), was sent to Campbeltown. A similar-sized boat was sent to Peterhead in December 1912, but this one, *Alexander Tulloch* (ON.622), lasted just two years before being tragically wrecked on 26 December 1914.

above The new station at St Abbs with the slipway built for the 38ft Watson Helen Smitton (ON.603), which is pictured on the day of her arrival in April 1911. She served the station for twenty-five years. (By courtesy of Andy Anderson)

opposite bottom The Campbeltown motor lifeboat William MacPherson (ON.620) with her volunteer crew in July 1912, just after she had arrived on station. A 43ft Watson motor type, she served at Campbeltown for seventeen years and saved twenty-nine lives in that time. (From an old postcard supplied by John Harrop)

left The pioneering motor lifeboat Maria (ON.560) in the river Tay off Broughty Ferry, where she served for eleven years. (By courtesy of the RNLI)

Motor lifeboats take over

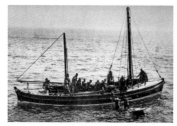

above The 45ft Watson motor lifeboat Duke of Connaught (ON.668) on service at Peterhead, rescuing two men from water. (By courtesy of the RNLI)

below The impressive 60ft Barnett motor lifeboat Emma Constance (ON.693) at Aberdeen, pictured on the day of her arrival in October 1926. The design was the first to incorporate twin engines, along with various other innovations. She could travel 250 miles at her cruising speed of eight knots, and had a top speed of 9.5 knots. (By courtesy of the RNLI)

Following the pioneering work to develop motor lifeboats during the first decade of the twentieth century, further advances were hampered by the First World War when, not only did lifeboat production cease, but work on shore projects, such as the new boathouse at Wick, was affected. The building at the Caithness station, which was started in 1913, was not completed until 1916, but the delay did not matter as the new motor lifeboat which was to operate from it, the 45ft Watson motor *Frederick and Emma* (ON.659), was also delayed, not arriving until June 1921.

Meanwhile, at some stations crewing proved to be problematic during the war, with a shortage of manpower due to conscription having a considerable impact at some places. Ballantrae was closed temporarily in 1917, and permanently in 1919. Banff station was closed from 1917 to 1921, but was reopened for three years before

operations were moved along the coast to nearby Whitehills.

Once hostilities had ceased, the RNLI adopted a policy of modernisation, which resulted in many new motor lifeboats being built to replace the pulling, sailing and steam lifeboats then in service. There were also several important improvements in the design of the motor lifeboat. The 45ft Watson motor type was developed and became the first standard motor lifeboat design; it was single-engined so carried auxiliary sails, and was kept afloat or launched from a slipway. As well as the 45ft Watson for Wick mentioned above, the other boat of this type for Scotland was *Duke of Connaught* (ON.668), which went to Peterhead in June 1921.

As more motor lifeboats were placed on station, the total number of stations was gradually reduced. As the pulling lifeboats that were being replaced had a limited range, the need for so many

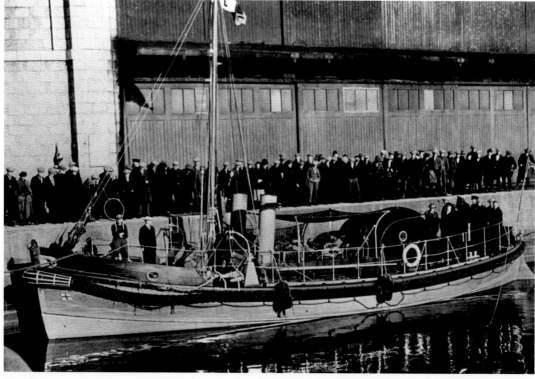

Motor lifeboats take over

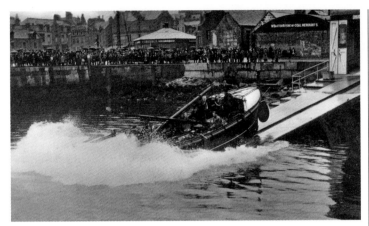

lifeboats was negated by the motor lifeboat. As a result, many stations were closed, starting in the 1920s with lifeboats permanently withdrawn from Crail, Port Errol, Lossiemouth, North Berwick and Johnshaven. A further spate of closures took place in the early 1930s as the number of motor lifeboats continued to expand. In 1930 the lifeboats at Ardrossan, Southend (Kintyre), Macrihanish and Huna were withdrawn. Balcary was closed the following year, as was the No.2 station at Campbeltown. Ayr, Port Logan, Ackergill and Buckhaven stations closed in 1932, followed by Stonehaven in 1934 and St Andrews in 1938.

By 1938, with the programme of motorisation well under way, of the thirty-three stations in Scotland twenty-nine had motor lifeboats while just four pulling boats remained. These four, at Skateraw, Newburgh, Aberdeen No.2 and Montrose No.2, were replaced during the next five years. The boat at Skateraw, just to the south of Dunbar, lasted until 1943 and became the last pulling lifeboat to serve in Scotland.

The motor lifeboats built during the inter-war era were basically sailing lifeboats fitted with a single engine driving a single propeller. But as the RNLI gained greater experience in the operation of motor lifeboats and more reliable engines were developed, larger

boats were designed taking advantage of all the benefits that motor power offered, and these craft were able to cover ever greater areas.

In the 1920s James Barnett, the RNLI's Consulting Naval Engineer, designed a 60ft lifeboat that employed twin engines and twin propellers, eliminating the need for the auxiliary sails that single-engined motor lifeboats had to carry in case of break down. Although only four of Barnett's impressive 60ft lifeboats were built, one of them, *Emma Constance* (ON.693), was sent to Scotland, coming to Aberdeen in 1926 when the RNLI took over the running of that station.

Emma Constance served at Aberdeen for twenty-five years, during which time she saved more than ninety lives. She undertook many fine rescues including

above left Launch of the 42ft motor self-righter Lady Rothes (ON.641) at Fraserburgh, where she served from July 1915 to March 1937.

below Launch of the 35ft Liverpool pulling lifeboat Sarah Kay (ON.560) at Skateraw. She served the station for thirty-seven years and, when withdrawn in 1943, was the last pulling lifeboat in Scotland.

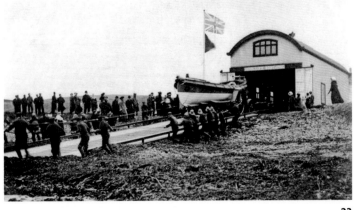

Motor lifeboats take over

right The first lifeboat to serve at Islay, Frederick H. Pilley (ON.657), pictured at Port Askaig. She was on station from March 1934 to June 1935, and was replaced by the 45ft 6in Watson motor Charlotte Elizabeth (ON.774). The need for a lifeboat at Islay was demonstrated on 26 October 1936 when the Latvian steamer Helena Faulbaums of Riga was driven onto rocks at the island of Beul-nan-uamh and foundered. News of this reached Port Askaig at 1am on 27 October. Leaving his sick bed, Coxswain Peter MacPhee took the lifeboat and reached the scene of the wreck, thirty miles away, at 9am. Four of the crew of twenty survived, managing to get ashore, and they were rescued by the lifeboat using breeches buoy. For this service Coxswain MacPhee was awarded the Latvian Order of the Three Stars.

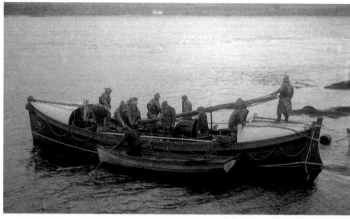

below The scene at Scrabster harbour during the naming ceremony of the new Thurso 45ft 6in Watson motor lifeboat H.C.J. (ON.708) on 13 September 1929 by the Duchess of Portland. She served Thurso for almost twenty-seven years. (By courtesy of Andy Anderson)

a particularly difficult one on Christmas Day 1935, when she launched to the trawler *George Stroud,* which had gone aground 50ft from the North Pier wall in heavy seas and a south-easterly wind.

The lifeboat was taken alongside the casualty to try to save the trawler's crew, then being struck repeatedly by heavy seas which flung her against the foundations of the pier. Sadly only two of the five crew on board the trawler were saved, but the incident had showed the advantage of the large motor lifeboat. Coxswain Thomas Sinclair was later awarded the Bronze medal his courage, determination and skill in taking the lifeboat between the pier wall and the wreck five times.

The 6oft Barnett, impressive though it was, proved to be a little too large for many stations, as it could not be slipway launched due to its size, and so was restricted to stations where a mooring was available, and keeping lifeboats afloat was, at this time, not the norm with the RNLI preferring to keep lifeboats in boathouses. As a result, during the 1920s two slightly smaller classes of motor lifeboat were designed: the 45ft 6in Watson motor and the 51ft Barnett, both of which were suitable for slipway launching.

The first 51ft Barnett lifeboat to be built was sent to the Stromness station in Orkney. The station had been offered a 6oft type, which would have been ideal in many respects, but the committee and crew at Stromness felt that their boat should be housed. Their ideal lifeboat should be around 50ft long with twin engines, a speed of not less than nine knots, have protection for the crew in a forward cockpit, and a low foot rail fitted below the railings on deck. These proposals were discussed with Barnett, and many were incorporated in a new type developed specifically for Stromness.

The new type, first of which was named *J.J.K.S.W.* (ON.702) and went to Stromness in March 1928, had an operating range of 100 miles and was compact enough to fit inside the

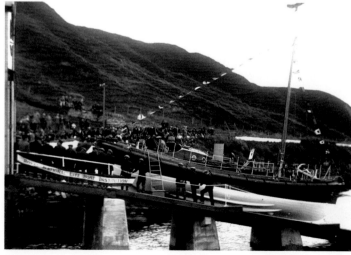

Motor lifeboats take over

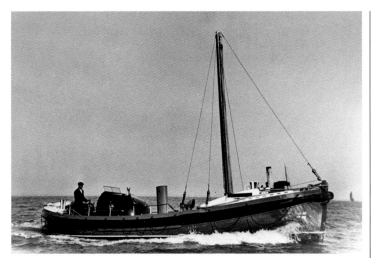

left The 40ft 6in Watson motor J. and W. (ON.722) was the first motor lifeboat to serve at Portpatrick. She arrived at the station in December 1929 and was replaced in March 1937 by the large and more powerful 46ft Watson Jeanie Speirs (ON.788). Only four 40ft 6in Watson motor lifeboats were built, including this one, whose sister vessel, Sir David Richmond of Glasgow (ON.723), also served in Scotland, at Troon.

above 51ft Barnett 'Stromness' type J.J.K.S.W. (ON.702) arriving at Stromness in March 1928, with the boat she replaced, John A. Hay, alongside the slipway.

below J.J.K.S.W. (ON.702) on the slipway at Stromness dressed overall for her naming ceremony on 6 June 1928. (By courtesy of John Harrop)

boathouse. The type became known as the 51ft Barnett 'Stromness' class and was much lighter, and in total thirteen boats of this class were built. The boat's hull was divided into eight watertight compartments and fitted 160 air cases; the cabin had seating for ten people and cockpits forward and aft, fitted with shelters, had space for a further twelve. Stornoway, Campbeltown, Lerwick and Barra Island all operated 51ft Barnett lifeboats from the 1930s well into the 1950s.

Smaller motor lifeboat types were also developed during the inter-war years, such as the 40ft Watson motor. *K.B.M.* (ON.681), a 40ft by 11ft craft to this design, arrived at Buckie in July 1922 and served there with distinction for more than twenty-five years. This was followed by a 40ft 6in version, of which two came to Scotland, arriving at

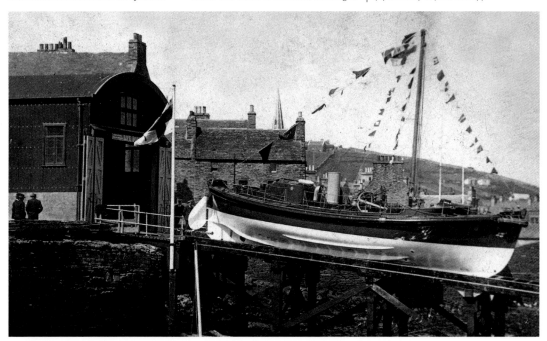

Motor lifeboats take over

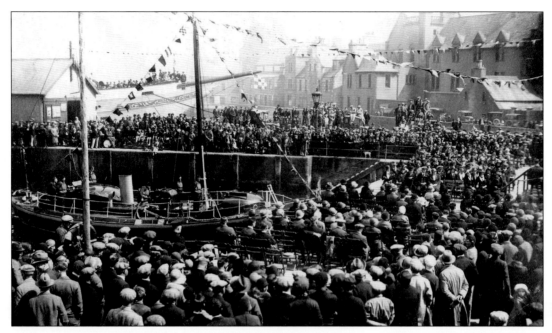

above Lerwick harbour packed with well-wishers and supporters for the naming ceremony of the new 51ft Barnett lifeboat Lady Jane and Martha Ryland (ON.731) on 25 June 1932. The lifeboat was named by the Duchess of Montrose and went on to serve in Shetland for twenty-eight years. (By courtesy of the RNLI)

below Montrose lifeboat John Russell (ON.699) was a 45ft 6in Watson motor type and one of only two lifeboats of this class which were single engined.

below right The 51ft Barnett lifeboat City of Glasgow (ON.720) at moorings in Campbeltown harbour, where she served from 1929 to 1953, saving 173 lives.

their stations of Troon and Portpatrick during December 1929. These boats were among four new lifeboats built during 1929-30 to guard the approaches to the important and busy Clyde estuary, with the other two going to Girvan and Campbeltown.

It was notable that all four lifeboats had been funded through contributions from Glasgow. The Troon and Portpatrick boats were provided out of legacies, from the late Lady Richmond and the late Mrs Agnes Colquhoun respectively, while the Girvan boat was a gift from Mrs Lawrence Glen of

Glasgow and the new Campbeltown through fund-raising in the city. This lifeboat, one of the 51ft Barnett types, was named City of Glasgow (ON.720) as a mark of appreciation of the considerable financial help received from the RNLI's Glasgow Branch during the 1920s. Between 1926, when it raised £2,390, and 1929 Glasgow more than doubled its contributions to RNLI funds. In 1929 the city's people raised £5,152, more than in both Manchester and Liverpool. And in 1930 over £13,000 was contributed, with £4,000 more coming in the form of legacies.

Motor lifeboats take over

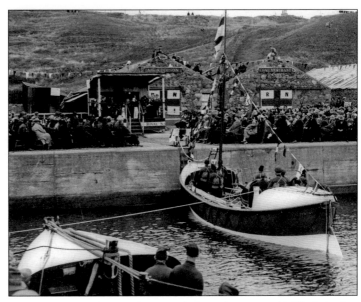

Another technical advance came in 1932 when a diesel engine was fitted to a lifeboat for the first time, and soon diesel-powered craft were operating from Scottish stations. Diesel engines outperformed their petrol counterparts, consuming less fuel and giving lifeboats a far greater range, something that was particularly important for many Scottish stations. The first diesel-engined lifeboat in Scotland was *John and Charles Kennedy* (ON.790), which arrived at Fraserburgh in March 1937.

The power of motor craft also meant that lifeboats could be operated from places which had been unsuitable for pulling lifeboat operation, and so, in the 1930s, life-saving provision in the country was widened as the challenging seas around the west coast and Northern Isles, which rendered pulling self-righting lifeboats ineffective, could now be tackled. The newly-developed twin-engined motor craft had a range that made it possible to operate along the country's rugged west coast and three new stations were established here in the 1930s: at Barra Island in 1931, Islay in 1934 and Tobermory in 1938.

In addition to the west coast, Shetland had its first RNLI lifeboats

in the 1930s, with the latest and most powerful craft being sent for service at stations which became the Institution's most northerly. A 51ft Barnett was sent to Lerwick in 1930 and *K.T.J.S.* (ON.698), a 45ft 6in Watson motor built in 1926 for Longhope, was transferred to Aith in May 1933. Two years later a new 51ft Barnett, *The Rankin* (ON.776), was completed for service at Aith, and since then these two stations have played a key role in sea rescue in the north.

above The scene at Whitehills during the naming ceremony of the 35ft 6in motor self-righting lifeboat Civil Service No.4 (ON.756) on 5 October 1932. She was the twenty-first lifeboat provided by the Civil Service Lifeboat Fund, despite her name, and was christened by the Duchess of Fife. (By courtesy of the RNLI)

left and below The ceremony of the 45ft 6in Watson motor Charlotte Elizabeth (ON.774) on 25 June 1935. Somewhat unusually the ceremony was held at Alexander Robertson's yard at Sandbank on the Clyde, where the lifeboat had been built, and was performed by Miss Elizabeth Sinclair, the donor, who had given the boat through the Glasgow Branch. The boat served at Islay for twenty-four years and was the first new boat built for the station, which was only established in 1934. (By courtesy of RNLI)

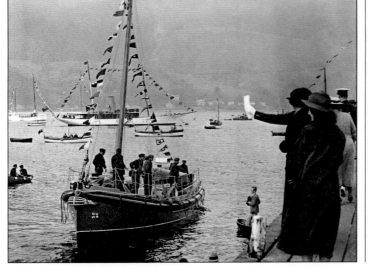

Wartime service

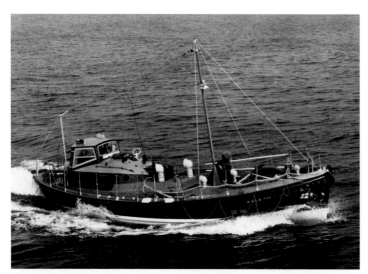

above The 46ft Watson motor lifeboat The Good Hope (ON.821) was completed in 1939 and went on station at Montrose in October 1939 right at the start of the Second World War. (By courtesy of RNLI)

Nighttime operations were particularly hazardous as few, if any, lightships or aids to navigation displayed lights, and restrictions were placed on radio communication. In addition, floating mines presented an unknown hazard, and attack by enemy aircraft or warships was a distinct possibility.

Younger crew members were lost to the armed forces in many areas, while the decline in income experienced by the RNLI affected all lifeboat stations. Although few new lifeboats entered service during the period of the conflict, just as war was starting both Peterhead and Montrose received new 46ft Watson motor lifeboats, and a new 35ft 6in Liverpool motor went to the Aberdeen No.2 station in October 1939.

Despite the difficulties and the greater demands on lifeboats, many notable services were undertaken and some outstanding medal-winning rescues were performed in Scotland and elsewhere. The war was just a few months old when, on 5 December 1939, the Broughty Ferry lifeboat *Mona* saved crew of the steam trawler *Quixotic*, of Aberdeen, which had gone ashore on the Bell Rock only fifty feet from the lighthouse. During the rescue, carried out in darkness, the Coxswain managed

At the outbreak of the Second World War, almost the whole of the lifeboat fleet had been motorised as a result of the modernisation programme pursued by the RNLI, and only fifteen pulling and sailing boats remained in service. Although lifeboat stations were thus relatively well equipped, the conflict of 1939-45 presented many challenges to the RNLI and its volunteer crews.

Lifeboats were forced to operate in conditions more hazardous than normal and even routine services could prove more difficult than in peacetime.

right The Aberdeen No.2 lifeboat George and Elizabeth Gow (ON.827) arrived at Aberdeen in October 1939, but in August 1943 was taken over by the RAF for air-sea rescue work in the Azores, and she is pictured during her time in service with the RAF. She returned to Aberdeen in September 1946 and served the station until June 1962. (By courtesy of RNLI)

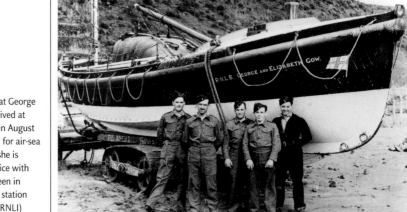

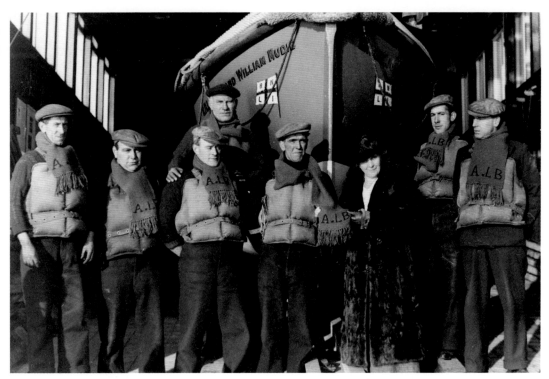

above The Arbroath lifeboat crew, in front of John and William Mudie (ON.752), were shot at by German aeroplanes when on service. (By courtesy of the RNLI)

to get the lifeboat alongside the casualty by approaching stern first. The lifeboat was rising and falling heavily in broken water, and careful boathandling skills were needed to prevent the waves from carrying the lifeboat onto the rocks.

At one point, a sea breaking over the lifeboat's bow washed several crew aft, with two being injured, and a third nearly swept through the guard rails and overboard, but all clung on. The Coxswain was able to hold the lifeboat in position for half an hour, enabling the trawler's crew, soaked, chilled and exhausted by three hours' exposure to the winds and breaking seas, to jump aboard, one by one. The lifeboat landed the survivors at Broughty Ferry at 1.30am, more than five hours after putting out, and Coxswain James Coull was awarded the Silver medal.

While this incident did not involve any wartime casualty, a few months later, on 9 February 1940, the Arbroath lifeboat *John and William Mudie*

(ON.752) and her crew were involved in an unpleasant incident. The lifeboat was launched to two minesweepers and a hopper-barge, but as she reached the casualties two German bombers attacked the barge with bombs and machine guns. The minesweepers opened fire on the bombers, and the lifeboat crew found themselves under fire both from the German aeroplanes and the minesweepers, but they made for the barge undeterred. Ten bombs from the aeroplanes dropped close to the lifeboat and exploded, which the crew said afterwards, 'seemed to lift the lifeboat out of the water and made all the air-cases inside her rattle,' but she held on. An English fighter then appeared and drove the bombers off, and fortunately neither the barge nor the lifeboat had been hit.

The lifeboat went alongside the barge, *Foremost*, of Aberdeen, which had already been bombed and two of her crew killed, and rescued the other

Medal winners

BROUGHTY FERRY December 1939 • Coxswain James Coull was awarded the Silver medal for saving the crew of the steam trawler Quixotic, and Acting Second Coxswain George B. Smith and mechanic John Grieve were awarded the Bronze medal; the other five crew, Sam Craig, G. Watson, G. Gall, William Findlay and Robert Smith, were accorded the Thanks of the Institution on Vellum.

ARBROATH February 1940 • For the courageous rescue during which the lifeboat came under enemy fire, Coxswain William Swankie was awarded the Bronze medal; the Thanks Inscribed on Vellum was accorded to the six crew members: Second Coxswain David Bruce, Bowman Robert Cargill, Mechanic Harry Swankie, and crew members William Scott, Joseph Cargill and Charles Smith; Coxswain Swankie was also awarded the British Empire Medal.

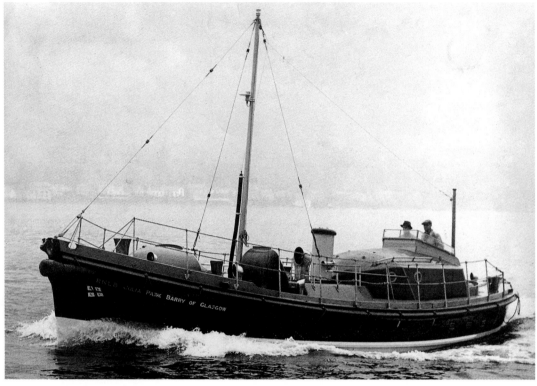

above Peterhead lifeboat Julia Park Barry of Glasgow (ON.819), which was called out four times in the space of seventy-five hours to save the crews of three steamers in difficulties in January 1942. (By courtesy of the RNLI)

seven. A letter of congratulations from HM the Queen was later sent to the Arbroath crew: 'The Queen has heard with great interest of the fortitude displayed by the crew of the Arbroath lifeboat to the aid of a dredger which was being attacked by a German bomber. . . whilst it is no surprise to learn of the gallantry of her fellow countrymen, she would be glad if you would convey to Mr William Swankie and all his crew her congratulations.'

The most outstanding rescue undertaken during the Second World War by any lifeboat crew in Scotland came in early 1942 when the Peterhead lifeboat crew, manning the 46ft Watson *Julia Park Barry of Glasgow* (ON.819), were involved in a series of rescues that earned Coxswain John McLean the Gold medal, the first to be awarded to a Scottish Coxswain for more than a century. On 23 January 1942 the lifeboat escorted the steamship *Runswick*,

of Whitby, which had been badly damaged in a collision, into Peterhead Bay along with two other steamers, *Saltwick*, of Whitby, which had also been damaged, and *Fidra*, of Glasgow.

As the weather worsened, soon becoming a hurricane, the lifeboat was called to help *Runswick*, which had dragged her anchors and gone ashore in the early hours of 24 January. As the lifeboat left harbour, seas filled her cockpits, and in the darkness and the snow Coxswain Mclean could see no further than the length of his boat. Huge seas breaking over *Runswick*, and just getting a rope on board proved to be exceptionally difficult. The steamer's crew put a pilot ladder over the side and, watching the lifeboat as she rose and fell on the seas, scrambled down when they could, to be grabbed by the waiting lifeboat crew. The survivors were exhausted by their ordeal, but the entire crew of forty-four were rescued.

The gale was increasing, but the anchors of the other two steamers held until the third day when the wind was gusting to 105 miles an hour. At 10am on 25 January the Coxswain saw the second steamer, *Saltwick*, go ashore but, as her crew were not in serious danger, they were told to stay on board. The lifeboat crew continued to stand by until, at 4pm, the third steamer, *Fidra*, went ashore, so the lifeboat put out again, reaching *Fidra* in a quarter of an hour and finding her almost submerged.

Despite the very heavy seas breaking over the steamer, a line was got aboard as massive waves lifted the lifeboat almost onto the steamer. However, each time she came close to the deck, a few men jumped across. The lifeboat was alongside for fifty minutes until the whole crew had been rescued, and then returned to harbour. The lifeboat crew then went home for dry clothing, but had to return at once to stand by.

Sure enough, the plight of *Saltwick* soon became desperate and at 8.30am the lifeboat was asked to save her crew. The only way to approach her was to go between her and the shore and come up on her lee side. The lifeboat went round her bow, but was caught by a great sea which lifted her almost out of the water,

and flung her onto the rocks. Another sea washed the Second Coxswain from stern to bow, and nearly carried him and several other members of the crew overboard. But Coxswain Mclean went full astern to clear the rock, and, with the seas striking her at the same time, she was carried round the steamer's bow and into deeper water.

The lifeboat was sheltered from wind and sea, and was able to come alongside, saving thirty-six of *Saltwick's* crew, leaving the master and three officers on board. As the lifeboat came away, she struck the rocks twice more, but she got clear and safely to harbour.

It was then 11am on Monday 26 January, seventy-five hours and twenty-seven minutes since she had first gone out to *Runswick*. During the previous twenty-seven hours her crew had been able to get three changes into dry clothes, but had had little food and no rest. They had been out in the gale and bitter cold three times, twice in pitch darkness and blinding snow, and had rescued 106 lives. The lifeboat had been damaged, first against *Fidra* and then, more severely, on the rocks. But she had done her job, and completed an epic series of rescues that earned her Coxswain John McLean the Gold medal.

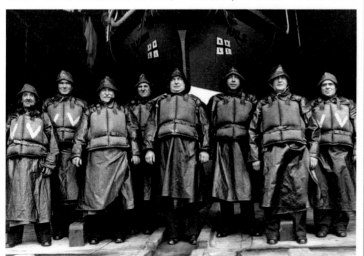

above The 3,970grt steamer steamship Runswick, which was carrying a cargo of coal, when she was in collision with another steamer, Saltwick, off Peterhead in January 1942.

left The Peterhead lifeboat crew, led by Coxswain John Mclean, who were involved in the series of epic rescues in January 1942, in the lifeboat house with the lifeboat Julia Park Barry of Glasgow (ON.819). (By courtesy of the RNLI)

Rebuilding after 1945

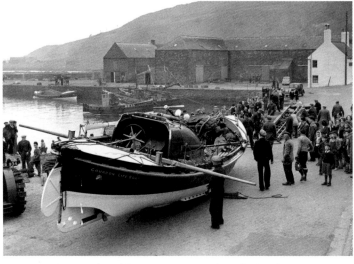

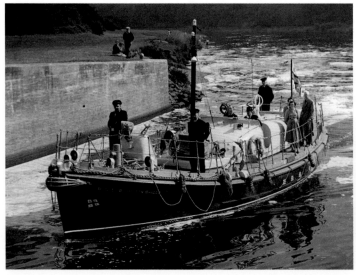

During the Second World War lifeboat construction and development more or less stopped. So after 1945 the need to build new lifeboats was considerable. Embarking upon a building programme for new boats, all of which had twin engines and twin propellers, the RNLI shared the optimism for a better and brighter future that swept the nation in the immediate post-war years. Many new boats were built, the pulling and sailing lifeboat was soon phased out, and a new chapter in the RNLI's history began.

In Scotland, the first change saw the station at Tobermory close in November 1947 due to manning difficulties, and operations transferred to a new station at Mallaig in January 1948.

The first new lifeboat to come to Scotland after the war, *J. B. Couper of Glasgow* (ON.872), arrived at St Abbs in October 1949, followed a month later by the 41ft Watson motor *Glencoe, Glasgow*, which went to Buckie. In 1950 two new 35ft 6in Liverpool motor lifeboats were sent to Scottish stations: *Robert Lindsay* (ON.874) was placed on station at Arbroath in July and *James and Ruby Jackson* (ON.876) went to Anstruther in October. Further Liverpool type boats went to Eyemouth and Gourdon, in 1951 and 1952 respectively, with another 41ft Watson, *St Andrew (Civil Service No.10)* and funded by the Civil Service Lifeboat Fund, going to Whitehills in February 1952.

The largest lifeboat to be developed after the War was the 52ft Barnett, and boats of this class were built for Aberdeen, Campbeltown and Stornoway in the early 1950s. The Barnetts were ideal for service in the demanding waters off Scotland; they had a midship steering position and a deck cabin, as well as twin

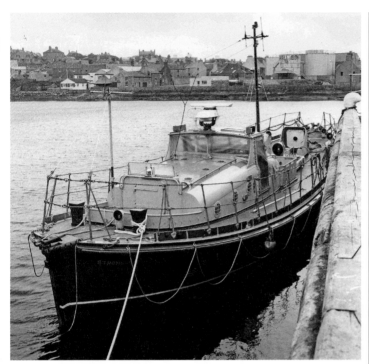

left The 52ft Barnett John Gellatly Hyndman (ON.923) from Stromness moored at Kirkwall pier after landing a patient from the North Isles of Orkney. (Orkney Photographic Archives)

engines, twin screws and shelter for both rescued and rescuers. The hull was subdivided into ten watertight compartments, the engine room had a double bottom and twin 72hp Gardner diesels powered the boats to a top speed of nine knots, while sufficient fuel was carried to give a range of 180 nautical miles at full speed.

Two further 52ft Barnetts were built for Orkney stations in 1955 at the Cowes boatyard of J.S. White. *John Gellatly Hyndman* (ON.923) went to Stronsay in February and *Archibald and Alexander M. Paterson* (ON.924) to Stromness three months later, with the boats being named on consecutive days in August 1955. In 1957 two more Barnetts went to the west coast, to Barra Island and Mallaig, both built by J.S. White and funded from the legacy of Mrs Ellen Mary Marsh Gordon Cubbin, of Douglas, IOM. These latter two boats were the first of an updated 52ft Barnett type, which had raised bulwarks at bow and stern and an enclosed wheelhouse.

In August 1958 a new 52ft Barnett, *Claude Cecil Staniforth* (ON.943), arrived at Lerwick and within two months she was involved in a dramatic rescue of the crew of the Soviet trawler *Urbe*, which sank near the Holm of Skaw, an uninhabited rocky islet off the north-eastern corner of the Shetland island of Unst, on 16 October 1958. The lifeboat put out at 9.32pm, completing a gruelling passage, heading north for fifty-three miles to reach the Holm of Skaw in the teeth of a northerly gale.

Some survivors were seen on the Holm of Skaw, and it was learnt that a man living in Baltasound, Andrew Mouat, who had good knowledge of the local waters, had volunteered to act as pilot so, at about 3am on 17 October, the lifeboat picked him up. About an hour later the starboard propeller was fouled by a net with the lifeboat three miles south of the Holm of Skaw, but she reached the scene on one engine and anchored forty yards from the beach. Ashore on Unst several groups

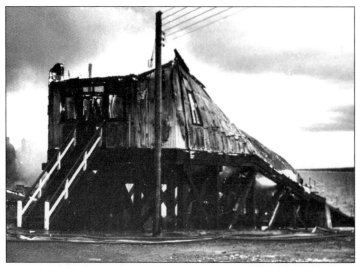

above The remains of the Thurso lifeboat house at Scrabster after it had been destroyed by fire in December 1956. (By courtesy of Andy Anderson)

below Whitehills lifeboat station was served by the 41ft Watson St Andrew (Civil Service No.10) (ON.897), pictured during her naming ceremony on 23 August 1952 (left), between 1952 and 1959, and by the larger 47ft Watson Helen Wycherley (ON.959), pictured on the slipway (right), between 1961 and May 1969, when the station was closed. (Both photos by courtesy of the RNLI)

of people had been trying to locate survivors while three trawlers searched offshore with a Shackleton aircraft.

In the beam of searchlights set up on Unst, the lifeboat's crew saw three survivors from the Soviet trawler sheltering behind a boulder. Coxswain Sales moved the beam of the lifeboat's searchlight to indicate where to fire a line, and Second Coxswain William Saks fired the rocket line. Using the line, the first two men were hauled off while the third man paid out the line by hand. The third man, the trawler's skipper, was rescued by lying on the breeches buoy and kicking out with his legs. The rescue was effected less than twenty minutes after the lifeboat had anchored, and the lifeboat's

crew managed to clear the starboard propeller before they set off again.

Searches were carried out for more survivors but without success, although two bodies were picked up and taken aboard the lifeboat, while the trawler itself was seen half a mile north of the Holm of Skaw with only part of the bow and masts visible. The lifeboat reached Baltasound at 12.45pm and landed the three Russian survivors, who were suffering from cold and exposure, as well as the two bodies. She then headed home, and eventually returned to Lerwick at 9.20pm, by when the coxswain had been without sleep for forty-one hours, but his efforts were later recognised by the award of the Silver medal by the RNLI.

As well as the 52ft Barnetts, a number of 47ft Watson motor lifeboats were built for service in Scotland, with the first boat of this type, *Dunnet Head (Civil Service No.31)*, being sent to Thurso in January 1956. Unfortunately the boat lasted less than a year as, disastrously, on 10 December the lifeboat and lifeboat house at Scrabster in which she was based were totally destroyed by fire. The destruction was so complete that no evidence was available to show the cause of the outbreak. A replacement 47ft Watson boat was built for Thurso, also funded by the Civil Service Lifeboat Fund, and named *Pentland (Civil Service No.31)*.

The 47ft Watson represented a major revision of the basic Watson design; power came from twin 60hp Gardner diesels giving a maximum speed of 8.9 knots and a range of 280 nautical miles. The hull was more bulky than on previous Watsons and substantial bulwarks were fitted above the fenders. Further examples of the class were built for Scottish stations during the late 1950s and early 1960s for Dunbar, Islay, Broughty Ferry, Portpatrick, Buckie, Whitehills and Longhope.

One of the most impressive records of gallantry was gained by Longhope Coxswain Daniel Kirkpatrick, who was awarded three Silver medals in the space of ten years, starting with the rescue by breeches buoy of the crew of fourteen of the trawler *Strathcoe*, which was ashore in Pentland Firth on 4 February 1959 in the 45ft 6in Watson *Thomas McCunn* (ON.759), which had been built in 1933 and served at Longhope for almost thirty years.

She was replaced at Longhope in April 1962 by the 47ft Watson *T.G.B.* (ON.962), in which two further outstanding services were performed.

On 3-4 January 1964 nine crew from the Aberdeen trawler *Ben Barvas* were saved by breeches buoy after the trawler had gone ashore on the Pentland Skerries. And in 1968 the Silver Third-Service clasp was awarded to Coxswain Kirkpatrick for the rescue of fifteen from the trawler *Ross Puma*, which was wrecked on 1 April 1968 on the Little Rackwick Shoals in gale force winds and rough seas, with squalls reducing visibility to less than fifty yards.

above The 47ft Watson motor lifeboat Laura Moncur (ON.958) during her naming ceremony at Cluny Harbour, Buckie on 25 August 1961, with the old boathouse in the background. (By courtesy of John Innes)

below Longhope lifeboat crew, led by Coxswain Daniel Kirkpatrick (second from left). When he was awarded his third Silver medal for a rescue in 1968, he became the only man alive at the time to hold three such awards. (By courtesy of the RNLI)

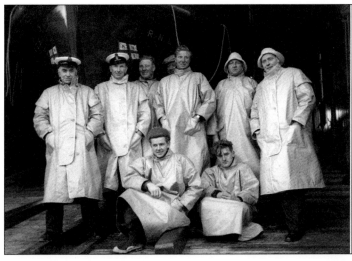

Tragedy in the post-war era

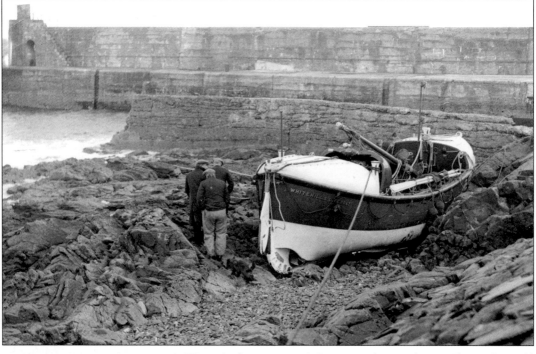

above Whitehills lifeboat Civil Service No.4 (ON.756) ashore on the rocks at the mouth of the harbour on 9 April 1948. She was got off the rocks and sent to Herd & McKenzie's yard at Buckie for dismantling. (By courtesy of the RNLI)

above The plaque on the memorial at Fraserburgh commemorates the loss of thirteen lifeboat men in the three Fraserburgh lifeboat disasters, dating from 1919, 1953 and 1970. On 9 February 2013 a ceremony was held at the lifeboat station to remember the capsizing of the lifeboat John and Charles Kennedy sixty years earlier, with the crew gathering to pay their respects to those who died.

Despite the post-war optimism of the RNLI's ambitious building programme and modernisation of the lifeboat fleet, several tragedies overtook Scotland's lifeboat stations in the 1950s and 1960s. Before any lives had been lost, however, the Whitehills lifeboat *Civil Service No.4* (ON.756) was damaged on 8 April 1948 after returning from service to the steamship *Lindean*, of Leith, which had gone ashore near Macduff. The lifeboat was asked to stand by while the steamer's crew was taken off by rocket apparatus.

The lifeboat then returned to station but, as she entered harbour, a big sea caught her, carried her forward and took her across the harbour entrance. She struck the rocks close to a small concrete parapet, onto which one of the men was able to jump with a line. In ten minutes all seven crew were safely ashore, but the boat was stranded. Although no lifeboat men were lost, the boat was severely damaged when she was refloated the next day and was

taken out of service. This incident could have served as a warning for what was to come as it highlighted a deficiency in design, namely that lifeboats were insufficiently powerful and manoeuvrable to avoid being caught by large seas. And five years later this is what happened to the Fraserburgh lifeboat, *John and Charles Kennedy*.

Fraserburgh 1953

The lifeboat launched from her slipway at Fraserburgh just before 1pm on 9 February 1953 to escort fishing vessels across the bar through heavy swell. She escorted in two vessels and then went to *Harvest Reaper*, which was waiting off Kinnaird Head. But *Harvest Reaper* made for Macduff, so the lifeboat returned to harbour. Just off the end of the north pier a very heavy swell lifted her stern and, as she passed the end of the pier an even bigger swell broke over the starboard quarter and filled the cockpit. All the crew except the coxswain, who was holding the wheel,

were thrown under the canopy and against the engine controls.

The lifeboat's stern was forced round and, broadside to the swell, she turned over. The coxswain was thrown clear and swam towards the harbour, but a piece of wreckage hit him on the head, halting his efforts. The other six men were trapped under the canopy, and only the second coxswain managed to escape by forcing himself down and out from under the boat, and he was washed up alive south of the harbour. The capsized boat was also carried south, and twenty to thirty minutes after she capsized she went ashore.

For the next three days an onshore gale battered the boat as she lay on the rocks. On 13 February the gale moderated, but by then the seas and rocks had damaged her beyond repair. The boat was then off the rocks, and on the morning of Sunday 15 February she was refloated and towed to harbour, where she was righted. There was nothing to show engine failure, or of any other part of the boat failing.

Arbroath 1953

A few months after the Fraserburgh disaster, tragedy struck again, this time at Arbroath, where the 35ft 6in Liverpool class lifeboat *Robert Lindsay* capsized on service while crossing the harbour bar, with the loss of six of her crew of seven. She had launched on the

night of 26 October 1953, together with the Anstruther lifeboat *James and Ruby Jackson*, after distress rockets had been seen east of Fifeness. The rockets were fired by the sand dredger *Islandmagee*, of Dundee, which was on passage from the Firth of Tay to the Firth of Forth but which sank with all hands.

The Anstruther lifeboat launched first, and *Robert Lindsay* also went out, at 12.50am on 27 October, in a south-easterly gale and very rough seas. Both lifeboats carried out a thorough search, maintaining contact with one another, but nothing was found so the boats returned to their respective stations. Because conditions were so bad at Arbroath, the local coastguards went to the east pier with the rocket apparatus as the lifeboat entered the harbour.

The onshore gale was blowing against the tide causing a backwash off the piers, and a number of people watched as the lifeboat tried to enter the harbour. But at 5.47am her lights disappeared as a huge and very steep cross sea struck the boat and capsized her. Cries for help were heard and the coastguard fired rocket lines at random. By chance one fell across the second coxswain, Archibald Smith, who was subsequently hauled ashore, but the rest of the crew were drowned having been trapped in the lifeboat.

The lifeboat men's funeral was held on 31 October and was attended

In memory

FRASERBURGH 9 February 1953 · The six lifeboatmen who gave their lives in John and Charles Kennedy were Coxswain Andrew Ritchie, Mechanic George Duthie, Bowman Charles Tait Snr, Assistant Mechanic James Noble and crew members John Crawford and John Buchan.

ARBROATH 26 October 1953 · Six of the crew all lost their lives: David Bruce, Coxswain Harry Swankie, Mechanic Thomas Adams, Bowman William Swankie, Jnr, Assistant Mechanic Charles Cargill, David Cargill; Coxswain Bruce had been coxswain since 1952 and first joined the crew in 1922. The oldest member of the crew was Harry Swankie, who had been mechanic since 1932 and was aged sixty-three. Charles and David Cargill were brothers aged twenty-eight and twenty-nine.

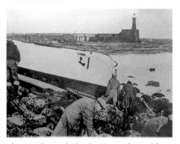

above John and Charles Kennedy upside down on the rocks at Fraserburgh after capsizing on service on 9 January 1953. In her sixteen years on station, she completed ninety-eight services and rescued 199 lives.

left and below John and Charles Kennedy after being righted. She was extensively damaged, and as repairs would have cost over £10,000, it was decided that she should be broken up, after the engines, propellers and other items had been taken out. (By courtesy of the RNLI)

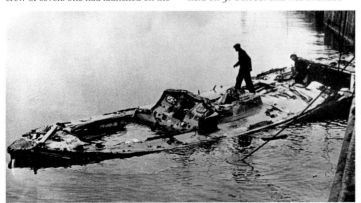

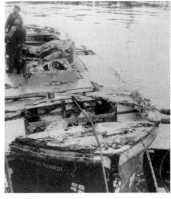

Tragedy in the post-war era

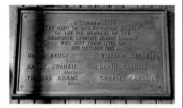

above The bronze plaque has been erected in the storm wall of the fish quay at Arbroath harbour to commemorate the six crew members of the lifeboat Robert Lindsay who lost their lives on the 27 October 1953. The Lord Lieutenant of Angus, the Earl of Airlie, unveiled the memorial on 7 January 1956. The Provost of Arbroath, Mr. J. K. Moir, who was chairman of the fund which was raised after the disaster, presided, and the memorial was dedicated by the Rev. Colin Day, Minister of St. Minian's Church.

below The Arbroath lifeboat Robert Lindsay lying on the rocks after her capsize while fishermen and helpers prepare to right her before the incoming tide, October 1953. The lifeboat was a 35ft 6in Liverpool type, completed in 1950, and one of thirty-one such boats built since the war. (By courtesy of RNLI)

by various RNLI representatives. A lifeboat disaster fund was opened and more than £35,000 was contributed, including £500 from the RNLI. On 8 December 1953 a public enquiry into the disaster was conducted and the jury returned a formal verdict of 'accidental death by drowning with no blame or default attached to anyone'.

The two tragedies of 1953 had been caused by lifeboats capsizing and not coming upright again. While the respective designs were on the whole sound, the fact that neither was self-righting was proving to be a significant flaw. In addition, the lifeboats were relatively slow and their lack of manoeuvrability meant, if they were overtaken by waves that approached quickly, they could not be turned fast enough to face these seas.

Broughty Ferry 1959

However, what happened in the next tragedy, just over six years later at Arbroath's neighbouring station, Broughty Ferry, is not entirely clear, but the lifeboat was again unable to cope with the heavy seas. In the early hours

of 8 December 1959 the Watson lifeboat Mona launched from her boathouse at Broughty Ferry to the North Carr lightvessel, which had broken adrift from its moorings.

Sometime between 5.15am and 6am the lifeboat capsized just to the south of the entrance to the river Tay, although her exact position is not known and exactly what happened is unclear, but the official report stated that 'the capsize was almost certainly caused by the lifeboat being thrown off course and across the sea . . . [and she] was probably in shallow water at the time'. Weather conditions were exceptionally severe with a strong south-easterly gale blowing across the entrance to the river and the lifeboat probably first got into difficulties when approaching the bar. After the capsize, the lifeboat drifted bottom up in a north-westerly direction until her mast touched bottom in the shallow water between Buddon Ness and Carnoustie, and came ashore.

In the official report, the RNLI stated that Mona, a 45ft 6in by 12ft 6in Watson cabin lifeboat with twin engines, was one of nineteen boats

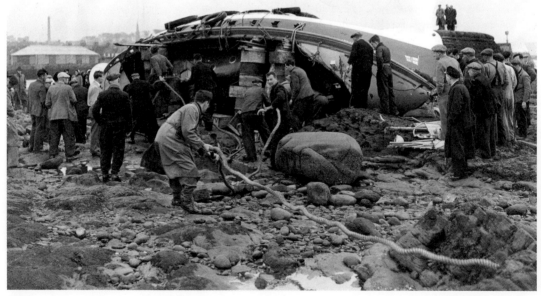

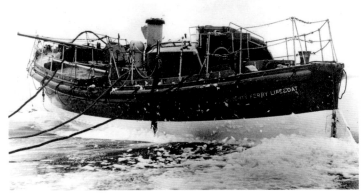

of this class built between 1927 and 1935, and this was the first disaster to happen to any of them, adding 'crews have always spoken very highly of the sea-keeping qualities of these boats. The sistership to *Mona*, *Thomas McCunn* based at Longhope, crossed the Pentland Firth both ways against the tidal stream on 7 December in a whole gale (force ten to eleven), which is strong evidence of the soundness of the design of the boat'.

By the time of the Broughty Ferry tragedy, the RNLI had just introduced the 37ft Oakley type, the first lifeboat design that was both inherently stable and self-righting, a combination that had eluded naval architects hitherto. It had become clear that lifeboats had to be self-righting if further tragedies were to be avoided, but a decade after *Mona* had capsized two further capsizes in Scottish waters considerably hastened the RNLI's move to a fleet of lifeboats that were all self-righting.

Longhope 1969

At Longhope, the tragedy of 1969 was particularly keenly felt by the small community on the Orkney island if Hoy. On 17 March 1969 the station's 47ft Watson motor lifeboat *T.G.B.* (ON.962) was launched to the Liberian ship *Irene* in a south-easterly gale in the Pentland Firth, estimated at the time at force nine, and accompanied by very rough seas. *T.G.B.* was tracked as she headed for the casualty, first being three miles south-east of Cantick Head lighthouse, and then a mile east of Swona Island. When she was halfway between Brough Ness and Pentland Skerries heading east, at 9.28pm, her last recorded signal was received by Wick radio. Shortly after 10pm, Wick radio was asked to inform *T.G.B.* that conditions alongside *Irene* were 'almost impossible', and the Coastguard became concerned about the safety of the lifeboat having received no more messages from her.

Coast rescue emergency parties went to search the east coast of South Ronaldsay, while the 70ft Clyde lifeboat *Grace Paterson Ritchie*, which was at Kirkwall, put out. At 9.15pm *Irene*

above left Broughty Ferry lifeboat Mona washed up ashore after capsizing. A memorial service to those who lost their lives was held at St James Church, Broughty Ferry, on 11 December 1959.

above Coxswain Ronald Grant of Broughty Ferry, who lost his life in the disaster of December 1959. (RNLI)

In memory

BROUGHTY FERRY 8 December 1959 · The entire crew of eight on board Mona were drowned. They were: Coxswain Ronald Grant, Second Coxswain George Smith, Bowman George Watson, Mechanic John Grieve, Assistant Mechanic James Ferrier, Alexander Gall (former coxswain), John J. Grieve (son of the mechanic) and D. Anderson.

below The Broughty Ferry lifeboat Mona washed ashore after capsizing with salvagers examining her. (RNLI)

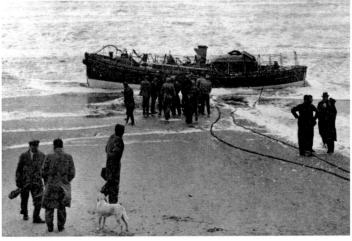

Tragedy in the post-war era

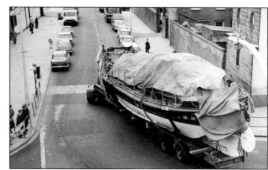

above left The Liberian steamship Irene aground on South Ronaldsay in March 1969. (Orkney Photographic Archives)

above right Covered by a tarpaulin, T.G.B. is driven by road out of the RNLI's depot at Boreham Wood after being salvaged following the capsize on 17 March 1969. She was subsequently repaired and put back in service. (By courtesy of the RNLI)

below The fine memorial in Osmondwall Cemetery on Hoy to the eight lifeboatmen lost in T. G. B. in March 1969. The plaque at its base reads 'Greater love hath no man than this, that he lay down his life for his fellow men' and lists the names of those who gave their lives.

grounded half a mile south of Grim Ness, from where a Coastguard team brought ashore her crew in the early hours of 18 March. Just after 11pm on 17 March, Kirkwall coastguard asked *Grace Paterson Ritchie* to make for a position south of *Irene* and rendezvous with *T.G.B. Grace Paterson Ritchie* reached the position at 11.15pm and fired a parachute flare, but received no reply. And in the massive seas visibility was very poor, so finding the Longhope lifeboat was impossible until daybreak, when a Shackleton aircraft from RAF Kinloss and a helicopter from RNAS Lossiemouth joined *Grace Paterson Ritchie* as well as the Stronsay, Thurso and Stromness lifeboats in a major search operation.

Not until 1.40pm on 18 March did the Thurso lifeboat crew spot the Longhope lifeboat, upturned, four miles south-west of Tor Ness. The stricken lifeboat was towed to Scrabster Harbour, escorted by the Stromness lifeboat. Only seven bodies were recovered, six with lifejackets on. The Coxswain, Daniel Kirkpatrick, was not wearing a lifejacket. The door of the port side of the wheelhouse was found open and it

is probable that the missing man, James Swanson, was either lost overboard before the capsize, or that his body was lost through the door.

Fraserburgh 1970

Less than a year later, another tragedy hit Scotland's lifeboat community, with the station at Fraserburgh losing more of its lifeboat men just seventeen years after the previous lifeboat had capsized on service. On 21 January 1970 another Watson class lifeboat, the 46ft 9in *Duchess of Kent*, capsized on service to the Danish fishing vessel *Opal*, with the loss of five of her six crew. The lifeboat was called after fishing vessel's engine room flooded, a pump was required, and she was in need of immediate help.

The lifeboat, having left Fraserburgh at 6.38am, reached the scene thirty-six miles north east of her station just before 11am and found various vessels, including two Russian vessels, standing by *Opal*, from which a helicopter had removed one of the crew, leaving three others on board. At 11am she reported she was approaching *Opal*, which was being towed by the Russian trawler *Jwa*, with other vessels in the area, and this was the last message from the lifeboat.

The wind at the time of the capsize was force eight to nine, and the waves were averaging about fifteen or sixteen feet in height, with occasional waves twice that. As the lifeboat approached *Opal* from the west, and was increasing speed to get ahead of the vessel, she was

struck by a very large breaking wave on her port bow which overwhelmed her. The bow was lifted high into the air and the vessel capsized bow over stern. She lay capsized with her starboard side visible to those aboard *Opal* and another trawler, *Sarma*.

The Russian trawler *Jwa* continued on her course with *Opal* in tow, while the lifeboat floated bottom upwards. The lifeboat's sole survivor, John Jackson Buchan, swam to and scrambled aboard the capsized lifeboat having been thrown out of it during the capsize. Meanwhile, another trawler, *Victor Kingisepp*, approached the scene and her crew made strenuous efforts, at considerable personal risk, to right the lifeboat, which was eventually done at 2.31pm, but the four crew trapped inside were dead; the Mechanic, Fred Kirkness, was never found. *Victor Kingisepp* took the upturned lifeboat in tow and made for Buckie.

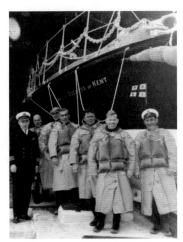

The whole country was stunned by the disaster and messages of sympathy were received from around the world. In the aftermath of these tragedies, the RNLI carried out detailed investigations into the capsizes, and, while the crews had clearly shown the highest bravery and courage, future lifeboats needed to be designed to be fully self-righting.

above The funerals of the deceased lifeboatmen took place at Fraserburgh on 25 January 1970 with over 10,000 people in attendance to pay their last respects, including RNLI President, HRH The Duke of Kent. (Photograph by Robert Wiseman)

left The Fraserburgh lifeboat crew in front of the lifeboat Duchess of Kent with Coxswain Johnny Stephen on right. (By courtesy of Andy Anderson)

In memory

LONGHOPE 17 March 1969 · The entire crew of eight on board T.G.B. were drowned. Those who gave their lives were Coxswain Daniel Kirkpatrick, Second Coxswain James Johnston, Bowman Ray Kirkpatrick, Mechanic Robert Johnston, Assistant Mechanic James Swanson and crew members John Kirkpatrick, Robert Johnston and Eric McFadyen.

FRASERBURGH 21 January 1970 · The crew members who lost their lives were Coxswain John Stephen, Mechanic Frederick Kirkness and crew members William Hadden, James R. S. Buchan and James Buchan; Frederick Kirkness' body was never found. Assistant Mechanic John (Jackson) Buchan was flung clear and was picked up by a Russian trawler.

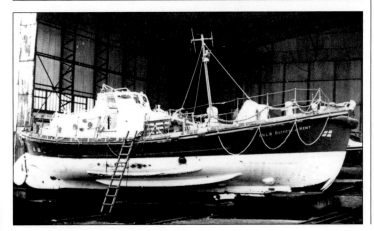

above left Fraserburgh lifeboat Duchess of Kent approaching the Danish fishing vessel Opal on 21 January 1970. (By courtesy of Andy Anderson)

left The Fraserburgh lifeboat Duchess of Kent at Buckie in January 1970. The bodies of those who lost their lives in her were transferred to the Buckie lifeboat by the fishing vessel that towed her in, and the lifeboat herself was brought into Buckie harbour at 5pm on 22 January. She was placed in a shed in the boatyard with a cover over her and, after she had been thoroughly examined, the equipment was removed and she was cut by the yard's workmen and burned. (RNLI)

above The 52ft Barnett Ramsay-Dyce (ON.944) at moorings on the inner side of the approach jetty to St Clement's Bridge on the North Side of Victoria Dock in the early 1970s. Ramsay-Dyce was the second 52ft Barnett to serve at Aberdeen, and she was on station from September 1958 to June 1976, saving thirty lives during that time. (RNLI)

below The same jetty on the North Side of Victoria Dock is used for the 17m Severn Bon Accord (ON.1248), but a longer pontoon, shared with the port's pilot boat, has been installed to improve boarding arrangements, with a fuel tank provided on the jetty. The oil tanks visible in both photos indicate the harbour's close association with the offshore industry. (Nicholas Leach)

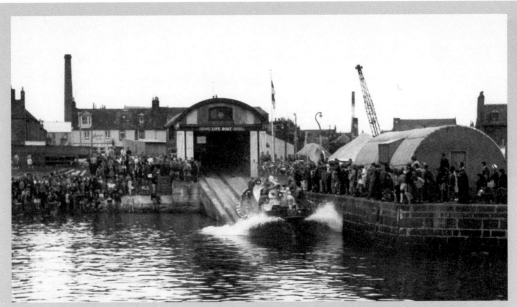

above 42ft Watson The Duke of Montrose (ON.934) launching at Arbroath on 19 July 1963, watched by a crowd consisting of locals and holiday-makers. The boathouse and slipway were built on the south side of the Inner Dock in 1932. (RNLI)

below In the modern view, taken almost forty years later in August 2002, 12m Mersey Inchcape (ON.1194) launches down the same slipway from the same boathouse, which has been refurbished and extended to accommodate the ILB. The white building to the right, against which Honorary Secretary Stuart Ferguson is leaning, was used for the D class ILB at one time.

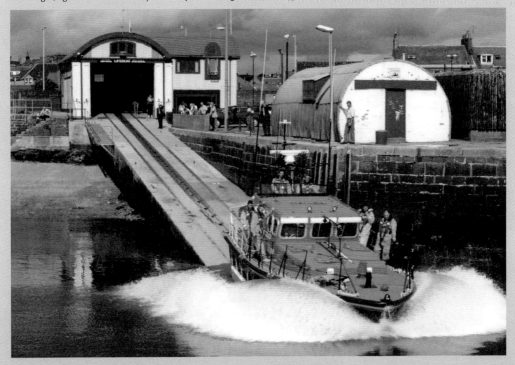

A new generation of self-righters

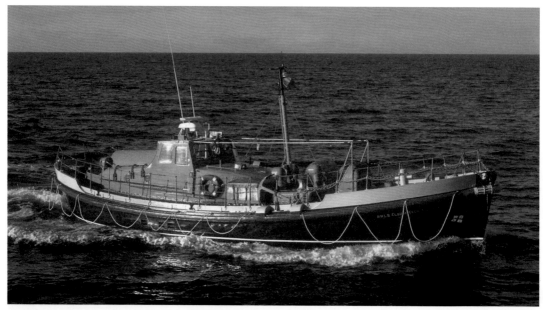

above 52ft Barnett Claude Cecil Staniforth (ON.943) gave sterling service at Lerwick from August 1958 to August 1978, undertaking almost 100 services. She is pictured here after having been fitted with a self-righting air-bag, which was kept in the semi-circular tube seen on the aft cabin. (By courtesy of the RNLI)

right The 37ft Oakley The Doctors (ON.983) was one of three Oakley lifeboats to serve in Scotland. She is pictured at Anstruther during her naming ceremony on 28 July 1965. She served this station for more than twenty-five years. (By courtesy of the RNLI)

below Buckie lifeboat Laura Moncur (ON.958), a 47ft Watson motor type built in 1961 and modified to become inherently self-righting in 1973-74 by having her superstructure extended to provide enough buoyancy to right the boat in the event of a capsize.

The tragedies of the post-war era highlighted the design faults of the traditional displacement-hulled lifeboats. Although seaworthy vessels, these lifeboats, built during the immediate post-war era, were not self-righting, and this major weakness needed to be addressed before more lives were lost. Yet overcoming the problem of building a stable hull which was also self-righting seemed to elude naval architects until the 1950s.

The first measure gave existing lifeboats, mainly the 46ft 9in Watson, 47ft Watson and 52ft Barnett types, a self-righting capability and was the installing of air-bags. The air-bag inflated when the boat rolled over more than 100 degrees and provided sufficient extra buoyancy to bring the lifeboat upright again. By the 1970s, many of Scotland's lifeboats had been modified by the addition of the self-righting air-bag, and this piece of

A new generation of self-righters

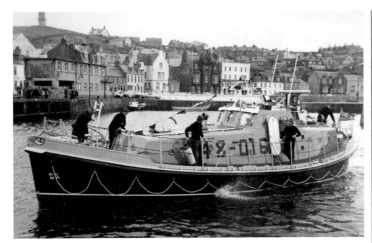

equipment was used for real when the Barra Island lifeboat, the 52ft Barnett *R.A. Colby Cubbin No.3* (ON.935), capsized on 18 November 1979.

She was answering a call from the Danish coaster *Lone Dania*, and the air-bag performed exactly as intended. On the same night, Islay lifeboat, the 50ft Thames class *Helmut Schroder of Dunlossit* (ON.1032), also capsized and righted going to the same casualty. There was no loss of life from either boat, clearly vindicating the decision to make lifeboats self-righting.

Although air-bags improved matters, the smaller 35ft 6in Liverpool and 42ft Watson lifeboats could not be so modified. Better designs were therefore required, and the first design which combined self-righting with a stable hull design, and which proved an ideal replacement for the two smaller lifeboat classes, was the 37ft type conceived by Richard Oakley in the mid-1950s. This used a water ballast transfer system which saw water transferred from a ballast tank to a righting tank in the event of a capsize.

The new 37ft Oakley design was not only self-righting, but also had good lateral stability. In Scotland, Oakleys were sent to St Abbs, Kirkcudbright and Anstruther. The design which succeeded the Oakley, the 37ft 6in

Rother, was self-righting by virtue of its watertight wheelhouse, and this method was also employed in the 48ft 6in Solent lifeboats of which several served in Scotland from the late 1960s.

Although only eleven boats of this steel-hulled type were built, nine were sent stations in Scotland, including Thurso, Peterhead, Montrose and Stornoway. The first new lifeboat built for the station at Lochinver, established in 1967, was the 48ft 6in Solent *George Urie Scott* (ON.1007), which arrived in May 1969. At Fraserburgh, where the station had been closed in 1970 following the lifeboat disaster, was reopened in 1979 and a Solent class lifeboat was deemed most suitable.

Medal winners

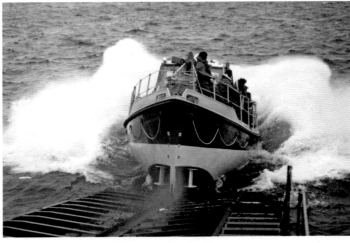

Inshore lifeboats

above The first inflatable ILB in Scotland, No.17. She was stationed at Broughty Ferry from 1964 to 1967. (RNLI)

right The first ILB at North Berwick, No.112, later renumbered D-112, was named Blue Peter and is pictured with the TV programme's presented Valerie Singleton on board. (RNLI)

below Aberdeen's D class inshore lifeboat Trevor Edwin Jones (D-386) crossing the flooded Maryculter caravan site during a ten-hour service on 8 October 1993. Thirteen people and six animals were rescued. This was not the first time Aberdeen lifeboat crew have even involved in helping out during flooding. During a twelve-day period of gales in January 1937 the river Dee flooded causing widespread damage and isolating many buildings. The No.2 lifeboat Robert and Ellen Robson (ON.669) was called out to rescue a woman and two men from a farmhouse. The coxswain took the lifeboat stern first through the front door. The farmhouse is now included among the local landmarks pointed out on coach tours. (RNLI)

One of the more important developments in lifeboat provision during the 1960s came with the introduction of the inshore rescue boat (IRB), or, as it later became known, the inshore lifeboat (ILB). The first ILBs were introduced in England and Wales during the summer of 1963, when eight were sent to various stations. Such was their success that in each of the subsequent years more and more places began to operate the boats. By 1966 the number of ILBs on station had risen to seventy-two, mostly operating only during the summer months.

The early ILBs were rather rudimentary inflatable boats with outboard engines. They could be launched quickly and were ideally suited for work inshore helping people cut off by the tide, stranded on rocks or swimmers blown out to sea. They were soon improved and more equipment was added including VHF radio, flexible fuel tanks, flares, an anchor, a spare propeller and first aid kit. The ILB's advantage over the conventional lifeboat was its speed which, at twenty knots, was considerably faster than any lifeboat in service during the 1960s.

Despite their success in England and Wales, fewer ILBs were stationed in Scotland, particularly compared to England's busy south coast. This was primarily because of the nature of Scotland's coastline, with ILBs being unsuitable for work on the rugged west and north coasts, or the Northern Isles, where all-weather lifeboats operated with no need for ILB support. But further south, at busy spots such as on the Firths of Clyde and Forth, ILBs have more than proved their worth.

The first ILBs in Scotland were sent to Broughty Ferry and Largs in 1964, followed by Helensburgh and Kinghorn the next year. A station was established at the small village of Kippford on the banks of the Urr estuary in 1966, and in 1967 ILB stations at Tighnabruaich, South Queensferry and North Berwick were established and it was soon found that ILBs could cover areas effectively and efficiently where hitherto there had been no lifeboat cover, such as at

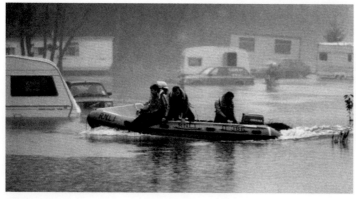

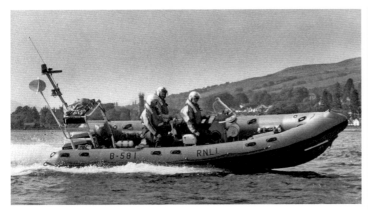

above ILB and boathouse at Tighnabruaich during the dedication ceremony of the D class inflatable Douglas MacMillan Drew (D-345), 5 September 1987.

left Atlantic 21 Andrew Mason (B-581) served at the busy Helensburgh station covering the Firth of Clyde. (RNLI)

Helensburgh, which looks over both the north shore of the Firth of Clyde and the eastern entrance to the Gareloch, and Tighnabruaich, well situated for incidents in the Kyles of Bute.

The ILB station opened in 1967 at North Berwick, a busy seaside town in East Lothian on the south shore of the Firth of Forth north east of Edinburgh, was one of several funded by the Blue Peter television programme's Pieces of Eight appeal. The first ILB, *Blue Peter III* (D-112), served from 1967 to 1972 and has been followed by four more similarly named boats.

The D class inflatables, as they were designated in the early 1970s, were, and still are, hugely successful and carry out many rescues every year. However, by the late 1960s a larger ILB was deemed necessary, capable of night operation and with a greater range than the inflatable, but which retained its advantages. After various different designs had been tested, a rigid-inflatable developed at Atlantic College in South Wales was found to be the most suitable. The boat had a rigid wooden hull with inflatable sponsons, which gave great stability. The twin outboard engines enabled a speed of over thirty knots to be achieved.

Designated the Atlantic 21, the new design was developed and refined by the RNLI, and in 1972 the first of the class went on station at Hartlepool. The first Atlantic 21 in Scotland was stationed at Largs, where the prototype, B-500, was sent for trials in 1972; these proved very successful and the station has operated an Atlantic lifeboat ever since. Another of the early Atlantics,

Medal winners

NORTH BERWICK July 1973 · The D class inflatable Blue Peter III (D-216) was launched at 3pm on 26 July 1973 to some bathers in difficulties to the east of North Berwick harbour. On reaching the scene, the ILB crew spotted a man in the water close to rocks, struggling in the heavy swell and so, with some difficulty, he was hauled aboard the ILB. During the rescue two very heavy seas hit the ILB, and the survivor was injured. Another man was seen floundering in the water, but by the time the ILB reached his position he had disappeared and no trace of him was ever found. Bronze Medals were awarded to Helmsman Benjamin Pearson and crew member Alexander Russell, and the Thanks Inscribed on Vellum were accorded to crew member James Pearson.

LARGS July 1983 · The Silver Medal was awarded to crew member Arthur Hill in recognition of his courage and determination when he entered the water from the Atlantic 21 Independent Forester Liberty (B-547) on 24 July 1983 and ducked down about three feet to get under the cabin of an upturned boat to rescue a young girl trapped in a small air-pocket. Helmsman John Strachan was accorded the Thanks Inscribed on Vellum for his leadership and judgement. The Maud Smith Award for the most outstanding act of lifesaving by a life-boatman during 1983 was awarded to Arthur Hill for this service.

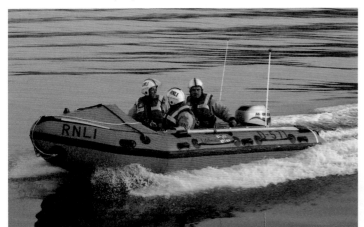

left The 16ft 3in Avon EA16 type D class inflatable Three Brothers (D-571) on exercise in Campbeltown Loch. She served at Campbeltown from 2001 to 2010 and was launched from a road-going trailer towed by a Land Rover.

Inshore lifeboats

Inshore lifeboat stations

ILB stations in Scotland in chronological order of establishment [*Co-located with existing ALB]

1964	Largs	1968	Aberdeen*	1988	Kirkcudbright
1964	Broughty Ferry*	1968	Arbroath*	1993	Campbeltown*
1965	Helensburgh	1968	Dunbar*	1993	Kessock
1965	Kinghorn	1970	Arran (Lamlash)	1994	Montrose*
1966	Kippford	1972-82	Oban	1995	Kyle of Lochalsh
1967	Tighnabruaich	1974	Stranraer	2003	Anstruther*
1967	Queensferry	1974	St Abbs	2004	Troon*
1967	North Berwick	1976	Invergordon	2008	Loch Ness
1967-84	Stonehaven	1986	Macduff	2013	Stonehaven

above Atlantic 21 The Rotary Club of Glasgow (B-578) on exercise off Macduff, where she served from 1989 to 2006.

below Atlantic 75 Peggy Keith Learmond (B-739) off Largs, where she served from 1998 to 2011.

B-505, was sent to Queensferry, one of the busiest stations in Scotland, operating from a boathouse beneath the iconic Forth railway bridge.

The benefits of the new design soon became apparent and the importance to the RNLI of these fast rigid-inflatable boats cannot be understated. This was further demonstrated during the 1990s when a slightly bigger version of the Atlantic 21 was developed, known as the Atlantic 75, which had greater speed, as well as water ballast tanks fitted so it could tackle bigger seas.

By 2000 eleven stations in Scotland were operating Atlantic rigid-inflatables, while the next version of the design, the Atlantic 85, was being developed. This boat was larger still, with room for a fourth crew member as well as more electronic equipment, including a radar and VHF direction finder. The first Atlantic 85 to come to Scotland, B-804, was sent to Macduff and the second, B-814, to Kirkcudbright, where Atlantic 21s had been operated for more than a decade without being replaced by Atlantic 75s. The station at Macduff is notable in that the ILB is launched by a mobile crane, so it can be launched from any quayside.

In October 2007 the RNLI announced that it was taking the unusual step of establishing an inland station at Loch Ness by taking over the Maritime Coastguard Agency's facilities near Drumnadrochit. The relief Atlantic 75 was kept on a hydraulic hoist at Temple Pier and became Scotland's first inland lifeboat station. The rescue boat had been involved in 186 incidents on the Loch since being established in 1995 by the Coastguard Agency.

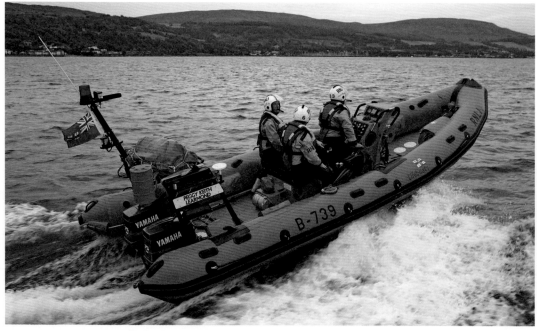

above The 1959-built 47ft Watson motor Francis W. Wotherspoon of Paisley (ON.951) at moorings at Port Askaig, Islay. She served as the Islay lifeboat from 1959 to 1979 and saved sixty lives during that time. Port Askaig, on the east coast of the island, provides an area sheltered from the prevailing current that flows down the Sound of Islay and is the natural location for both the lifeboat station and the passenger ferry services to the Scottish mainland.

below 17m Severn Helmut Schroder of Dunlossit II (ON.1219), and the small boarding punt, moored in essentially the same spot as her predecessors, although dredging undertaken in the late 1990s enlarged the berth so that the larger lifeboat can be operated. The island of Jura is in the background, and the rocky outcrop, to the right, also appear in the upper photograph.

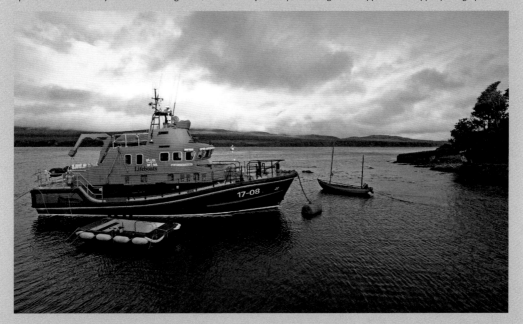

The modern era

right Aith's 52ft Barnett John and Frances Macfarlane (ON.956) was one of many lifeboats of this class to serve in Scotland. Built in 1960, she was the last Barnett to be built and served at Aith for twenty-five years. (By courtesy of the RNLI)

Medal winners

TROON September 1980 · On 12 September the Dutch dredger Holland I was breaking her moorings off Irvine in severe weather and so the 44ft Waveney Connel Elizabeth Cargill slipped her moorings under the command of Coxswain Ian Johnson just before 2pm. Even though the dredger was only three miles away, the passage through heavy beam seas was challenging for the lifeboat crew. The lifeboat was laid over on her beam ends several times and at one point rolled so far to starboard that the side of her wheelhouse was almost in the water. The dredger was in severe danger with her deck awash and, with the wind having risen to gale force nine, effecting a rescue was paramount. Coxswain Johnson took the lifeboat alongside five times, with her crew secured by their lifelines. The lifeboat was repeatedly thrown against the dredger, but one man was taken off on each of five approaches. By 2.45pm the last man had been taken off, the return to Troon was as difficult as the outward passage through heavy confused seas. For this service the silver medal was awarded to Coxswain Johnson and medal service certificates were awarded to the crew.

below The naming ceremony of Connel Elizabeth Cargill (ON.1006) at Troon on 5 August 1968 by Mrs Connel Leggatt.

below right Capsize trials of Connel Elizabeth Cargill. (Courtesy of RNLI)

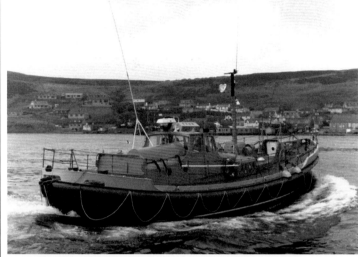

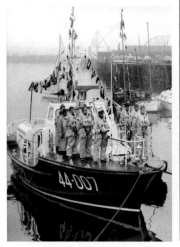

With the newly-introduced fast inflatable inshore lifeboats proving their worth during the 1960s, the RNLI began to develop faster all-weather lifeboats. In 1963 a 44ft steel-hulled lifeboat was purchased from the United States Coast Guard (USCG) for trials. This boat, self-righting by virtue of its watertight wheelhouse, was faster than and completely different from the conventional lifeboats then in service which could only reach nine knots.

The USCG boat, designated 44-001 by the RNLI, was taken on a tour of stations throughout the United Kingdom and Ireland to assess her suitability for operations in British waters. The reaction of lifeboat crews to the new type was so positive that the RNLI ordered six to be built. The type was given the class name Waveney and, of the initial batch of six built, the last one was stationed in Scotland.

Named *Connel Elizabeth Cargill* (ON.1006, operational number 44-007), she went into service at Troon in August 1968 having been funded from the legacy of the late W.A. Cargill. She served with distinction for seventeen years and saved 137 lives in that time. She was involved in a medal-winning service on 12 September 1980 when she

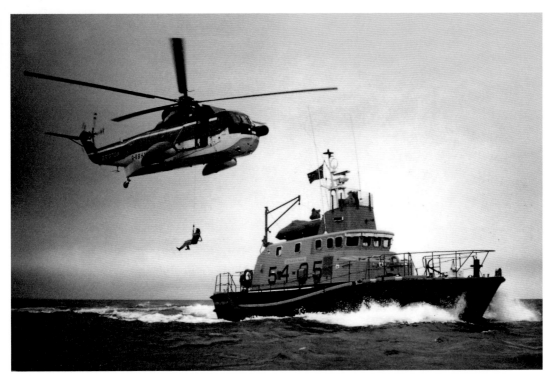

went to the Dutch dredger *Holland I*, from which five people were saved, in storm force winds and rough seas.

In 1967, the year before Scotland's first Waveney arrived in Troon, the country's lifeboat fleet was made up of thirty-two offshore lifeboats, of which nine were 52ft Barnetts, eight were 47ft Watsons and four were 46ft 9in Watsons. Two-thirds of Scotland's lifeboat stations were operating the largest lifeboats then in service. And while the Waveney was a fine lifeboat, a larger type was needed for the West Coast and Northern Isles, where heavy Atlantic swells could make rescue work particularly challenging, so the RNLI developed another, larger type.

The Arun class, at 52ft, was larger than the Waveney and was also faster, being capable of speeds approaching twenty knots. It had a fully enclosed wheelhouse to provide crew protection, carried a small Y class inflatable and had a flying bridge on top of the superstructure. Introduced into service in 1971, the Arun was one of the finest lifeboat types ever developed by the RNLI. The size, speed and general layout meant the design was eminently suitable for service in any conditions, including the hostile waters off Scotland's west and north coasts.

Between 1971 and 1990 forty-six Aruns were built, with fourteen

above The 54ft Arun B.P. Forties (ON.1050) was the first of her class in Scotland. She is pictured exercising with a search and rescue helicopter. These aircraft have played an important role in sea rescue since 1945. (By courtesy of RNLI)

below Lerwick's 52ft Arun Soldian (ON.1057) served the Shetland station for nineteen years and was involved in several outstanding medal-winning rescues durign that time. (By courtesy of RNLI)

The modern era

right The unique steel-hulled 50ft Thames class lifeboat Helmut Schroder of Dunlossit (ON.1032) served at Islay from 1979 to 1997. Although only two boats of this type were built, they gave good service and were well liked by their crews.

Medal winners

CAMPBELTOWN October 1981 · On 2 October Campbeltown lifeboat Walter and Margaret Couper (ON.1059) launched to the trawler Erlo Hills, which was drifting with engine failure and damaged steering gear in storm force northerly winds and very rough and confused seas. The lifeboat, working with the coaster Ceol Mor, attempted to tow the trawler clear of Rathlin Island, but this failed. So to rescue the crew of the casualty who were in considerable danger, the lifeboat had to be driven alongside the heavily rolling trawler no fewer than six times to save the crew of fourteen. In recognition of his courage, skill and determination during this service, the Silver medal was awarded to Coxswain/Mechanic Alexander Gilchrist, with the Thanks Inscribed on Vellum beign accorded to the rest of the lifeboat crew.

below 52ft Arun Sir Max Aitken II (ON.1098) passing Cantick Head lighthouse while stationed at Longhope. Built in 1984, she served at Stornoway before a five-year stint in Orkney.

intended specifically for service in Scotland. The first of these, one of the earliest examples of the class, went to the busy port of Aberdeen in June 1976, while others went to the stations in Shetland, Orkney and many on the west coast, including Barra Island and Stornoway in the Outer Hebrides. All had huge areas to cover and their old nine-knot lifeboats, mostly Barnetts, had frequently undertaken rescue missions lasting many hours, testing crews to the limit. So the Arun, with its greater speed and crew comfort, represented a major step forward.

The 52ft Arun at Lerwick, Soldian (ON.1057), placed on station in

August 1978, performed a number of noteworthy rescues, the finest of which came on 31 October 1994 when she went to the fish factory ship Pionersk, which had run aground three miles south of Lerwick in confused breaking seas, storm force winds and darkness. Coxswain/Mechanic Hewitt Clark, in a confined area less than 100ft wide, repeatedly manoeuvred the lifeboat alongside the casualty to rescue sixty-four people. He was awarded the Silver medal for this service, in recognition of his outstanding seamanship, leadership and courage, and the Thanks Inscribed on Vellum were accorded to the crew.

The Waveney and Arun lifeboats represented the first part of a modernisation programme undertaken by the RNLI during the last quarter of the twentieth century. It continued in the 1980s with the introduction of two new classes of fast lifeboat: the 47ft Tyne and 12m Mersey types, intended for stations which practiced slipway and carriage launching respectively.

In Scotland, Tynes were stationed at Fraserburgh, Wick and Longhope, where they were initially launched from a boathouse and down the slipway but were later placed afloat as the RNLI reviewed its policy on maintaining boathouses when

above The lifeboat house and slipway built in 1913-16 for the station's first motor lifeboat, Lady Rothes (ON.641). The house was enlarged for subsequent lifeboats, with a major adaptation undertaken in 1985 to accommodate a Tyne class lifeboat. Following the provision of a berth, adjacent to the boathouse on the north side of North Pier in 1997, the lifeboat went afloat and the boathouse was used only as a crew facility. It was demolished in 2005 to make way for a new shore facility as well as an expansion of the quayside. Behind the house, but demolished before this photo was taken, stood two previous lifeboat houses.

below On the same quayside, which was rebuilt and slightly enlarged, a new shore facility was built in 2005-06 providing much improved crew and changing facilities for the volunteers. The new building is the major change to this part of Fraserburgh harbour, which is known as Balaclava Outer Harbour, with both photographs taken from the North Pier looking due west. The buildings on Shore Street, the road running from north to south along the outskirts of the harbour, have changed little since the lifeboat house was built, but the harbour has been developed to accommodate larger fishing vessels.

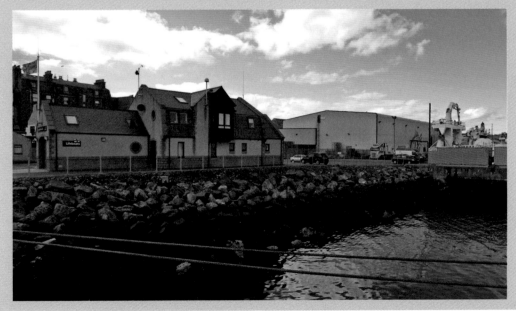

above Lerwick lifeboat crew involved in the Gold medal rescue stand in front of Michael and Jane Vernon (ON.1221); they are, left to right ,Ian Leask, Michael Grant, Brian Lawrenson, Peter Thomson, Richie Simpson and Coxswain Hewitt Clark. (By courtesy of the RNLI)

above right Lerwick lifeboat Michael and Jane Vernon alongside the cargo vessel Green Lilly taking off survivors during the Gold medal-winning rescue on 19 November 1997 off the east coast of Bressay. (By courtesy of the RNLI)

Medal winners

LERWICK November 1997 · Coxswain Hewitt Clark demonstrated incredible skill in handling the lifeboat and succeeded in rescuing five men from the cargo vessel Green Lily on 19 November. He made the decision to launch after it appeared that all other help for the casualty ad gone: a towline had parted, the helicopter could not work above the casualty, and she was close to the rocky shore, leaving Coxswain Clark with no margin for error as he manoeuvred the lifeboat in limited sea room, battling 15m breaking seas and violent storm force eleven winds. For this oustanding rescue Clark was awarded the Gold medal by the RNLI, its highest accolade. A special RNLI Vellum was awarded posthumously to Coastguard helicopter Winchman Bill Deacon who tragically died during this service.

moorings were available. The stations at Portpatrick and Montrose both received Tynes in 1989, and they were kept afloat in the harbour. Only three 12m Merseys were stationed in Scotland: at Arbroath, where the boat was slipway launched; at Anstruther, where the boat was carriage launched; and at Girvan, where the boat was kept afloat.

Throughout the 1980s and 1990s, many stations in Scotland, where the lifeboat had been slipway-launched from a boathouse, were changed and the lifeboat was placed on a mooring. Among those stations which once operated with a boathouse and slipway were Longhope, Fraserburgh, Thurso, Wick and Peterhead, where sheltered moorings were found for the lifeboat and new shore facilities constructed.

Although the new designs of fast lifeboat, all capable of at least fifteen knots, were fine rescue craft, a new generation of even faster lifeboats was designed during the 1990s to further enhance lifeboat coverage. The 14m Trent and 17m Severn classes, which entered service in 1992, could reach twenty-five knots, were built of fibre reinforced composite, a lightweight yet extremely strong material, and had twin propellers protected by extended bilge keels.

The Trent was introduced in 1994 and, of the first ten to enter service, two went to stations in Scotland: *Douglas Aikman Smith* (ON.1206) was sent to Invergordon in May 1996, and *Sir Ronald Pechell Bt* (ON.1207) went to Dunbar in December 1995. Further

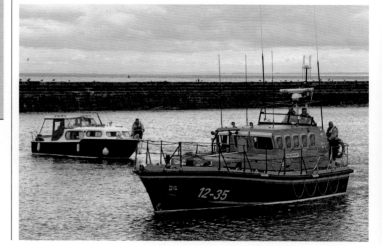

right Arbroath lifeboat Inchcape (ON.1194), one of just three 12m Merseys in Scotland, tows a broken down cabin cruiser into harbour on 28 July 2010.

The modern era

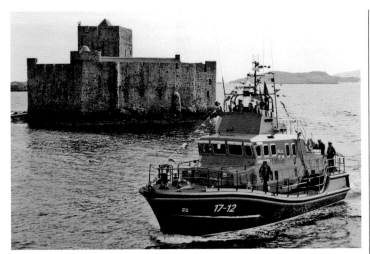

left Barra Island's 17m Severn Edna Windsor (ON.1230) passing the iconic Kisimul Castle, only significant surviving medieval castle in the Western Isles, at the end of her naming ceremony on 24 April 1999. She was one of many Severn class lifeboats to be stationed in Scotland during the late 1990s and early part of the twenty-first century.

above 14m Trent Sir Ronald Pechell Bt (ON.1207) on exercise at Dunbar. Built in 1995, she was the second Trent class lifeboat to go on station in Scotland. Tragically she was wrecked in the early hours of 23 March 2008 after she broke from her sea-bed moorings at Torness Power Station and was swept onto granite rocks, suffering severe damage to her hull.

below Eyemouth and Dunbar Trent class lifeboat Barclaycard Crusader (ON.1209) and Sir Ronald Pechell Bt (ON.1207) entering Eyemouth harbour, bringing in the 75ft trawler Mayflower V on 17 February 1997. Barclaycard Crusader had gone to the aid of the stricken fishing vessel 100 miles to the east of the station in severe gale force nine winds, and the two lifeboats worked together to bring the trawler to safety. (Courtesy of the RNLI)

Trents were stationed at Eyemouth, Portree, Wick, Broughty Ferry and Troon, which received the last Trent to be built. At Oban on the west coast, one of Scotland's busiest stations, a Trent went on station in July 1997 to replace the 33ft Brede Nottinghamshire (ON.1102), an intermediate lifeboat type of which only twelve were built.

The first Severns in Scotland went to Islay and Lerwick, with further boats of the class stationed round the country's west and north coasts, as well as at Buckie and Aberdeen in the east. The Severn, one of the largest lifeboats ever built for service with the RNLI, had a long range making it ideal for rescues on the west coast and in the Northern Isles, which are regularly exposed to fierce gales and storms.

Within five months of going on station at Lerwick, the then new Severn class lifeboat Michael and Jane Vernon (ON.1221), the tenth Severn to be built, was involved in an epic rescue. On 19 November 1997, under the command of Coxswain Hewitt Clark, who had already been involved in several medal-winning rescues, she was taken alongside the cargo vessel Green Lily, which was rolling violently in horrendous weather conditions, and rescued the crew of five.

The Severns and Trents were complemented during at the start of the twenty-first century by another new design, the 16m Tamar. The Tamar was intended primarily for slipway launching and incorporated much advanced equipment, including Systems and Information Management computers to help with operating the boat's systems. The first Tamar in Scotland was sent to Peterhead in March 2006, and a second went to Longhope seven months later.

As well as introducing more advanced and sophisticated rescue craft, the RNLI looked to expand lifeboat coverage in areas where the distance between stations was deemed

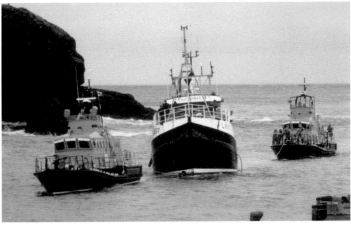

The modern era

right The first 16m Tamar lifeboat in Scotland, The Misses Robertson of Kintail (ON.1282), arrives at Peterhead to be welcomed home by the boat she is replacing, 47ft Tyne Babs and Agnes Robertson (ON.1127), on 7 April 2006.

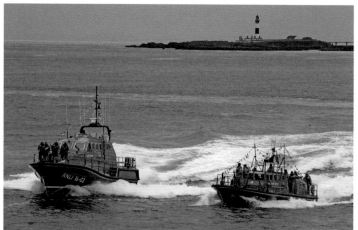

above 14m Trent Elizabeth of Glamis (ON.1252) was funded by the Broughty Ferry Lifeboat Appeal and serves at Broughty Ferry, one of Scotland's busiest lifeboat stations. (By courtesy of RNLI)

below A spectacular sight off Hoy, Orkney as the new 16m Tamar Helen Comrie (ON.1284), centre, made her way towards Longhope pier on 14 October 2006, arriving at her new station for the first time. She was escorted home by Thurso releif lifeboat Beth Sell (ON.1262) and Stromness relief lifeboat The Will (ON.1201), together with the local pilot boat, while the water cannons spraying from the MCA Emergency Towing Vessel Anglian Sovereign complete the backdrop.

too great. So, new stations were opened on the west coast at Tobermory in 1990 and Portree in 1991, with another new station coming on line at Leverburgh in the Outer Hebrides in 2012. An inshore station was established at the Kyle of Lochalsh in 1995, supplementing the four existing west coast stations at Islay, Mallaig, Barra Island and Stornoway, which had for many years operated in relative isolation. Coverage of the Western Isles and the Minch was much enhanced. Inland waters in Scotland were also covered by the RNLI for the first time in 2008, when a station at Drumnadrochit was opened to cover the busy waters of Loch Ness.

Scotland's lifeboat stations remain much in demand, and 2012 proved

to be the busiest year ever for the country's volunteer lifeboat crew. Statistics showed that 1,055 people were rescued, with lifeboats launching from the country's forty-six stations on 1,008 occasions. The previous highest number of rescues was 1,026 in 2006. The busiest station was Broughty Ferry, with 103 launches between its two lifeboats, and the busiest ILB station was Queensferry, where the volunteer crew launched sixty-six times.

In 2013 a forty-seventh station was added when the RNLI reopened Stonehaven, in Aberdeenshire, following the closure of the Maritime Rescue Institute, an independent charity that had hitherto provided rescue cover for the area.

Lifeboats in Scotland, station by station

Introduction to Part Two

In 1960 Scotland was served by thirty-two lifeboat stations, with just three in the Western Isles, at Stornoway, Barra Island and Mallaig. In 2013, just over fifty years later, the RNLI established its forty-seventh station in Scotland, at Stonehaven, as the Institution continues to adapt its service to provide the best and most effective coverage.

While Scotland's east coast has lifeboat stations dating back to the early 1800s, on the west coast many stations are relatively young. The recent expansion in lifeboat cover there has been made possible by advances and improvements in lifeboat design.

Details of all the lifeboat stations in Scotland, old and new, are included in this section, which is arranged geographically starting at Kippford on the south-west coast, going north to Shetland, and then down the east coast to Eyemouth. The information in each entry includes key data and current lifeboats for each station, details of lifeboat houses, launch methods and operational changes. Space does not permit all the outstanding services to be described, but those that have been described are representative of the many courageous life-saving acts performed by the lifeboat men and women of Scotland.

above 47ft Tyne Moonbeam (ON.1152) was placed on station at Montrose in May 1989 to become the latest lifeboat to serve one of the oldest lifeboat stations in the country that is still operational.

below Kyle of Lochalsh lifeboat Spirit of Fred. Olsen (B-856) with the iconic Eilean Donan Castle, one of Scotland's most famous landmarks, forming the backdrop.

Kippford

Key dates

Opened	1966
RNLI	1966
Inshore lifeboat	1966

Current lifeboats

ILB D class inflatable
D-718 Catherine
Donor Legacy of Mrs Catherine Frances
Harrison, Tamworth, Staffordshire
On station 10.11.2009
Launch Trator and trailer

right The lifeboat house used for the D class inflatable was converted from a residential property purchased in 2001, situated on the landward side of the road.

below The small ILB house built in 1977 and used until 2001.

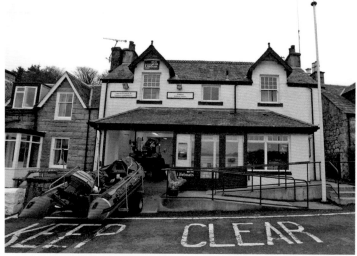

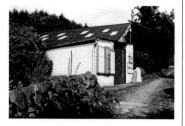

right D class inflatable Catherine (D-718) returning to station after exercise.

below D class inflatable Catherine (D-718) on exercise in the Urr estuary.

1966 An inshore lifeboat station was established in May, operational during the summer months only; the ILB was

kept in a small house situated at the top of a narrow lane leading down to the beach and estuary.

1977 A replacement ILB house was built by the crew at the top of a narrow lane leading to the river.

1999 The station became operational all year round.

2001 A residential property was purchased and converted to provide improved accommodation for the D class ILB and lifeboat crew.

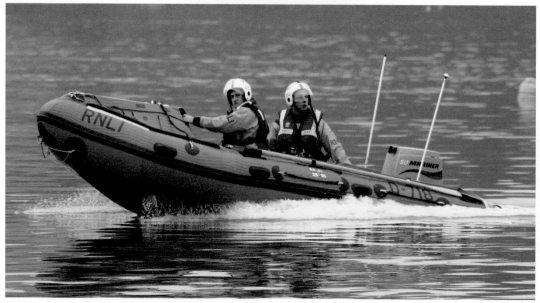

Balcary

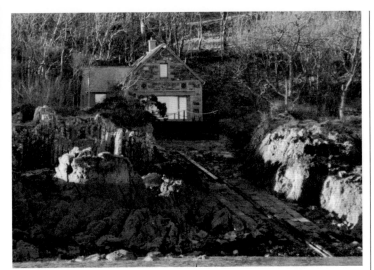

Key dates

Opened	1884
RNLI	1884
Closed	1931

right and below The lifeboat house built in 1884, used until the station was closed in 1931, has become a private residence.

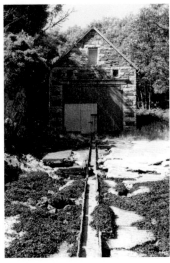

1884 The station was established to cover the west side of Auchencairn Bay and a lifeboat house was built at Balcary Point opposite Hestan Island. **1892** The slipway was extended to counteract problems of silting. **1931** The station was closed, having been served by two self-righting lifeboats, the first of which was on station for thirty years. The lifeboat house was sold; it was used as a private boathouse, but during the 1990s was converted into a private residence; the slipway is still in existence.

Kirkcudbright

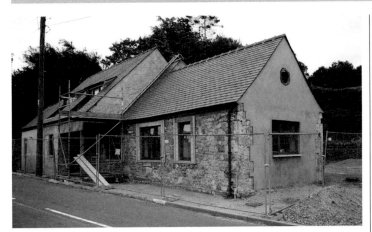

Key dates

Opened	1862
RNLI	1862
Motor lifeboat	1928-89
Inshore lifeboat	1988

Current lifeboats

ILB Atlantic 85
B-814 Sheila Stenhouse
Donor Bequest of the late Sheila Stenhouse
On station 14.12.2006
Launch Trolley down slipway

Station honours

Framed Letter of Thanks	1
Thanks Inscribed on Vellum	1

left The lifeboat house built in St Cuthbert's Street in 1862 and much alteredsince; it was used as a doctor's clinic before being extended, as pictured.

1862 A lifeboat station was established following representations by the Town Council to the RNLI stating the need for a lifeboat after several ships had been wrecked near the bar of the river Dee. A lifeboat house was constructed in St Cuthbert's Street, at the Creekhead, in the town, from which the lifeboat was launched by being brought down the street to the quay on a carriage, a rather unsatisfactory arrangement; used until 1892 when it was sold, this first

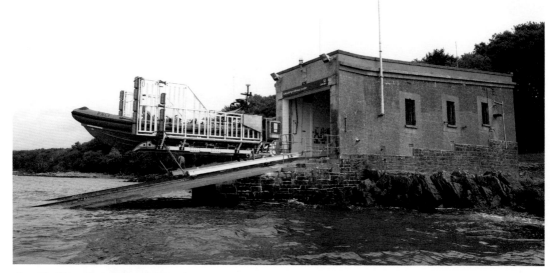

above The lifeboat house built at Cutlers Pool in 1892-3 and modernised several times, most recently for the Atlantic 85.

below The lifeboat house and slipway built at Cutlers Pool.

boathouse was converted into a doctor's clinic and was extended in 2009.

1892-3 A new lifeboat house and slipway were constructed at Cutlers Pool on the Torrs Shore, about three miles out of the town and nearer the mouth of the river Dee where most vessels got into difficulty.

1965 The lifeboat house was adapted for the 37ft Oakley class lifeboat.

1969 The narrow roadway leading to the station at Cutlers Pool was rebuilt with the help of the Army.

1988 An Atlantic 21 inshore lifeboat

was sent to station on 24 July for evaluation for a twelve-month trial period, which proved successful.

1989 The lifeboat house and slipway was adapted to accommodate the new Atlantic 21 ILB, and the offshore lifeboat was withdrawn on 18 April.

1998 A crew assembly facility was constructed in the town, from where the crew travelled to the lifeboat house.

2006 The lifeboat house was renovated, the slipway rebuilt and a new launching trolley was installed to enable the Atlantic 85 to be launched.

right The crew facility built in the town in 1998 where the Land Rover is housed and the crew assemble before proceeding to the lifeboat house. The station celebrated its 150th anniversary in July 2012

below The Land Rover used to transport crew to the Cutlers Pool lifeboat house.

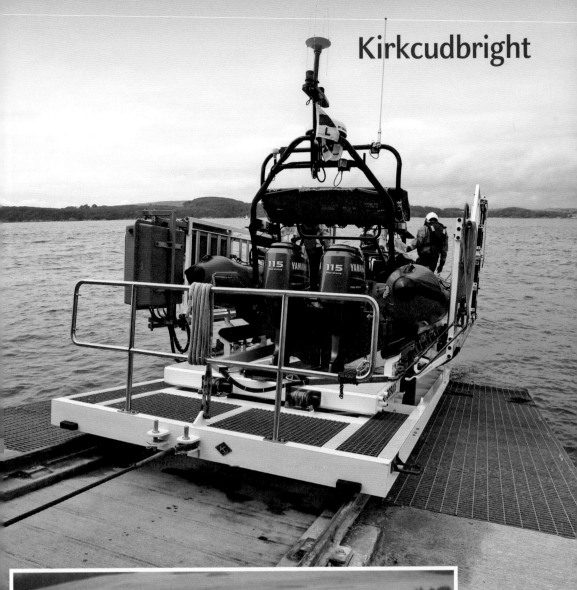

Kirkcudbright

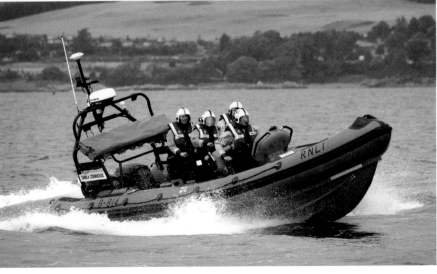

above Atlantic 85 Sheila Stenhouse (B-814) on the launching trolley which runs on rails down the slipway.

left Atlantic 85 Sheila Stenhouse (B-814) on exercise.

Isle of Whithorn

right and below Remains of the lifeboat house built in 1869-70 with, at right angles to them, the launchway down onto the beach. The station was served by three self-righting pulling lifeboats.

1869 A lifeboat station was opened after requests by the local coastguard had been made to the RNLI.

1869-70 A 'very well-built and substantial' lifeboat house was built for £156 7s 0d in a small bay on the east ridge of a promontory which divides the bays of Wigtown and Luce, enabling the lifeboat to be launched from the east or west side of the island.

1909 The lifeboat house was modified.

1920 As no services had been carried out for more than a decade, the station was closed and the lifeboat house and site were sold for £50. The boathouse was demolished, but the slip remains.

Port Logan

1866 The station was established and the 30ft self-righter Edinburgh and R M Ballantyne was placed on station in December; a lifeboat house was built for £126 10s 0d, and it has since been demolished. The lifeboat was taken by carriage to Tirally Bay, Drummore and other places for launching as required.

1908 A new lifeboat house was built to accommodate a larger boat, a 35ft Rubie self-righter, at a cost of £877.

1925 The Clayton & Shuttleworth tractor T14 was supplied in May to improve launching arrangements.

1932 The station was closed in April; only one service had been performed since 1914 and the motor lifeboat at Portpatrick could cover the area.

right and below The lifeboat house built at Port Logan in 1908 and used until the station closed in 1932. It is now used as the village hall with the original crew loft at the front still used.

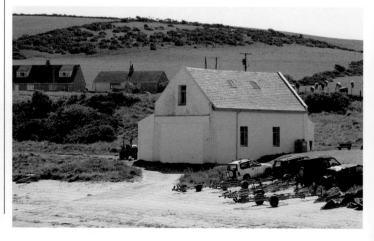

Portpatrick

Key dates

Opened	1877
RNLI	1877
Motor lifeboat	1924
Fast lifeboat	1989

Current lifeboats

ALB 16m Tamar
ON.1301 (16-21) John Buchanan Barr
Built 2011
Donor Legacy of Catherine Barr, in memory
of her late husband, Dr John Buchanan
Barr MBE
On station 13.11.2011
Launch Afloat

Station honours

Framed letter of thanks	1
Thanks Inscribed on Vellum	1
Bronze medal	2
Silver medal	1

1875 After the wreck of the schooner *James Irving* in March, it was decided to open a lifeboat station at Portpatrick.
1877 The station was inaugurated on 15 December after a lifeboat house had been built on the north pier, with doors at the southern (seaward) end. In order to launch, the lifeboat was brought over rollers onto the North Pier and, at low water, was lowered into the inner harbour by crane, which was situated a short distance from the boathouse. At high water, the lifeboat was launched over a roller set in the coping stones at the edge of the quay; a ladder near the crane enabled the crew to board the lifeboat once it was afloat.
1900 Following an accident with the crane on 19 December 1899, in which the lifeboat fell 14ft and was seriously damaged, the new lifeboat was kept afloat in the harbour in the winter, and in the boathouse in the summer.
1907 A new crane was provided at a cost of £275 to lift the lifeboat into and out of the water; the lifeboat was kept permanently in the boathouse, with a door made at the north end.

left The lifeboat house built at the edge of the harbour in 1877 when the station was established; it was used as a souvenir outlet with historical exhibits and photos.

below The lifeboat house built in 1877 with, to the right, the extension added in 1992-93 to provide improved crew facilities. The house was refurbished in 2012-13 and converted to a souvenir shop.

Portpatrick

above and below The naming ceremony of 16m Tamar John Buchanan Barr (ON.1301) at the harbour, 26 May 2012.

opposite 16m Tamar John Buchanan Barr (ON.1301) arriving at Portpatrick for the first time, 8 November 2011.

right The berth for John Buchanan Barr (ON.1301) was constructed in 2012.

below The lifeboat house built in 1877 with the adjacent crew facility.

1914 A cradle and rails were provided from the 1907 crane to the boathouse, to ease the movement of the lifeboat over the pier; this arrangement was used until 1922; the cranes and trolley rails were removed for scrap in 1940.
1922 The station's first motor lifeboat was placed on moorings in the harbour; the lifeboat has been afloat ever since.
1977 A centenary vellum was awarded.
1992-93 An extension to the 1877 boathouse was built to improve crew facilities; it provided a souvenir outlet, a galley, crew room, toilet, washing and shower facilities, a general-purpose store and a lookout training room.
2012-3 A new pontoon berth was built for 16m Tamar class lifeboat; this involved dredging, the placement of pontoons and pile moorings, resiting of the fuel storage tank, electrical works and resurfacing in the vicinity of the workshop; the old boathouse was refurbished to become an RNLI shop.

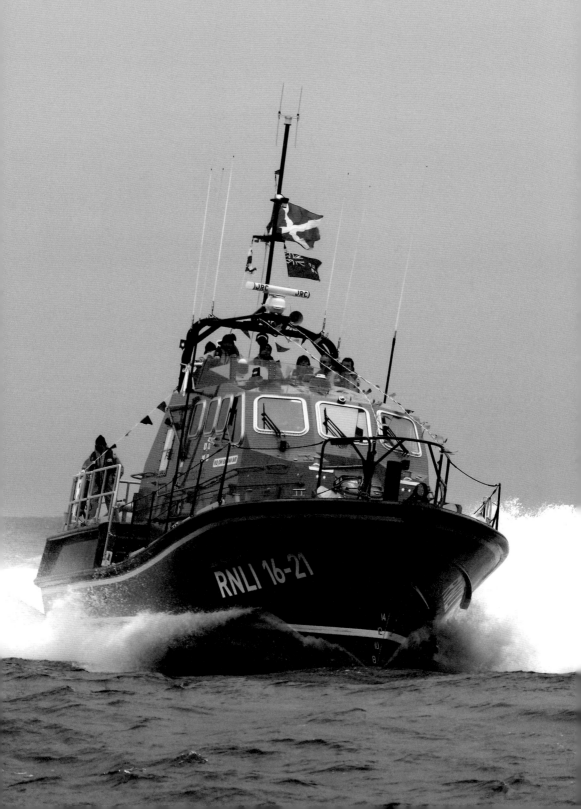

Portpatrick

Stranraer

Key dates

Opened	1974
RNLI	1974
Inshore lifeboat	6.1974

Current lifeboats

ILB D class inflatable
D-697 Stranraer Saviour (Civil Service No.49)
Donor The Communications and Public
Service Lifeboat Fund
On station 5.6.2008
Launch Trolley and Land Rover

right The inshore lifeboat house built in 1994 for the D class ILB and launch vehicle.

opposite D class inflatable Stranraer Saviour (Civil Service No.49) (D-697).

below Stranraer Saviour (Civil Service No.49) (D-697) being launched at Portpatrick using the Land Rover. The ILB is carried on a road-going trailer and can be launched at various sites around the Mull of Galloway.

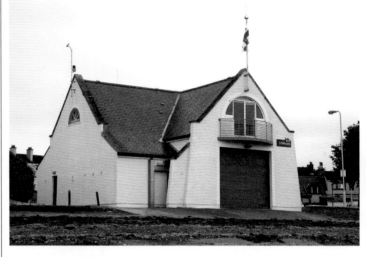

1974 An inshore lifeboat station was established on 4 June to cover Loch Ryan and the west side of the Mull of Galloway; the ILB was operational during the summer months only and housed in a Marley 'M' plan ILB house, situated on the beach at Agnew Park, to the west of the ferry terminal.

1994 A new ILB house was constructed on the site of the first house, which was demolished; the new boathouse provided greatly improved crew facilities with, on the ground floor, housing for the D class inflatable and Land Rover launching vehicle, a workshop and petroleum store, and crew facilities on the first floor.

1996 The D class lifeboat was placed on all year round service.

1998 The new ILB *Tom Broom* (D-538), funded by the Stamford Branch appeal, was placed on service on 19 October.

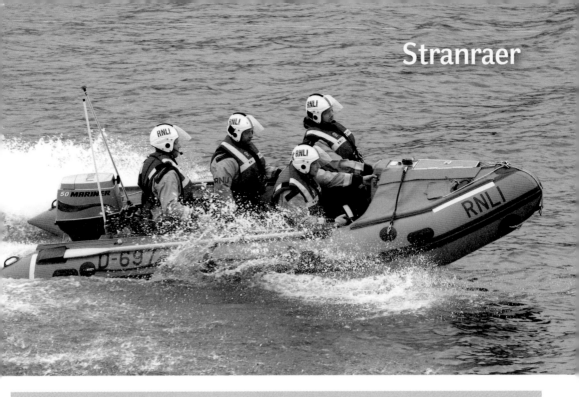

Ballantrae

1869 Following the wreck of the brig *Elpis*, of Athens, off Ballantrae in November, the Honorary Secretary of the Girvan lifeboat station suggested that a lifeboat be sent to Ballantrae; the RNLI concurred, ordering a 33ft by 8ft 1in self-righting lifeboat from Woolfe.

1871 The station was established in January, when the lifeboat *William and Harriot* (ON.268) arrived; a lifeboat house was built to a standard design by a local builder at a cost of £194 16s 0d.

1905 The lifeboat house was enlarged to accommodate a new lifeboat.

1919 The station was closed due to crewing difficulties caused by First World War conscription and the lifeboat was withdrawn on 29 May; the lifeboat house of 1869, used throughout the life of the station, remains standing.

Key dates

Opened	1871
RNLI	1871
Closed	1919

above The lifeboat house built in 1870-71, to accommodate the lifeboat and launching carriage, was used until 1919.

left The lifeboat house overlooking the small harbour at Ballantrae was used until the station closed in 1919. It has since been used as a store and remains unaltered.

Girvan

Current lifeboats

ALB 12m Mersey
ON.1196 (12-37) Silvia Burrell
Built 2001
Donor Legacy of the late Miss Silvia Burrell,
of Edinburgh, a life governor of the RNLI
On station 29.8.1993
Launch Afloat

Station honours

Thanks Inscribed on Vellum	2

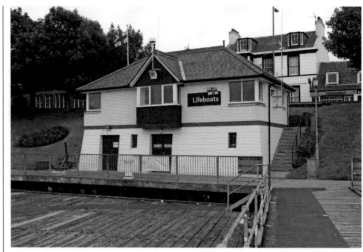

right The shore facility completed in 1993
overlooking the small harbour.

opposite 12m Mersey Silvia Birrell
(ON.1196) returning to the harbour.

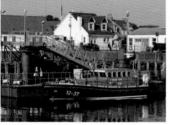

above 12m Mersey Silvia Burrell (ON.1196)
alongside the berthing pontoon.

below Silvia Birrell at her moorings, with
the shore facility at the head of the jetty.

1865 A lifeboat station was established
and a lifeboat house was built on a
site given by the Duchesse de Coigny,
facing the beach; the lifeboats, starting
with *Earl of Carrick*, were launched by
carriage and could be take by road to
other launching sites if necessary.

1910 The lifeboat house was moved
and rebuilt on a new site at a cost of
£800; the house was used until 1931,
and stood until the 1960s when it was
demolished to make way for the beach
Pavilion Development.

1931 The first motor lifeboat, *Lily Glen –
Glasgow* (ON.739), arrived and was kept
at moorings in the harbour.

1960 Following the completion of the
new harbour jetty, alongside moorings
were taken up at the head of the jetty,
on the south side of the harbour, to
improve boarding arrangements; a gear
store was built near the foot of the jetty,
backing on to Knockcushan Street.

1965 A Centenary Vellum was awarded.

1992-3 A new shore facility was
constructed on the site of the previous
building; it included a store and
changing area, a self-contained souvenir
outlet, crew training room, galley, toilet
and washing facilities.

2004 A new pontoon was installed to
improve boarding arrangements.

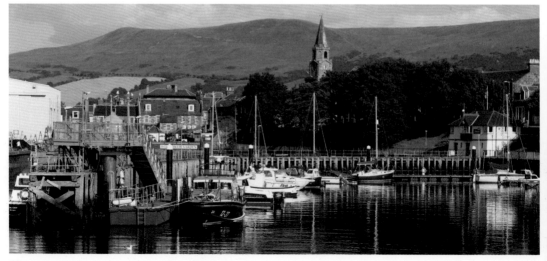

Girvan

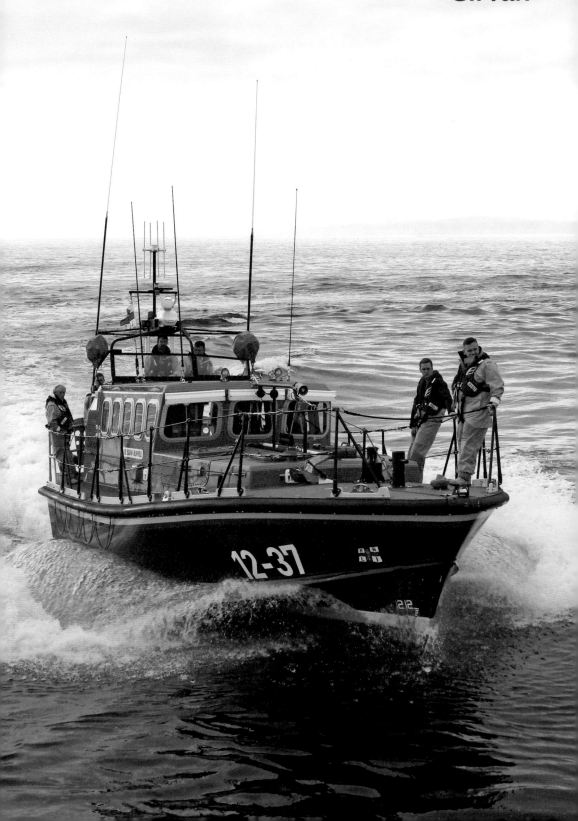

Ayr

Key dates

Opened	1803-p.1840 and 1859
RNLI	1859
Closed	1932

above The 35ft Liverpool lifeboat Janet Hoyle (ON.604) being pulled out of the boathouse on the south side of the river. This was the last lifeboat to serve at Ayr. The railway bridge has been dismantled and the slipway down which the lifeboat was launched no longer exists.

right The lifeboat house built in 1907 has been incorporated into other buildings to became a restaurant.

below The lifeboat house seen from the north side of the river, with the additions front and back hiding its original use.

1802 A lifeboat for Ayr was built by Henry Greathead, funded by Provost George Charles and a donation from the Royal Artillery Co, of Ayr.
1803 The lifeboat arrived in February and was managed by the Harbour Trust.
1819 The lifeboat had become unfit for service and so the Harbour Trust had a new lifeboat built; this lasted until the 1840s and by 1843 it was broken up.
1859 The Harbour Commissioners asked the RNLI in February to supply plans for a lifeboat, but the RNLI instead provided a new 32ft self-righting lifeboat and launching carriage. The RNLI were expanding operations and in *The Lifeboat* journal it was stated 'This station together with some others on the west coast of Scotland, had been allowed to fall into decay.' The lifeboat was kept in the original boathouse built previously by the Commissioners; the boat and her equipment arrived in June.
1861 A new and larger lifeboat house, with a Pilot's Room attached, was built at a cost of £249 18s 0d on a site given by Magistrates & Councillors of Ayr.
1881 The lifeboat house was moved, at the expense of the Harbour Authorities, to make was for a new dock.
1883 The lifeboat house was badly damaged during a severe storm in

December, and was repaired for £103.
1888 A watchroom, attached to the lifeboat house, was built for £139.
1905 The boathouse had to be moved to make way for an extension of the railway to the south side of the harbour.
1907 A new lifeboat house, on Harbour Street at the foot of Fort Street, was built for a new, larger lifeboat at a cost of £635 4s 4d. The 35ft twelve-oared Liverpool class lifeboat *Janet Hoyle* (ON.604) arrived in January; despite serving the station for twenty-two years she carried out just one effective service.
1913 A watchroom was provided on the Pavilion Tower.
1929 The RNLI awarded a Centenary Vellum, noting that Ayr was one of the five oldest stations in Scotland. The station's seven lifeboats had, up to then, saved seventy-one lives. The Vellum was presented on 14 September by the Earl of Glasgow, and it was received by Provost T.S. Stewart, Branch Chairman.
1932 In January the RNLI decided to close the station as the motor lifeboat at Troon could adequately cover the area. *Janet Hoyle* (ON.604) was withdrawn on 1 April. The boathouse of 1907 was sold, being used as a cement store and extended at the front, with later additions when converted into a restaurant.

Troon

above The crew facility (on right) and ILB house on the quayside in the harbour.

Key dates

Opened	1871
RNLI	1871
Motor lifeboat	1929
Inshore lifeboat	2004
Fast lifeboat	1968

Current lifeboats

ALB 14m Trent
ON.1275 (14-38) Jim Moffat
Built 2004
Donor The Moffat Charitable Trust, Lifeboats of the Clyde Appeal and other gifts and legacies
On station 25.2.2004
Launch Afloat alongside pontoon

ILB D class inflatable
D-684 Telford Shopping Centre
Donor Businesses and shoppers in Telford
On station 17.12.2007
Launch Davit

Station honours

Framed Letter of Thanks	3
Thanks Inscribed on Vellum	3
Bronze medal	1
Silver medal	2

1871 The station was established at the request of the local inhabitants. The first lifeboat was a 32ft self-righter and a lifeboat house was built on a site in Portland Street given by the Duke of Portland, who owned the harbour; to launch the lifeboat, it was rolled out of the boathouse to the launch site, and lowered by crane into the coaling basin, the house was used until 1904 and has since been demolished.

1904 Moorings were taken up in the Inner Harbour beyond the Gut Bridge, initially on a trial basis; a gear store was situated beyond the harbour buildings, underneath the old sail-loft.

1905 It was decided that the lifeboat should be kept afloat all the year round; the lifeboat house was sold to Ayr County Council, it was later demolished and a Police station built on the site.

1929 The first motor lifeboat, Sir David Richmond of Glasgow (ON.723) was placed on station in December. New shore facilities were built on the Shipbreakers breakwater quay.

1949 The shore facilities were transferred to a site adjacent to the

above D class inflatable Telford Shopping Centre (D-684) by the launch davit.

left 14m Trent Jim Moffat (ON.1275) returns to harbour after exercise.

below 14m Trent Jim Moffat (ON.1275) on exercise off Troon harbour.

Troon

above The inshore lifeboat house and launching davit on the quayside.

opposite 14m Trent Jim Moffat (ON.1275) on exercise off Troon harbour. She was the last Trent class lifeboat built by the RNLI.

below 14m Trent Jim Moffat (ON.1275) alongside the pontoon installed in 2001.

Inner Basin, near the lifeboat moorings.
1953 A bottle of rum, which had been on two successive Troon lifeboats for sixteen years, was opened during an exercise trip when an American airman, who was to be 'rescued' by helicopter, was accidentally knocked out.
1968 44ft Waveney *Connel Elizabeth Cargill* (ON.1006) was placed on station

and kept moored in a small dock.
1971 Centenary Vellum awarded.
1981 The lifeboat store was extended to provide a crew room.
1987 A new crew assembly building was built on the quayside to provide a workshop and store, a fuel store, and improved crew facilities; a new mooring berth was dredged to accommodate the 52ftArun lifeboat *City of Glasgow III* (ON.1134).
1996 An extension to the boathouse was built to provide, on the ground floor, a workshop and souvenir sales outlet, and on the first floor a crewroom.
2001 A pontoon berth was installed to provide improved boarding arrangements, and the area round the station was fenced off.
2004 An inshore lifeboat was placed on service in January and a new ILB house and davit on the quayside, adjacent to the crew facility and lifeboat, were completed in September.

14-38

Irvine

right The lifeboat house of 1834 was built by the Harbour Trustees and was used until 1874. It later became part of the Harbour Master's buildings.

below The Irvine lifeboat Busbie (ON.168), which served the station from 1887 to 1898, on display in Heaton Park, Manchester after being withdrawn from service. She launched six times on service and saved thirty-three lives. (From an old postcard supplied by John Harrop)

1833 The local town clerk in Irvine, James Johnstone, wrote to Lloyd's in London requesting help in obtaining a lifeboat; the RNLI were passed the request, and they provided a £25 grant towards the building of a new lifeboat.
1834 The new lifeboat, measuring 26ft 3in by 7ft 11in, arrived in March.
1860 The Harbour Trustees asked the RNLI to take over the station.
1861 The RNLI agreed to take over the station, provided a new 30ft ten-oared self-righting lifeboat, named *Pringle Kidd*, and altered the existing lifeboat house to accommodate the new boat.

1873-4 The station was completely renovated, and a new lifeboat house was built by W. McLachlan & Son on a new site at a cost of £320 16s 6d. A new lifeboat, the 33ft self-righter *Isabella Frew*, was also built for the station.
1883 Repairs were made to the lifeboat house at a cost of £63.
1894 On 29 December the lifeboat *Busbie*, on station since 1887, was capsized when returning from service to the Norwegian ship *Frey*; of the twenty-nine people on board including the rescued survivors, five were swept into the sea. One of the rescued Norwegians was drowned, but the others were hauled back aboard the lifeboat once she had righted herself.
1898 A new lifeboat, the 37ft self-righter *Jane Anne*, was sent to Irvine in March, built at a cost of £681, And a new slipway was built.
1903 On 4 February, while the lifeboat was on service to the galliot *Alpha*, one of the lifeboat crew was knocked overboard, but was quickly recovered.
1905 A trolley way costing £46 was laid to improve launching arrangements.
1914 As no effective services had been performed since 1906, the RNLI decided to close the station in April and on 31 July the lifeboat was withdrawn.

1807 A lifeboat station was established under the auspices of the local Harbour Trustees and a North Country type lifeboat, measuring 26ft 6in by 7ft 3in, was funded by the Earl of Eglinton. The lifeboat performed a number of rescues, including one to the brig *Lady Montgomerie,* which was wrecked at Saltcoats in November 1830, a service for which the RNIPLS awarded Lieut William Lyons, who was in charge, the Silver medal.

1843 The lifeboat was being kept 'in a shed on the south side of the harbour'.

1847 The lifeboat undertook another servcie in July 1839, but by about 1847 the boat was deemed unfit for further service and was broken up locally.

1853 Local shipbuilder Mr Shearer wrote to the RNLI asking for assistance in operating a lifeboat run by the Ardrossan Lifeboat Society; the RNLI offered a 27ft eight-oared self-righter, which was spare; the boat was accepted and, having been paid for locally, was sent to Ardrossan.

1854 The lifeboat arrived in February and a boathouse was built for it by the Ardrossan Lifeboat Society. This lifeboat only performed one service during her time on station.

1869 In November the RNLI decided to take the station over after being approached by the Inspecting Officer of Coastguard at Greenock, G. Beatson, and implemented its renovation.

1870 The take-over was completed and a new lifeboat, the 33ft ten-oared self-righter *Fair Maid of Perth,* was sent to the station in June, with a formal inauguration being held on 18 June 1870. A lifeboat house was completed at the bottom of Harbour Street, near the entrance to the docks, at a cost of £234 by local builder R. Barlow.

1891 The lifeboat house was moved to a new site at the expense of the local harbour company , which was building a new dock on the original site.

1892 A new lifeboat, the 37ft self-righter *Charles Skirrow* (ON.309), arrived in February after being exhibited at the Royal Naval Exhibition in London from May to October 1891.

1930 The RNLI decided in April to close the station and the last lifeboat, the 35ft twelve-oared Liverpool type *James and John Young* (ON.636) which had been placed on station in August 1913, was withdrawn. The motor lifeboat sent to Troon in December 1929 could adequately cover the area.

Key dates

Opened	1807
RNLI	1857
Closed	1862

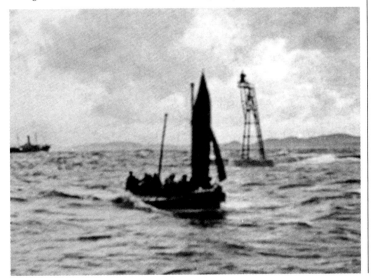

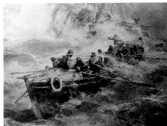

above A painting depicting the 33ft self-righter Fair Maid of Perth, which served at Ardrossan from 1870 to 1880.

left The 35ft Liverpool sailing lifeboat James and John Young (ON.636) entering Ardrossan harbour on a high tide, with the breakwater to the right being almost submerged. She served from 1913 until the station closed in 1930. (Grahame Farr, by courtesy of the RNLI)

Largs

Current lifeboats

ILB Atlantic 85
B-854 R. A. Wilson
Donor The Toby Charitable Trust
On station 6.11.2011
Launch Tractor and do-do carriage

Station honours

Framed Letter of Thanks	3
Thanks Inscribed on Vellum	1
Silver medal	1

above The ILB house built in 1997-98 at Barrfields slipway for the Atlantic 75.

above The ILB house built in 1981 and used until the late 1990s.

below Atlantic 85 R. A. Wilson (B-854) was placed on service on 6 November 2011.

1964 An inshore lifeboat station was established in May; the ILB was operated from a small boathouse at Barrfields slipway, on Greenock Road, to the north of the town of Largs, facing Great Cumbrae Island.

1972 An Atlantic class inshore lifeboat B-500 was sent to station for trials, making Largs the first station in Scotland to operate a B class ILB.

1973 The station was upgraded, with the D class ILB being withdrawn and replaced by the Atlantic 21 *William McCunn and Broom Church Youth Fellowship* (B-513).

1981 A new Marley ILB house was built for the Atlantic 21 and launch vehicle at Barrfields slipway, on the same site as

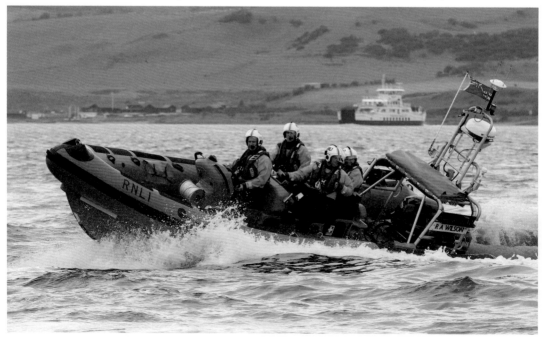

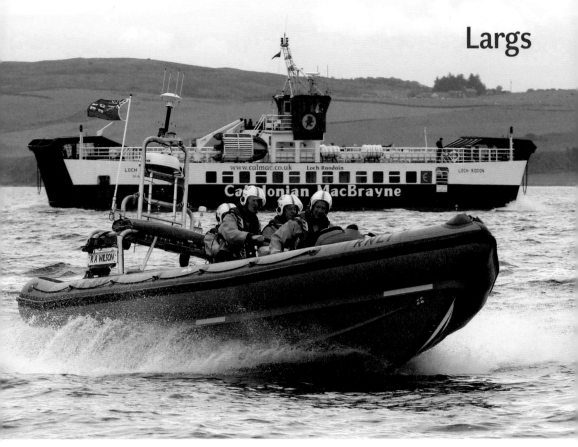

the previous house.

1997-8 A new ILB house was built at Barrfields slipway on the seafront for the Atlantic 75 *Peggy Keith Learmond* (B-739) and its launching tractor, providing greatly improved crew facilities, replacing the previous house which was demolished to make way for the new building. The official opening of the new boathouse was carried out by HRH The Princess Royal on 3 July.

2004 The station celebrated forty years of service as a lifeboat station.

2011 The latest generation of B class inshore lifeboat, the Atlantic 85 *R.A. Wilson* (B-854), was placed on station.

above Atlantic 85 R.A. Wilson (B-854) is put through her paces at the end of her naming ceremony in June 2012 with the Cal Mac car ferry Loch Riddon and Cumbrae island in the background.

left and below Atantic 85 R.A. Wilson (B-854) being launched at the end of her formal naming ceremony on 23 June 2012. The launching tractor TW10 is a Talus MB 764 type built in 1982.

Helensburgh

Key dates

Opened	1965
RNLI	1965
Inshore lifeboat	6.1965

Current lifeboats

ILB Atlantic 75
B-791 Gladys Winifred Tiffney
Donor Legacy of Gladys Tiffney.
On station 12.12.2002
Launch Trolley and tractor

above The inshore lifeboat house at Rhu Marina completed in 1997 for Atlantic 75.

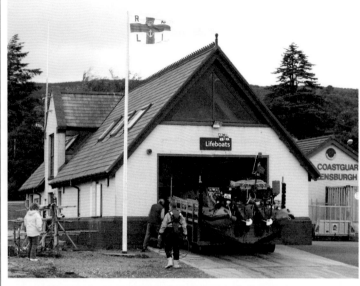

above The first ILB house at Rhu Marina was erected in 1965 for the station's first D class inflatable. (Grahame Farr)

below Atlantic 75 Gladys Winifred Tiffney (B-791) launching on exercise down the slipway at Rhu Marina.

1965 An inshore lifeboat station was established at Helensburgh in June; the D class inflatable ILB D-66, provided by the Helensburgh ladies lifeboat guild, was kept in a small wooden boathouse at Rhu Marina, on the northern outskirts of Helensburgh; the ILB was launched into the mouth of the Gareloch. The station provides cover for a busy pleasure craft area of the Clyde.

1971 B class Atlantic 17 inshore lifeboat, a prototype design, was placed on station for training and evaluation.
1972 The D class inflatable ILB was withdrawn.
1977 A new ILB house and launchway were built at Rhu Marina for an Atlantic 21; it was used until 1996 and then demolished.
1978 The Atlantic 17 lifeboat was

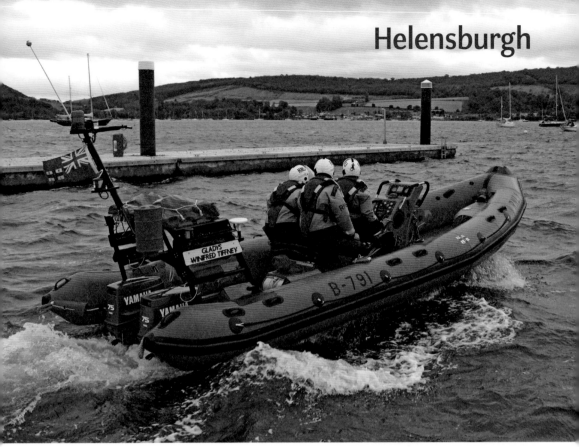

withdrawn and replaced by the Atlantic 21 *Round Table* (B-543).
1996 A new slipway was built over the existing slipway, to make launching and recovery easier.
1997 A new and larger ILB house was built on the same site as the previous house; the new building included housing for a larger lifeboat on the ground floor and improved crew facilities on the first floor. The boathouse was highly commended in the Helensburgh & Lomond Planning Design Awards.
2003 Atlantic 21 B-581 *Andrew Mason*, on station since, was withdrawn from service and was replaced by the Atlantic 75 *Gladys Winifred Tiffney* (B-791).

above Atlantic 75 Gladys Winifred Tiffney (B-791) putting out on exercise from Rhu Marina.

below left Atlantic 75 Gladys Winifred Tiffney heads down the Clyde estuary.
below Recovery of Gladys Winifred Tiffney after exercise.

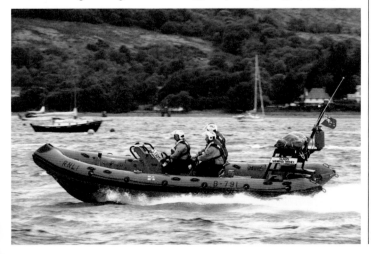

Arran

Key dates

Opened (at Kildonan)	1870
RNLI	1870
Closed	1902
Reopened (at Lamlash)	1970
Inshore lifeboat	6.1970

Current lifeboats

ILB Atlantic 75
B-770 The Boys Brigade
Donor The Boys' Brigade Appeal
On station 24.1.2001
Launch Tractor and do-do carriage

right The first lifeboat house at Kildonan was built in 1870 and used until 1902, since becoming a store.

below The ILB house built in 1985 and used for the D class inflatable ILBs and then the twin-engined C class ILB.

below The inshore lifeboat house at the Old Pier was built in 1997 for an Atlantic ILB and its launching rig.

1870 A lifeboat station was established at Kildonan, on the south side of the island, where a lifeboat house was built; a 32ft ten-oared self-righter, named *Hope*, was placed on station.

1902 The station was closed at Kildonan and the lifeboat, only the second to serve the station was withdrawn. The boathouse, which was used throughout the life of the station, is still standing in use as a store by the Kildonan Hotel.

1970 An inshore lifeboat station was established at Lamlash; the D class inflatable ILB D-185 was housed in a small garage which adjoined the marine workshops at the back of the quay.

1984 D-185 was replaced by D-303 *Isle of Arran,* which was funded from money raised on the Isle of Arran.

1985 A new ILB house was built close to the Old Pier at Lamlash, on the seaward side of the main road, on land provided by Mrs Anne Spiers. The cost of the boathouse was met by a bequest from the late Mrs Mary Isabella Currie in memory of the crew of the Shaw, Savill & Albion steamer *Ceramic.* This house was used until 1997.

1986 The station was upgraded in September with the D class ILB being

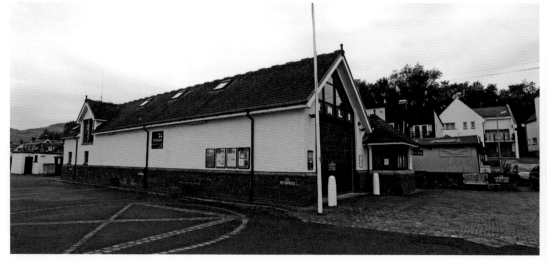

withdrawn and replaced by a twin-engined C class inflatable ILB.

1987 C class inflatable *Prince of Arran* (C-520) arrived at the station in June as the permanent station lifeboat.

1997 A new and larger ILB house was built on the site of the 1985 boathouse near the Old Pier for an Atlantic ILB, providing housing for the lifeboat and launch vehicle, a crew training room and souvenir outlet. The Atlantic launches in the shelter of Holy Island.

1998 The station was upgraded when an Atlantic 21, *Percy Garon* (B-527), was placed on station on 11 January; she carried out her first service an hour later.

2001 Atlantic 75 *The Boys Brigade* (B-770) was placed on service on 24 January.

above Atlantic 75 The Boys Brigade (B-770) with the Claedonian MacBrayne ferry Caledonian Isles approaching Arran's main town of Brodick.

left Atlantic 75 The Boys Brigade (B-770) heading out on exercise, passing Holy Island Outer lighthouse.

below On a calm morning, Atlantic 75 The Boys Brigade puts out on exercise across Lamlash Bay.

Tighnabruaich

Key dates

Opened	1967
RNLI	1967
Inshore lifeboat	5.1967

Current lifeboats

ILB Atlantic 85
B-862 James and Helen Mason
Donor Legacy of Mrs Janet Wilson Smith
On station 26.7.2012
Launch Tractor and trolley

right The ILB house, with a curved roof and a sea wall to give protection from the southerly fetch out into the Sound of Bute, was completed in 1998 for an Atlantic ILB.

below The ILB house of 1981 still stands, in the grounds of Tighnabruaich Hotel.

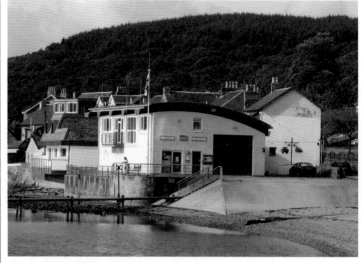

right Atlantic 85 James and Helen Mason (B-862) in the Kyles of Bute.

below James and Helen Mason being recovered and washed down afterwards.

1967 An inshore lifeboat station was established in May; the D class inflatable ILB was kept in a small boathouse in the grounds of Tighnabruaich Hotel, facing south, towards the Kyles of Bute.

1981 A new, larger ILB house was built on the site of the previous house; it was used until 1998.

1994 The twin-engined C class ILB *British Diver IV* (C-523) was placed on service for one year's evaluation.

1997 The station was upgraded with the Atlantic 21 *Blenwatch* (B-549) being placed on station on 25 September.

1997-8 A new ILB house was built for the Atlantic 75 *Alec and Maimie Preston* (B-743) and the launching tractor on the seaward side of the road through the village; the new house provided housing for the ILB and launching vehicle and crew facilities.

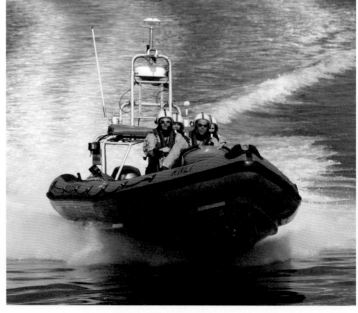

above The first lifeboat house, built in 1861, was used until 1898.

Key dates

Opened	1861
RNLI	1861
No.2 lifeboat	1910-1931
Motor lifeboat	1912
Fast lifeboat	1979
Inshore lifeboat	1993

Current lifeboats

ALB 17m Severn
ON.1241 (17-19) Ernest and Mary Shaw
Built 1999
Donor Gift from the estate of the late Ernest
 J. Shaw and from his widow, Mrs Mary
 Shaw, Glasgow
On station 31.5.1999
Launch Afloat

ILB D class inflatable
D-737 Alastair Greenlees
Donor Legacy of the late Alastair Greenlees
 and the Campbeltown Lifeboat Appeal
On station 5.8.2010
Launch Trolley and Land Rover

Station honours

Framed Letter of Thanks	1
Thanks Inscribed on Vellum	7
Bronze medals	9
Silver medals	3

1861 The station was established following a report from the Lloyds Agent indicating Campbeltown was a good location for a lifeboat. Lady Murray of Edinburgh provided the set-up costs, and a lifeboat house was built for £158 at the New Quay in the town centre; it was used until 1898 and in 1899 was dismantled and handed over to owner of site. It was later converted into public toilets.
1890 Gas and water services provided.
1894 Sound signals abolished and a mortar was provided.

1898 A new lifeboat house, with a stone slipway, was built at Quarry Green to the south of the town, on the landward side of Kilkerran Road facing Campbeltown Loch, at a cost of £885; horses used for launching were paid at a shilling per head for each horse. The boathouse was used for the No.2 lifeboat between 1910 and 1931; it has since been used by the Sea Cadet Corps.
1900 The lifeboat James Stevens No.2 (ON.413) was being lowered into the water by crane when the hook broke and the boat fell 14ft; there were no injuries.

below left The lifeboat house built in 1898 and used until 1931, pictured in the 1990s when sued by the Sea cadet Corp.

below The ILB house and crew facility completed in 2006 close to the moorings for the all-weather lifeboat.

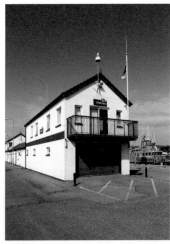

Campbeltown

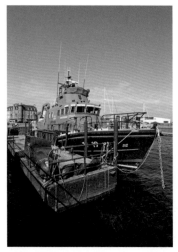

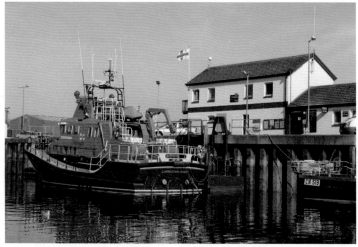

above 17m Severn Ernest and Mary Shaw (ON. 1241) moored alongside the pontoon on the north side of the Old Quay.

above right 17m Severn Ernest and Mary Shaw at moorings close to the crew facility and ILB house.

opposite 17m Severn Ernest and Mary Shaw (ON. 1241) on exercise off Davaar.

Opposite inset D class inflatable Alastair Greenless (D-737) on exercise. (Martin Fish)

below D class inflatable Alastair Greenless (D-737) on her road-going trolley outside the ILB house on the Old Quay. The ILB provides cover on the west side of Kintyre and can be driven to numerous different launch sites as required.

1903 Double pay was granted to the crew for a very arduous service on 28 December in severe cold weather; the lifeboat was seriously damaged when she was smashed onto the deck of the wrecked ship to which she had launched and returned to station without saving any lives. A crew member was washed out but was recovered, and the casualty's crew had to be saved by a shore boat.

1907 Megaphone supplied to the lighthouse keepers at Davaar Island for calling the lifeboat if necessary.

1908 Acetylene beach light supplied.

1910 A second lifeboat was supplied for use as a boarding boat for the larger lifeboat and also the service on the Loch only, but it was never launched on service; it was withdrawn in 1931.

1912 The first motor lifeboat, the 43ft Watson motor *William MacPherson* (ON.620), was placed on station in July.

1929 The new 51ft Barnett motor lifeboat, *City of Glasgow* (ON.720), was placed on moorings near the Old Quay in the main harbour.

1937 A dinghy belonging to the yacht *Myrtle*, which was hunting sharks, was towed away by a harpooned shark. The lifeboat saved the dinghy and its crew.

1961 Centenary Vellum awarded.

1980 A boarding pontoon was installed to improve boarding arrangements.

1983 A new crew room was built on the quay adjacent to the boarding pontoon.

1993 An inshore lifeboat was sent to station on 3 April for one season's operational evaluation.

1994 The inshore lifeboat station was officially established on 31 January; a new D class inflatable *Spirit of Kintyre* (D-455), funded locally, was placed on service on 26 March.

1995-6 A new two-storey ILB house was completed for the D class inflatable and Land Rover on the Old Quay, close to the all-weather lifeboat moorings.

2011 An anniversary vellum was awarded to mark 150 years of service.

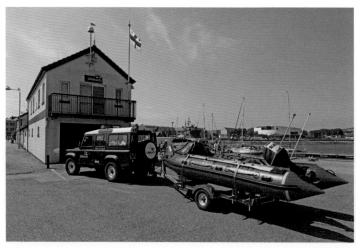

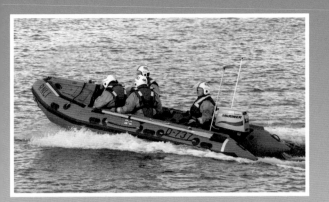

Campbeltown

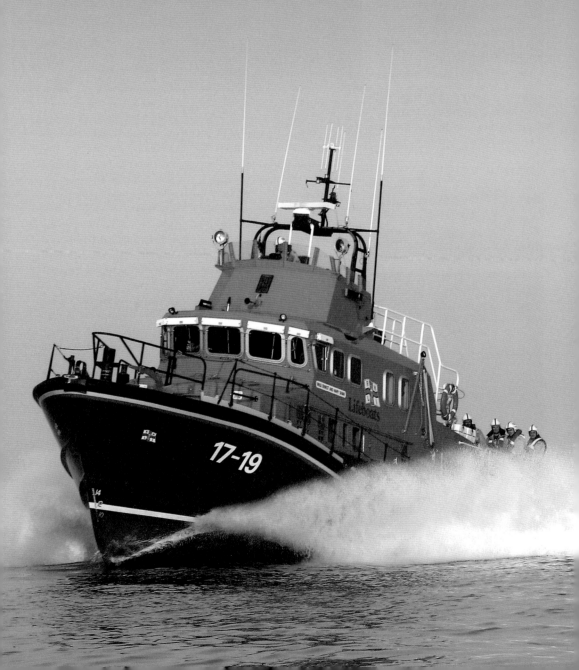

Southend (Kintyre)

right The site on the east side of Dunaverty Bay where the two lifeboat houses were built, close to the stone pier once used for loading stone into small coasting craft. The 1860 boathouse, on the left, has been renovated, while the support piles of the 1904 boathouse have had a store built onto them.

below The remains of the 1904 lifeboat house and slipway at Southend before being built upon. The building, designed by the RNLI's architect W.T. Douglass, had a 130ft long slipway and was built at a cost of £4,010 9s 2d.

above The tablet is still in place at the front of the 1860 boathouse. It was placed between the windows of the coxswain's apartment in memory of John Ronald Ker, drowned age 22 on 26 October 1867.

right The lifeboat house built in 1860 was used for the lifeboat until 1904 and has since been converted into a house.

1869 A lifeboat station was established at Southend, at the southern tip of the Mull of Kintyre. A two-storey lifeboat house was built for £461 by McNair & Sons on the east side of Dunaverty Bay, with the ground floor for the lifeboat on her carriage and accommodation on the first floor for the coxswain and his family. The station was funded from the gift of Mr R. Ker, of Auchinraith, and the three lifeboats which served the station were all named *John R. Ker*.

1875 The station was manned by a crew transported in a brake from Campbeltown.

1904-5 A new lifeboat house and slipway were built on a site close to the 1869 house to improve launching arrangements and house a larger lifeboat, the 38ft Watson sailing craft *John R. Ker* (ON.529); the 1869 house was converted into a winch house; the winch was used to haul the lifeboat out of the water, and she was then hauled round to the rear of the new boathouse and not recovered up the slipway.

1929 The station was closed and the lifeboat withdrawn on 31 December as the area could be covered by the Campbeltown motor lifeboat. The 1904 boathouse was largely dismantled, but the support structure remained; a store building was built on it circa 2010.

1989 The then owner of the 1869 boathouse donated the station's hand-operated winch to the Scottish Maritime Museum in Irvine.

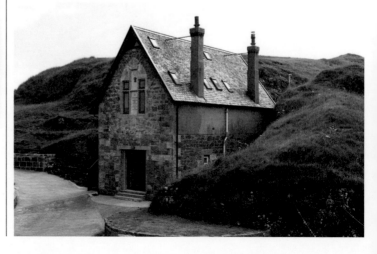

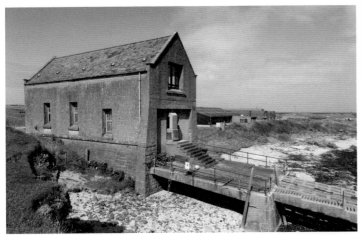

Key dates

Opened	1911
RNLI	1911
Closed	1930

left The lifeboat house and slipway built in 1911 were used throughout the life of the station, and subsequently became derelict. However, the building was refurbished in the 1990s, including having a new roof, but largely retains its original external appearance with the slipway intact.

1911 A lifeboat station was opened following the loss of a trawler which had been caught in a blizzard and driven ashore at Westport, four miles north of Machrihanish, in 1908. Rescue attempts from Campbeltown failed and so a decision was made to establish a lifeboat station at Machrihanish, which is due west of Campbeltown, from where the station was manned. A lifeboat house and slipway were built at a cost of £2,464 8s 2d and the first and only lifeboat, the 35ft self-righter *Henry Finlay* (ON.618), arrived in September.

1930 In October the RNLI decided to close the station; the lifeboat had never been launched on service and the area was covered by the motor lifeboats at Campbeltown and Islay. The lifeboat house and slipway remain standing, and the boathouse became derelict with the roof removed. However, it was refurbished during the 1990s, and was used by a local industrial company.

above The formal naming and dedication ceremony of the lifeboat Henry Finlay (ON.618) and inauguration of the station.

below The refurbished lifeboat house and slipway of 1911 are situated at the western end of the small village of Machrihanish.

Islay

Key dates

Opened	1934
RNLI	1934
Motor lifeboat	1934
Fast lifeboat	1979

Current lifeboats

ALB 17m Severn
ON.1219 (17-08) Helmut Schroder of
 Dunlossit II
Built 1996
Donor Mr Bruno Schroder and Mrs George
 Mallinckrodt
On station 9.3.1997
Launch Afloat

Station honours

Framed Letter of Thanks	2
Thanks Inscribed on Vellum	2
Bronze medals	3
Silver medal	1

right 17m Severn Helmut Schroder of
Dunlossit II (ON.1219) moored at Port
Askaig, close to the shore facility.

opposite 17m Severn Helmut Schroder of
Dunlossit II (ON.1219) on exercise off the
north end of Islay.

opposite inset The crew facility at Port
Askaig close to the lifeboat moorings.

below 17m Severn Helmut Schroder of
Dunlossit II at moorings, with the Paps of
Jura forming the picturesque backdrop.

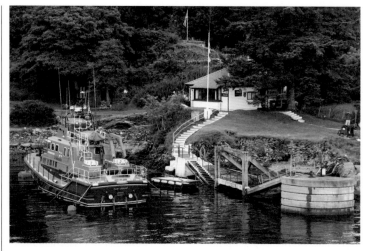

1934 A lifeboat station was established
at Port Askaig following a spate of
groundings near Islay early 1930s; the
lifeboat was kept at moorings in an
inlet out of the main channel.

1947 Owing to manning difficulties,
the lifeboat was transferred to Port
Ellen in April and the station was
known as Port Ellen until 1948.

1948 The station was moved back to
Port Askaig and was renamed Islay,
being officially reopened on 11 June; the
moorings were located close to the ferry
terminal and the Port Askaig Hotel, and

the lifeboat can be seen from the ferry.
1979 Timber fender piles were added
to alongside mooring for the lifeboat;
On 18 November the Thames lifeboat
Helmut Schroder of Dunlossit (ON.1032)
capsized while answering a distress call
from the Danish coaster *Lone Dania*.
1985 Bulk fuel storage facilities were
installed for the Thames class lifeboat.
1996-7 A deeper mooring berth was
constructed for the 17m Severn class
lifeboat by dredging a rocky basin; new
crew facilities were also constructed on
the site of the previous building.

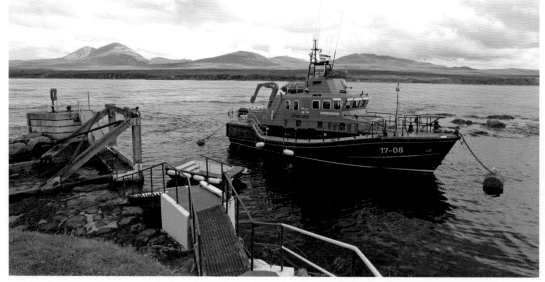

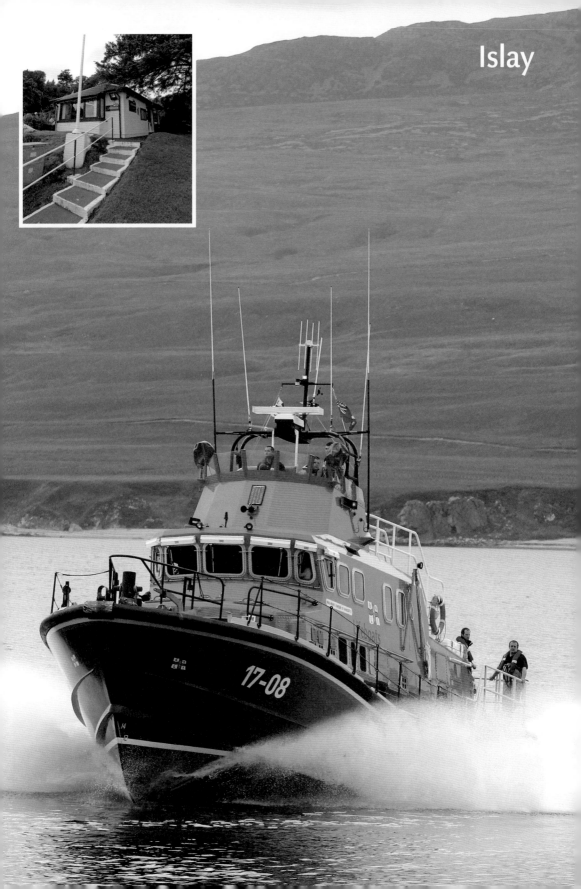

Islay

Oban

Key dates

Current lifeboats

ALB 14m Trent
ON.1227 (14-23) Mora Edith Macdonald
Built 1997
Donor Bequest of Miss Mora Edith
Macdonald, Glasgow, together with the
bequests of Mrs Janet Boyd Finlay-Maclean,
Mrs Harriett Elizabeth Willis Gaunt and
Mrs Annie Thomson Hart.
On station 17.7.1997
Launch Afloat

Station honours

Framed Letter of Thanks	2
Thanks Inscribed on Vellum	1

right The lifeboat mooring pen and crew
facility at the South Pier, close to the
Caledonian MacBrayne ferry terminal.

opposite 14m Trent Mora Edith
Macdonald (ON.1227) at moorings.

opposite inset Mora Edith Macdonald
(ON.1227) moored at Oban, with the
harbour, fishing port and popular west
coast holiday town across the bay.

right The Old Customs House, at the
South Pier, has been fitted out as a crew
facility, and is situated close to the lifeboat
mooring berth.

below Relief 33ft Brede Enid of Yorkshire
(ON.1101) on station at Oban in July
1995. Lifeboats of the Brede class, an
intermediate type, served the station from
1982 to 1997.

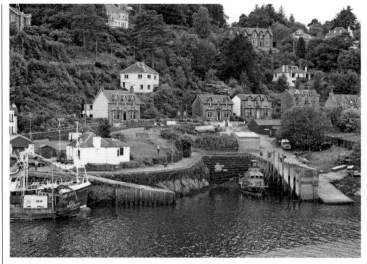

1972 An inshore lifeboat station was
established in May with the 18ft
McLachlan rigid-hulled ILB A-505,
which was kept afloat in the harbour;
tn the winter, the ILB was kept under
cover ashore and was non-operational.
1973 The 18ft McLachlan rigid-hulled
ILB A-511 was placed on station and
served until being withdrawn in 1982.
1978 The 42ft Watson motor lifeboat
Watkin Williams (ON.922) was sent to
station on 8 August, and was kept at
moorings in the harbour.
1980 A building adjoining the
boathouse was fitted out by the
crew for use as a store.

1982 The 33ft Brede *Ann Ritchie*
(ON.1080), an intermediate lifeboat
type, was sent to the station in October,
and was the first of three Bredes that
served the station through to 1997.
1990 A new mooring berth was
completed with alongside moorings,
close to the Caledonian MacBrayne
ferry terminal at the South Pier.
1991 The Old Customs House, at the
South Pier, was fitted out to provide
new shore facilities adjacent to the
lifeboat berth. The new facility was
formally opened on 7 December 1991.
1998 Improved crew facilities were
completed in November.

Oban

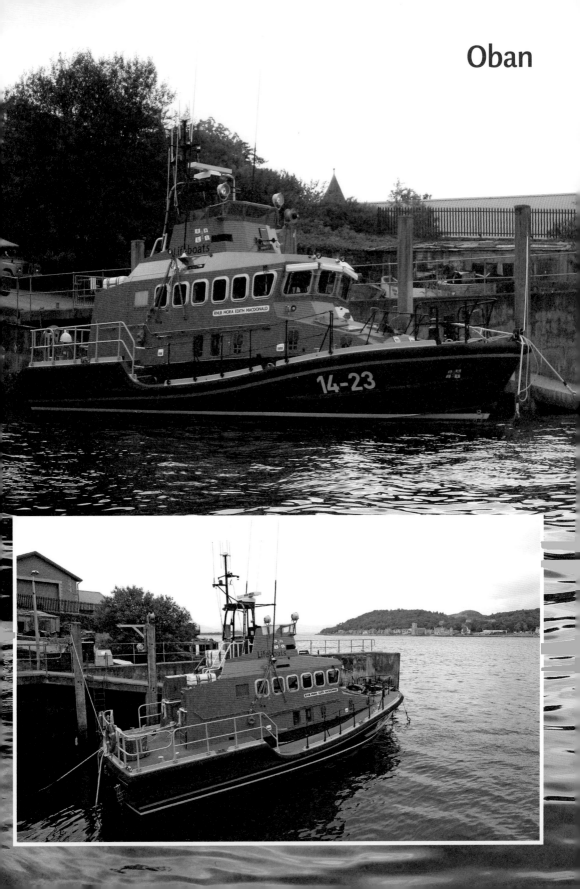

Tobermory

Key dates

Opened	1938-47 and 1990
RNLI	1938
Motor lifeboat	1938
Fast lifeboat	1990

Current lifeboats

ALB 17m Severn
ON.1270 (17-39) Elizabeth Fairlie Ramsey
Built 2003
Donor Bequest of Mrs Elizabeth F. Ramsey, of Edinburgh, and J. T. Graham.
On station 20.8.2003
Launch Afloat

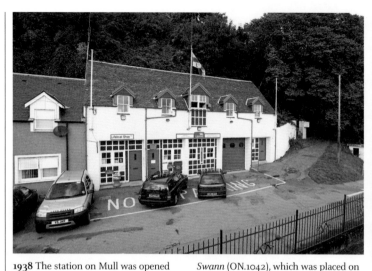

right The crew facility which was created in 1993 from an old garage and store at Mishnish Pier.

below The station's first lifeboat Sir Arthur Rose (ON.801) at the 1938 Empire Exhibition in Glasgow. She left Glasgow and came straight to Tobermory.

opposite 17m Severn Elizabeth Fairlie Ramsey (ON.1270) on exercise.

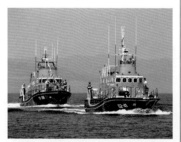

above 52ft Arun Ann Lewis Fraser (ON.1143) escorting 17m Severn Elizabeth Fairlie Ramsey (ON.1270) to Tobermory as the Severn arrived on station for the first time, 7 August 2003.

right Elizabeth Fairlie Ramsey (ON.1270) alongside the berth built in 2000.

1938 The station on Mull was opened with the lifeboat moored in the harbour; the first lifeboat, the 46ft Watson motor *Sir Arthur Rose* (ON.801), was exhibited at the 1938 Empire Exhibition in Bellahouston Park, Glasgow, between May and October.

1947 The station was closed because of manning difficulties and the lifeboat was transferred to Mallaig.

1990 The station was reopened in May, when the RNLI was expanding operations on Scotland's west coast, and moorings off the harbour were taken up for the 44ft Waveney *Ralph and Joy Swann* (ON.1042), which was placed on temporary duty in August.

1992 A lock-up garage and store adjacent to the ferry terminal at Mishnish Pier was bought to provide improved crew facilities.

1993 The garage was converted to provide crew facilities, comprising a separate office for HM Coastguard, housing for the boarding boat, an office, crew/training room workshop, and souvenir sales outlet.

2000 An alongside mooring berth, adjacent to the crew facility, was completed in June.

Tobermory

Mallaig

Current lifeboats

ALB 17m Severn
ON.1250 (17-26) Henry Alston Hewat
Built 2000
Donor Legacy of Miss Catherine Margaret
Hewat, Glasgow, in memory of her father,
together with the Mallaig Lifeboat Appeal
and other gifts and legacies
On station 30.1.2001
Launch Afloat

Station honours

Framed Letter of Thanks	1
Thanks Inscribed on Vellum	4
Bronze medal	1

right The crew facility and souvenir outlet among the harbour buildings at Mallaig.

opposite 17m Severn Henry Alston Hewat (ON.1250) on exercise in Loch Nevis.

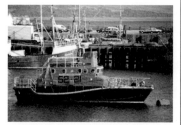

above 52ft Arun Davina and Charles Matthews Hunter (ON.1078) at the moorings in the middle of the harbour. She served the station from 1982 to 2001.

right 17m Severn Henry Alston Hewat (ON.1250) at moorings in the harbour.

below The pontoon berth installed in 2001 at the South Pier for 17m Severn Henry Alston Hewat (ON.1250).

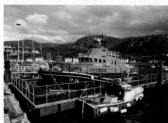

1948 When the station at Tobermory was closed in November 1947 owing to manning difficulties, a station was established in its place at Mallaig the following January with the Tobermory lifeboat *Sir Arthur Rose* (ON.801) transferred. The lifeboat was kept at moorings in Mallaig harbour, and crew facilities and a gear store were provided among the fishing sheds in the harbour. **1998** A property in the New Harbour Buildings complex was purchased, situated at the side of the entrance to the harbour and ferry terminal; after extensive refurbishment, the property was converted into a new shore building incorporating a souvenir outlet and greatly improved crew facilities. **2001** A new mooring pontoon was installed in the harbour to provide alongside boarding facilities. On 5 October crew member Patrick Morrison suffered a heart attack three minutes after the lifeboat launched on service. The lifeboat returned to station and he was taken to hospital, but he died later.

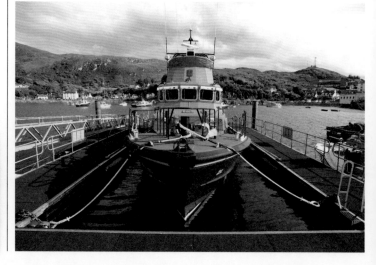

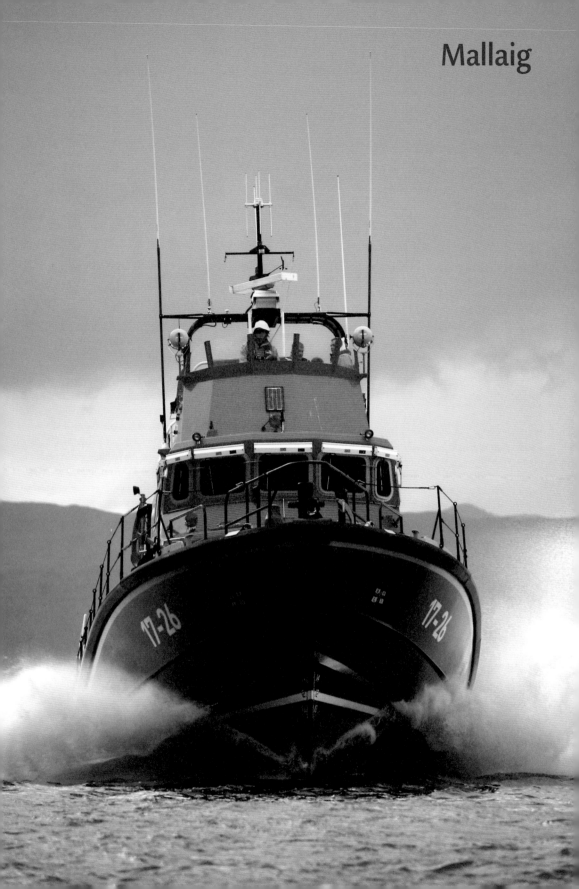

Mallaig

Kyle of Lochalsh

Key dates

Opened	1995
RNLI	1995
Inshore lifeboat	1995

Current lifeboats

ILB Atlantic 85
B-856 Spirit of Fred. Olsen
Donor Guests on Fred. Olsen Cruise Line
On station 15.12.2011
Launch Trolley and Land Rover

right The ILB house at Kyle of Lochash; the station covers the Sound of Sleat to the south and Inner Sound to the north, as well as Loch Alsh and Loch Duich.

opposite Atlantic 85 Spirit of Fred. Olsen (B-856) beneath the Skye Bridge.

above Atlantic 85 Spirit of Fred. Olsen (B-856) being launched by Land Rover.

below Spirit of Fred. Olsen (B-856) passing the lifeboat house heading out on exercise.

1995 An inshore lifeboat station was established, becoming operational at midnight on Sunday 23 April; the relief Atlantic 21 was kept in a building on the premises of the British Underwater Testing Evaluation Centre and towed by Land Rover to different sites around the Kyle and on Skye for launching; the main launch site was the ferry slipway at Kyle, which was shared the ferry to Skye, a service that was operational until the Skye Bridge was opened in 1995. Crew facilities were initially provided in a temporary portacabin. **1999-2000** A new permanent ILB house was built on a site to the west of the railway station for the new Atlantic 75 *Alexander Cattanach* (B-740) and the Land Rover; the building was completed in August 2000, and was funded by a gift from the anonymous donor who provided the Atlantic 75.

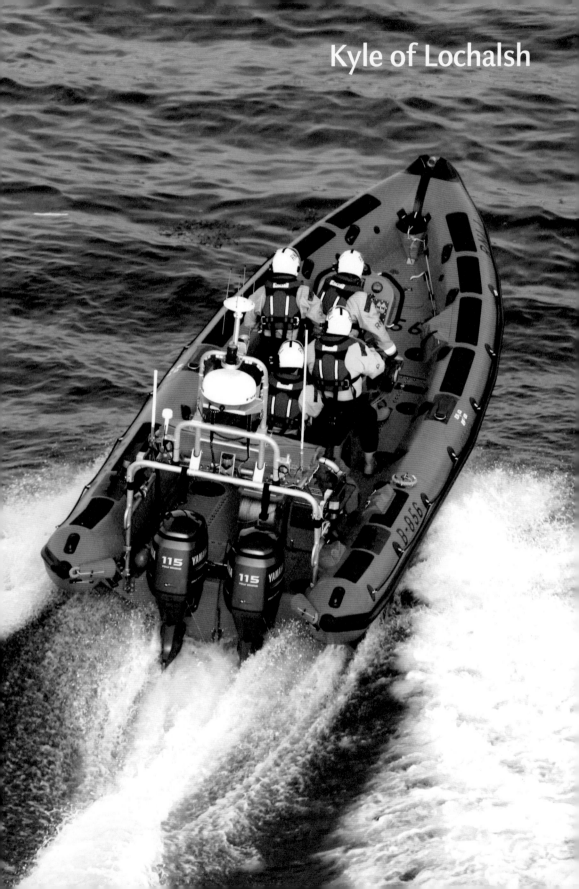

Portree (Skye)

Current lifeboats

ALB 14m Trent
ON.1214 (14-16) Stanley Watson Barker
Built 1996
Donor Bequest of the late Mr Stanley Watson
Barker, Dagenham, Essex; and legacies
of Mrs Eileen Arabian, West Didsbury,
Manchester, and Mr Jack Ronald Blaxland,
Lenham, Kent
On station 7.6.1996
Launch Afloat

above right The crew facility at Portree
Pier, close to the davit-launching boarding
boat, overlooking the small harbour.

right The inflatable boarding boat beneath
the davit on Portree pier.

opposite 14m Trent Stanley Watson
Barker (ON.1214) at moorings in the
picturesque harbour.

below 14m Trent Stanley Watson Barker
(ON.1214) leaving harbour on exercise.

1991 The station was established on
9 March with the 44ft Waveney *Connel
Elizabeth Cargill* (ON.1006) coming in
February for crew training; the lifeboat
was kept afloat at moorings in the

harbour with an inflatable boarding
boat davit launched from Portree Pier.
The 1976-built 44ft Waveney *Ralph
and Joy Swann* (ON.1042) was placed
on station on 2 May.

1994 A building on Portree Pier,
previously used by Moray Fish for fish
processing, was converted to provide a
workshop, crewroom, changing room
and shower and toilet facilities.

1996 The 14m Trent class lifeboat
Stanley Watson Barker (ON.1214)
was placed on service on 7 June.

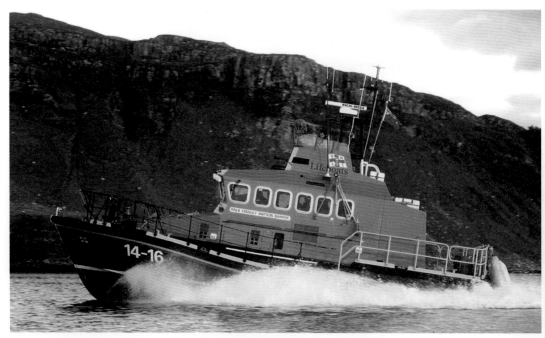

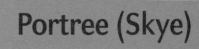

Barra Island

Key dates

Opened	1931
RNLI	1931
Motor lifeboat	1931
Fast lifeboat	1988

Current lifeboats

ALB 17m Severn
ON.1230 (12-31) Edna Windsor
Built 1997
Donor Bequest from Mrs Edna Windsor, a
 resident of Malaysia, together with other
 gifts and legacies
On station 13.6.1998
Launch Afloat

Station honours

Framed letter of thanks	1
Bronze medal	1
Silver medal	1

right The crew facility constructed in
1991 at Castlebay, the main settlement on
Barra Island, which is the most southerly
inhabited island in the Outer Hebrides.

below 17m Severn Edna Windsor
(ON.1230) heading out of Castlebay, with
the ferry linkspan in the background.

1931 A lifeboat station was established
at Barra Island and the first lifeboat,
the 45ft Watson motor *Hearts of Oak*
(ON.684), was kept afloat at moorings
in Castlebay, close to Kisimul Castle.
1932 The new 51ft Barnett *Lloyd's*
(ON.754) was placed on station in
August and served for twenty-five years.
1942 Crew member John McNeil
was taken ill and died of pneumonia
following the capsize of the boarding
boat on 22 January.
1979 The lifeboat *R. A. Colby Cubbin*

No.3 (ON.935) capsized on 18 November
while answering a distress call from the
Danish coaster *Lone Dania*.
1991 A new boatstore was constructed,
providing a workshop, assembly room,
kitchen, small store and toilet facilities.
1994 A new Schat launching davit for
the boarding boat was installed, and the
crew facilities were improved.
1998-9 A berth alongside Castlebay Pier
was constructed to improve boarding
arrangements in a joint venture with
Caledonian MacBrayne ferry company.

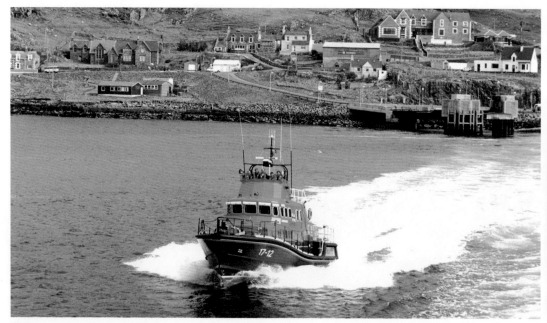

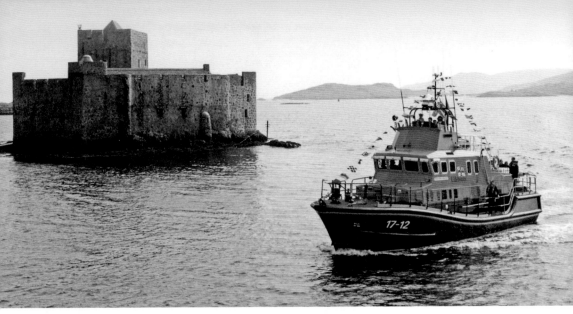

above 17m Severn Edna Windsor (ON.1230) passing Kisimul Castle at Castlebay after her naming ceremony on 24 April 1999.

left 17m Severn Edna Windsor (ON.1230) heading out to sea on exercise.

left 17m Severn Edna Windsor at moorings alongside the pier in the berth completed in October 1998.

below The crew facility at Castlebay, close to the mooring berth.

Leverburgh (Harris)

Key dates

Opened	2012
RNLI	2012
Motor lifeboat	2012

Current lifeboats

ALB 12m Mersey
ON.1195 (12-36) The Royal Thames
Built 1993 (ex-Eastbourne)
Donor Royal Thames Yacht Club, a local
 appeal and other gifts and legacies
On station 7.8.2012
Launch Afloat

right The shore facility installed at
Leverburgh pier in 2012.

below Relief 12m Mersey Lifetime Care
(ON.1148) arriving at Leverburgh on 2 May
2012 to open the station.

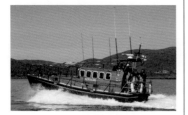

below 12m Mersey The Royal Thames
(ON.1195) and the boarding boat. (RNLI)

2012 A lifeboat station was established to cover the Sound of Harris. The local community petitioned the RNLI following the growth of offshore fish farming, vessels working on renewable energy projects and leisure boating in the area. On 2 May the relief 12m Mersey *Lifetime Care* (ON.1148) arrived at Leverburgh to be welcomed by hundreds of local people at Leverburgh Pier. This marked the culmination of an intense period of training for the station's volunteers and Leverburgh becomes the 46th RNLI lifeboat station in Scotland. Temporary crew facilities were completed close to the ferry slipway, and the station became operational on 11 May 2012.

2013 The station's operational status was confirmed on 3 May after the completion of the evaluation trial; within the first year of operation as a trial station the station answered seventeen calls for help.

Stornoway (Lewis)

Key dates

Opened	1887
RNLI	1887
Motor lifeboat	1929
Fast lifeboat	1984

Current lifeboats

ALB 17m Severn
ON.1238 (17-18) Tom Sanderson
Built 1998
Donor Bequests of Tom Sanderson,
Milnthorpe, Cumbria, who died in
November 1996; Miss Ayleen Barbour, Mrs
Olive Dickinson, William George Murdoch
and Miss Janetta Inglis Thomson, together
with a gift from Mrs Katherine Regan
On station 1.2.1999
Launch Afloat

Station honours

Framed Letter of Thanks	1
Thanks Inscribed on Vellum	2
Bronze medal	4
Silver medal	2

1887 A lifeboat station was established and a lifeboat house was constructed; a cement concrete slipway 140ft long was built to facilitate launching, which was undertaken by carriage. Four standard self-righting lifeboats were operated from this house, but, being reliant on oars and sail had a limited range, and thus carried out only a handful of services. The house and slip were used until 1929; the slipway has been demolished, but the house, situated on Newton Street, was used as a car repair garage until the area was redeveloped and was then demolished.

1900 Horse launching poles were supplied to make launching easier.

1929 Moorings in the harbour were

left The lifeboat house built in 1887 and used until 1929. This photograph was taken in August 2002, and the house has since been demolished.

below 17m Severn Tom Sanderson (ON.1238) at her moorings along Cromwell Street Quay, close to the crew facility.

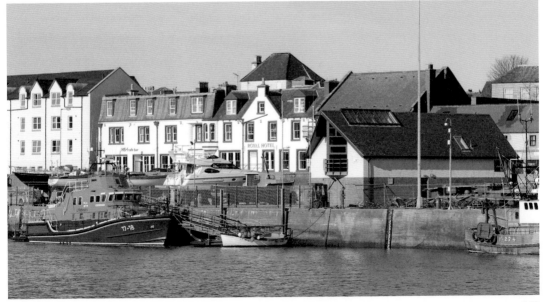

Stornoway (Lewis)

above left The building used as a crew facility until 1987.

above right The crew facility built on Cromwell Street Quay in 2002-3.

opposite 17m Severn Tom Sanderson (ON.1238) on exercise off Lewis.

below 17m Severn Tom Sanderson (ON.1238) returning to harbour

below right 17m Severn Tom Sanderson (ON.1238) in the mooring berth along Cromwell Street Quay.

taken up for the station's first motor lifeboat, the 52ft Barnett *William and Harriot* (ON.718), to the west of the ferry terminal; the lifeboat was moored in this area until 1995. A building on Cromwell Street Quay was used as a crew facility, and a small boarding boat was used to reach the lifeboat. The first radio-telephone in the RNLI' fleet was fitted to *William and Harriot*.

1955 The 52ft Barnett lifeboat *James and Margaret Boyd* (ON.913) was named by Princess Marina, Duchess of Kent, President of the Institution, on her first visit to the Hebrides.

1985 Minor adaptation and renovations were carried out to the building purchased to provide shore facilities.

1987 A new crew facility, known as Sir Max Aitken House, was constructed at Cromwell Street Quay, opposite Lewis Castle. It was officially opened on 26 August, having been funded by Sir Max Aitken. A Centenary Vellum was awarded to station in the same year.

1995 A new mooring berth was built at Cromwell Street Quay, with a mooring pontoon, access bridge, floodlights on quayside and security fencing.

2002-3 A new crew facility was constructed at Cromwell Street Quay adjacent to the mooring pontoon to provide improved facilities.

2012 The 125th anniversary of the station's founding was marked in August; in that time, the station's lifeboat has been launched 890 times and rescued 823 people.

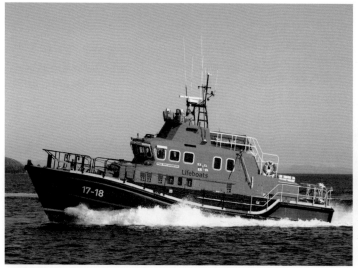

Lochinver

Current lifeboats

ALB 17m Severn
ON.1271 (17-40) Julian and Margaret Leonard
Built 2003
Donor Legacy of Mr Julian Maynard & Mrs
 Margaret Leonard, Saffron Walden and
 later of Brighton
On station 25.11.2003
Launch Afloat

right The crew facility built in 1994 close to the fish dock.

above The unusual sight of two relief 17m Severn lifeboats at Lochinver alongside the pontoon installed in 2004. On the outside is Margaret Joan and Fred Nye (ON.1279) with Beth Sell (ON.1262) on the inside.

below Margaret Joan and Fred Nye with Beth Sell moored together. In the background is Suilven, one of the most distinctive mountains in Scotland.

1966-7 During the winter of 1966-67 the 70ft Clyde cruising lifeboat *Grace Paterson Ritchie* (ON.988) was based at Ullapool on trials to ascertain the need for a station in the area; following a review of requirements, it was decided that a lifeboat at Lochinver would be best located to cover the sea between Cape Wrath to the north and Rubha Reidh in the south.

1967 The lifeboat, the reserve 46ft Watson motor *Dunleary II* (ON.814), was kept afloat at moorings in the harbour, and the station was declared officially operational on 18 August.

1969 A mechanic's workshop and store were built in the harbour.

1991 The Highland Regional Council undertook a large redevelopment of the harbour and this comprised the construction of a finger jetty and fish market building, as well as a new berth for the station's lifeboat, the 52ft Arun *Murray Lornie* (ON.1144).

1994 A new single-storey shore facility was constructed adjacent to the lifeboat berth, providing a crew room, changing room, workshop, store, toilet and shower. It was funded from the legacy of Mrs Eugenie Boucher, one of eight 'Penza' boathouses so funded.

2004 A new pontoon berth was installed at a cost of £291,798 to improve boarding arrangements for the new 17m Severn *Julian and Margaret Leonard* (ON.1271).

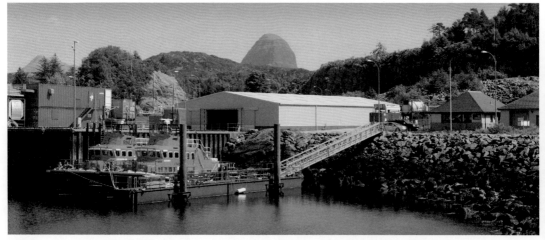

Lochinver

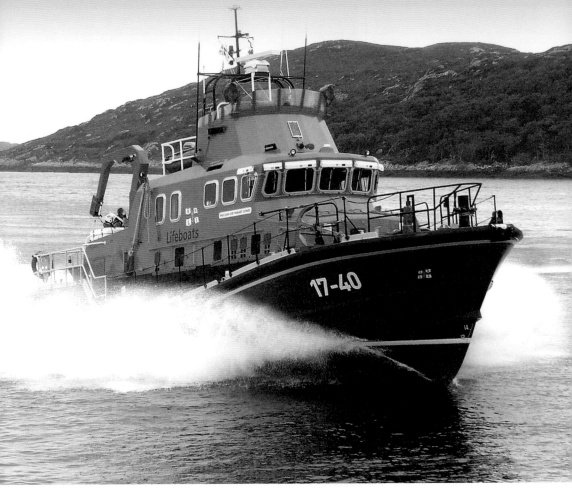

above 17m Severn Julian and Margaret Leonard (ON.1271) heads down Loch Inver towards her station. (Courtesy of RNLI)

left Covered in snow, 17m Severn Julian and Margaret Leonard lies at her berth. (By courtesy of Lochinver RNLI)

below The naming ceremony of 17m Severn Julian and Margaret Leonard took place on 17 April 2004. (Cliff Crone)

Thurso

Key dates

Opened	1860
RNLI	1860
Motor lifeboat	1929
Fast lifeboat	1988

Current lifeboats

ALB 17m Severn
ON.1273 (17-42) The Taylors
Built 2003
Donor Bequest of Mrs Vera Rita Elizabeth
Taylor, Aberdeen, together with the legacy
of Miss Agnes Anita Cluness
On station 7.4.2004
Launch Afloat

Station honours

Framed Letter of Thanks	2
Thanks Inscribed on Vellum	5
Bronze medal	3
Silver medal	7

right 17m Severn The Taylors (ON.1273)
at moorings alongside the Ice Plant Quay.

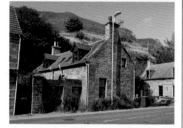

above The first lifeboat house, built in
1860, is now a private residence.

below The crew facility built on the Ice
Plant Quay in 2002, close to the berth.

1860 The lifeboat station was
established in Scrabster, on the western
side of Thurso Bay, where a lifeboat
house with a launchway was built; this
house was used until 1906, when it was
sold; it is still standing, much altered
and used as a private residence.

1876 The launchway into the harbour
was altered and extended.

1906 A new lifeboat house and roller
slipway was built, at the end of the
Harbour Quay just outside Scrabster
Harbour; this house was completed in
1909, and a new winch was installed in
1910; it was used until 1956 when, on 10
December, it was completely destroyed
by fire together with the lifeboat,

Dunnet Head (Civil Service No.31)
(ON.920), that was inside.

1957 A new lifeboat house and slipway
was built on the same site as the house
destroyed by fire; this house was used
for the lifeboat until 1988, then became
a crew facility, until being demolished.

1970 The lifeboat house was adapted
for the 48ft 6in Solent class lifeboat
The Three Sisters (ON.1014).

1981 Extensive repairs were made to
the slipway due to movement of the
concrete toe and general deterioration.

1984 Major slipway repairs were
undertaken to remedy serious defects.

1988 The 54ft Arun *City of Bradford
IV* (ON.1052) was placed on moorings
in the outer harbour at Scrabster
following the building of a new
berthing pier for the Orkney ferry, and
temporary crew facilities were provided
in portacabins on the quayside.

1989 The lifeboat house was adapted
to house an emergency relief 47ft Tyne
class lifeboat; a crew room and foul
weather clothing drying cupboard was
also built into the boathouse.

2001 The boathouse and slipway were
demolished to make way for an access
road as part of a new ferry terminal.

2002 A new crew room and workshop
were built on the Ice Plant Quay, with a
pontoon berth alongside this Quay.

this page 17m Severn The Taylors (ON.1273) on exercise off the island of Stroma in the Pentland Firth, passing the island's lighthouse which marks the dangerous Swilkie whirlpool.

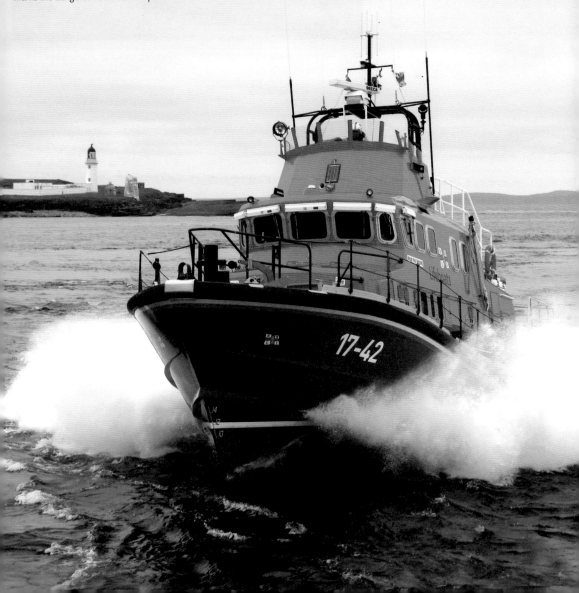

Huna

Key dates

Opened	1877
RNLI	1877
Closed	1930

above and right The lifeboat house built in 1889 from which the lifeboat was originally launched by carriage.

right The slipway built in 1890 to improve launching arrangements. To recover the lifeboat, it would either be floated onto the trolley and hauled back up the slipway using the winch, or beached at the east side of the boathouse (to right in photograph) and turned through 180 degrees to be placed on the trolley. The floor of the boathouse was constructed on two levels to make this operation easier.

below The lifeboat house built in 1889 facing the long slipway.

1877 A lifeboat station was established at Huna as the RNLI believed another lifeboat was needed on the southern shores of the Pentland Firth. Huna, to cover the eastern end of the Firth, was deemed the most suitable place. A lifeboat house was built by J. Charleson at a cost of £252 and the new station

was inaugurated on 6 December 1877.
1890 The lifeboat house was enlarged to accommodate a new lifeboat, the 37ft self-righter *Caroline and Thomas* (ON.202); to improve launching, which was difficult particularly at low tide, a slipway was constructed by Sinclair & Banks for £724; special rollers were later added for £100, and a winch was also placed on a concrete base in a field at the rear of the boathouse to haul the lifeboat up the slipway.
1930 The RNLI decided to close station as the motor lifeboats at Wick, Thurso and Longhope could cover the area.

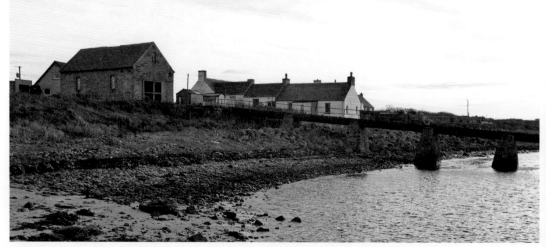

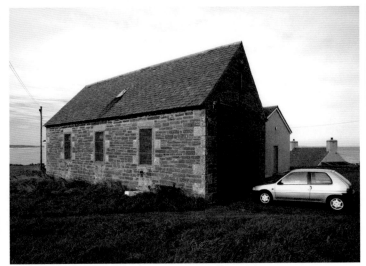

Key dates

Opened	1878
RNLI	1878
Motor lifeboat	1932

left The lifeboat house built in 1878 and moved to this location in 1886. It was originally close to Ackergill Tower on a site given by C. Duff Dunbar, of Hempriggs. Ackergill is a small and remote village, and manning the lifeboat was not always easy. In the early 1900s problems were experienced obtaining a full crew, so men from Wick were enrolled to fill the vacancies and they had to be taken by road to Ackergill when a call was received.

1876 The wreck of the schooner *Emilie* two miles from Ackergill on 23 December, when five of her six crew and four of nine men who went out to help in a salmon coble lost their lives, resulted in a request for the RNLI to establish a lifeboat station.

1877 The RNLI decided in June to form a lifeboat station at Ackergill.

1878 The station was established and a lifeboat house, designed by Wick architect Mr Brims, was built at a cost of £320; the station was formally inaugurated on 14 March 1878. The lifeboat was launched by carriage and could be taken to any suitable location around the bay.

1886 The lifeboat house was moved two miles further south, and rebuilt on a site overlooking the small harbour at a cost of £200.

1911 An unusual concrete slipway was constructed at a cost of £1,610 to make it easier to launch the 37ft self-righter *Co-Operator No.3* (ON.582), which had been sent to the station in 1907 and was larger than previous lifeboats.

1932 In April the RNLI decided to close the station as the lifeboat had answered few calls since 1907.

below and below left The ferro-concrete lifeboat slipway completed in 1910, and formally inaugurated on 29 April 1910. This was the first concrete slipway built in Britain, and it remains standing, largely in its original condition, close to the lifeboat house, overlooking the small harbour. The lifeboat sat at the top of the slipway in the open, covered by a tarpaulin.

Kirkwall

Current lifeboats

ALB 17m Severn
ON.1231 (17-13) Margaret Foster
Built 1997
Donor Legacy of Miss Margaret Ellen Foster, Emsworth, Hampshire
On station 26.3.1998
Launch Afloat

Station honours

Framed Letters of Thanks	2
Thanks Inscribed on Vellum	1
Bronze medals	3
Doctors Vellum	1

right 17m Severn Margaret Foster (ON.1231) berthed alongside the West Pier adjacent to the crew facility.

opposite 17m Severn Margaret Foster (ON.1231) on exercise in Shapinsay Sound.

below 17m Severn Margaret Foster (ON.1231) berthed alongside the West Pier in the Old harbour.

1968 In July the 70ft Clyde class cruising lifeboat *Grace Paterson Richie* (ON.988), which had been carrying out evaluation trials under operational conditions off the north east coast of Scotland, was based at Kirkwall during the winter of 1968-9 for trials having previously operated from Ullapool; following the Longhope lifeboat disaster in March 1969, she maintained coverage of the Pentland Firth area and operated from Kirkwall. For a trial period up to 31 March 1972, she was operated in Orkney North Isles from Mondays to Fridays and berthed in Kirkwall Harbour at weekends.

1972 The Kirkwall Lifeboat Station was officially established on 30 May, and the lifeboat *Grace Paterson Richie* (ON.988) was permanently based at Kirkwall, moored in the harbour.

1988 The 52ft Arun lifeboat *Mickie Salvesen* (ON.1135) was placed on station to replace the Clyde lifeboat.

1989 A new mooring berth, inside the knuckle in the harbour, was dredged.

1990 A new shore facility building was constructed on the West Pier, adjacent to new berth; it includes a general purpose room, workshop, changing room and toilet/shower facilities.

2003-4 A new pontoon berth to improve boarding arrangements, adjacent to the crew facility, was completed in January 2004 at a cost of £138,537.

Stromness

Current lifeboats

ALB 17m Severn
ON.1236 (17-16) Violet, Dorothy and Kathleen
Built 1998
Donor Bequest of Miss Violet Jane Matton,
 Seaford, East Sussex, and her sisters,
 Dorothy and Kathleen
On station 22.10.1998
Launch Afloat

Station honours

Framed Letter of Thanks	1
Thanks Inscribed on Vellum	1
Bronze medals	2
Silver medals	2

right The lifeboat house built at the Ness in 1868 and used until the early twentieth century. This photograph shows the house in 2006 in a semi-derelict state, having been used as a store for the golf club.

opposite 17m Severn Violet, Dorothy and Kathleen (ON.1236) on exercise off the west side of Hoy, heading to Stromness.

opposite inset 17m Severn Violet, Dorothy and Kathleen (ON.1236) returning to station after exercise.

right The lifeboat house and slipway built in 1926 on the waterfront at Stromness housed the lifeboat until 1984 and was used by the RNLI until the early 1990s.

below The lifeboat house and slipway remain in more or less original condition externally, but inside the house has been converted into a shop called Scapa Scuba which displays the original service boards.

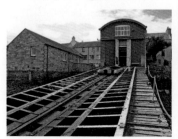

1866 A tragic wreck in January when the emigrant ship *Albion*, with 100 passengers and crew on board, became a total wreck at the Point of Oxan on the island of Graemsay, highlighted the need for a lifeboat at Stromness.

1867 The RNLI established a lifeboat station, and a lifeboat house and slipway were constructed at the Ness, to the south of the town, with a launchway onto the beach; this house was used until 1890 and is still standing. The station covered the north and west of Orkney and become the most northerly of the RNLI's lifeboat stations.

1890 Following problems in launching the lifeboat from her carriage out of the boathouse at the Ness, the lifeboat was moored in the harbour.

1901-2 There were problems in keeping the lifeboat afloat, so a site was purchased in the harbour and an existing building was converted into a lifeboat house, with a new timber slipway added to enable an efficient launch; this house was used until 1925.

1926 A new lifeboat house and slipway were built on the site of the 1901-2 boat house; built by Melville, Dundas & Whitsun, of Glasgow, it backed onto

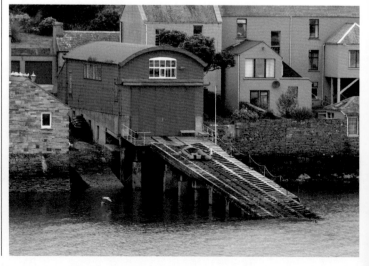

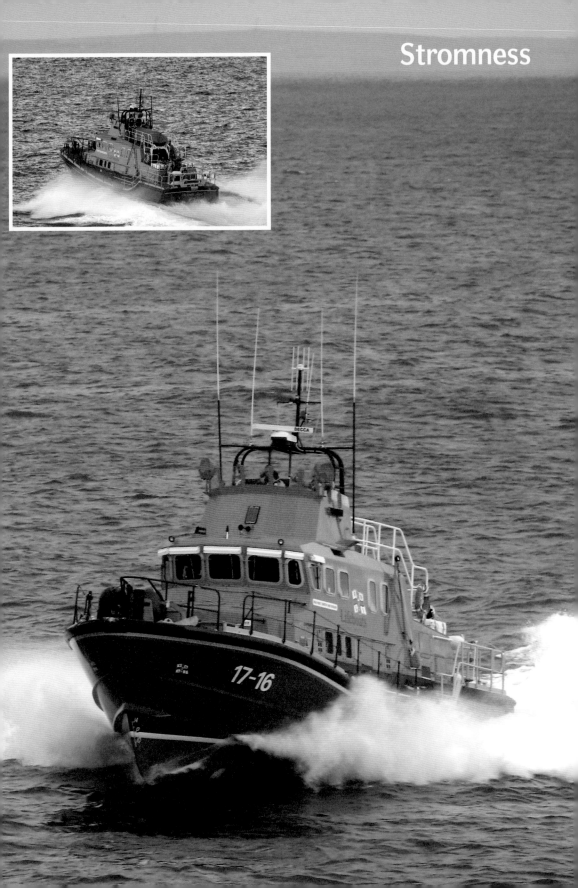

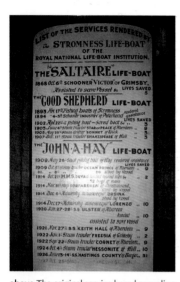

above The original service board recording services performed by the pulling and sailing lifeboats of Stromness. The board is on display in the old lifeboat house, which is now owned by Scapa Scuba.

above right Violet, Dorothy and Kathleen (ON.1236) at moorings alongside the South Pier at Stromness.

below The workshop and changing room at the south end of the harbour close to the South Pier. The facility was converted from a former harbour building in 1999.

below right The old Harbour Board Office building, near the ferry terminal, was converted in 2001 into a training room and store for the lifeboat crew and officials.

Dundas Street and was used for the lifeboat until 1984; it then became a training room and base for the lifeboat guild to sell souvenirs. In December 2001 the house was sold and converted internally into a dive shop and school.

1967 Centenary Vellum awarded.

1984 The 52ft Arun lifeboat *Joseph Rothwell Sykes and Hilda M* (ON.1099) was placed on station, and was operated from moorings off the harbour, near Inner Holm Island, with the 1926 boathouse being used as a crew room.

1988-9 Internal alterations to the boathouse were made; this included the provision of a crewroom, galley and a souvenir sales outlet. The timber walkway was repaired, as was the timber fendering on the slipway in

order to provide protection to the boarding boat. The boathouse was sold by the RNLI in about 2002 and became a diving shop which has the original service boards displayed inside.

1995 An alongside berth on the South Pier, south of the Scrabster Ferry terminal, approved by the local council was provided and became operational in May; a portacabin was placed on the pier for use as a temporary crew room.

1999 A new workshop and crew facility was constructed to provide a permanent base in the harbour on the same site as the portacabin, close to the alongside mooring berth.

2001 The old Harbour Office, near the ferry terminal, was converted into a training room and store.

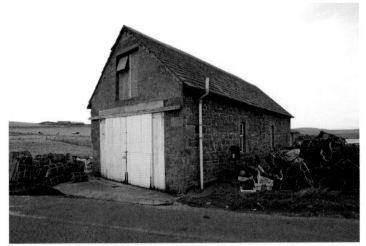

Key dates

Opened	1874
RNLI	1874
Motor lifeboat	1926
Fast lifeboat	1988

Current lifeboats

ALB 16m Tamar
ON.1284 (16-05) Helen Comrie
Built 2006
Donor Bequests of Thomas Leslie M. Comrie
and Dr Ben Porges, other gifts and legacies
On station 26.10.2006
Launch Afloat

Station honours

Framed Letter of Thanks	2
Thanks Inscribed on Vellum	3
Bronze medals	3
Silver medals	13

1874 The need for a lifeboat on Hoy to guard the Pentland Firth was brought to the attention of the RNLI when local residents wrote asking for a lifeboat. On 5 February the Inspector of Lifeboats, Captain John Ward, visited the island to discuss the matter and the RNLI agreed to form a lifeboat station at Longhope at the southern end of the island. The first lifeboat house was built on a neck of land connecting North and South Walls, known as The Ayre, on the remote island of Hoy.
1906 A new lifeboat house and roller slipway was constructed on Brims, the inlet to the south of the first house, facing Aith Hope on the southern coast of Hoy; the house incorporated a landing gangway on the lee side of the slip for the use of the fishermen.
1962 Major alterations were made to the boathouse to accommodate a lifeboat with a wheelhouse.
1969 On 17 March the lifeboat *T G B* (ON.962) capsized on service to the Liberian vessel *Irene* and her entire crew of eight were lost. They left seven widows, one widowed mother and eight children, all of whom were pensioned by the Institution. The crew

left The lifeboat house of 1874 was built for a carriage-launched self-righting lifeboat; it was used for the lifeboat until 1906. It remains standing, being used during the 1990s by local fishermen as a packing station, and located at the side of the road from Lyness to Longhope.

below The lifeboat house and roller slipway built in 1906 on the Brims side of Aith Hope. It was used until September 1999 and has since become home to the Longhope Lifeboat Trust.

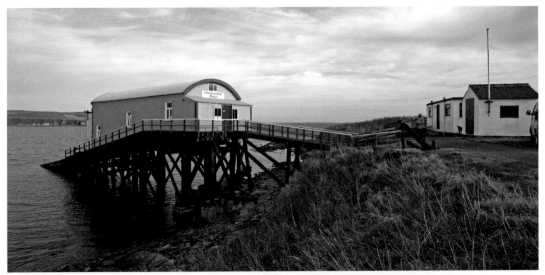

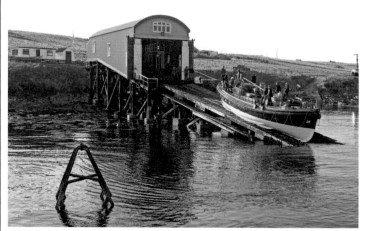

above The impressive memorial to the eight Longhope lifeboatmen who lost their lives when the lifeboat T.G.B. capsized on service in March 1969.

right The preserved lifeboat Thomas McCunn (ON.759) being recovered up the slipway into the lifeboat house of 1906. The house was in operational service until September 1999.

opposite 16m Tamar Helen Comrie (ON.1284) on exercise off Hoy.

opposite inset 16m Tamar Helen Comrie (ON.1284) moored in the specially built pontoon berth at Longhope pier.

right and below The crew facility constructed at Longhope pier near the harbour in 2001.

were Coxswain Daniel Kirkpatrick, Second Coxswain James Johnston (son of Mechanic), Bowman Daniel R. Kirkpatrick (son of Coxswain), Mechanic Robert R. Johnston, Assistant Mechanic James Swanson, and crew members Robert Johnston (son of Mechanic), John T. Kirkpatrick (son of Coxswain) and Eric McFadyen.

1972 Major works was carried out on the boathouse and slipway.

1974 Centenary Vellum awarded.

1989 The lifeboat house was adapted for a Tyne class lifeboat; a new fuel storage tank was installed, the slipway bilgeways were extended, and the bottom sections of the slipway keelway channel were replaced.

1991 A new crewroom and toilet facility was constructed in the roof space of the boathouse.

1999 Moorings were taken up permanently at Longhope Pier for the all-weather lifeboat; relief lifeboats had been kept at moorings in 1997 and 1998. The last launch from the 1906 boathouse took place on 11 September.

2001 A new crew facility and workshop were constructed at Longhope pier near the harbour and lifeboat moorings.

2003 A breakwater and pontoon berth were completed in April for £450,000.

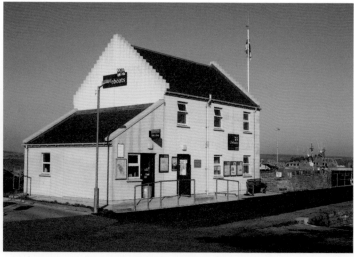

Longhope

Stronsay

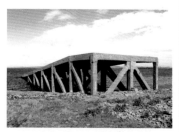

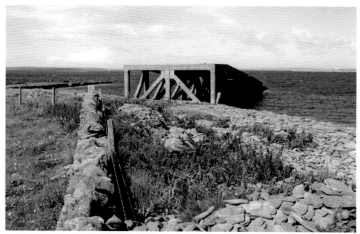

above All that remains of the lifeboat house and slipway built in 1911 is the concrete substructure. The house was dismantled in the 1940s but the substructure remains intact, and lies to the east of the island's main village, Whitehall. The rollers from the slipway were purchased by farmers for land rolling.

right The lifeboat house and slipway built in 1911 housed the lifeboat only until 1915, when John Ryburn (ON.565) was withdrawn and the station was closed.

below The reserve 45ft 6in Watson motor lifeboat Edward Z. Dresden (ON.707) at moorings in Whitehall. She served at Stronsay from 1952 to February 1955 and launched eleven times on service. (Orkney Photographic Archives)

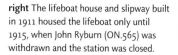

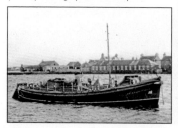

1904 The RNLI decided to place a lifeboat on he small island of Stronsay because of the growth of the fishing industry and to provide cover for the northern part of the Orkney archipelago. The island's main village, Whitehall, was one of Scotland's major herring ports in the nineteenth century.

1909 The first lifeboat sent to the station was one of the first motor lifeboats, *John Ryburn* (ON.565), and she was moored in Papa Sound between Stronsay and Papa Stronsay.

1911 A lifeboat house and roller slipway were built at the fishing station, to the east of Whitehall village.

1912 A house was built for the full-time mechanic, and was given the name 'Ryburn'; sold by the RNLI in 1937, it is still used as a private residence and is maintained in good condition.

1915 The station was closed, initially on a temporary basis, because of insufficient crew due to conscription; the house was used as a store until being dismantled in the 1940s.

1952 The station was reopened with a temporary lifeboat, *Edward Z. Dresden* (ON.707), was kept at moorings between the two piers in Stronsay Harbour, at Whitehall, and the gear was stored in premises on the West Pier.

1955 A new 52ft Barnett lifeboat, John Gellatly Hyndman (ON.923), was sent to the station in February.

1972 The lifeboat was withdrawn, as the area was covered by the newly-established station at Kirkwall. The station's service boards are on display in the local community centre.

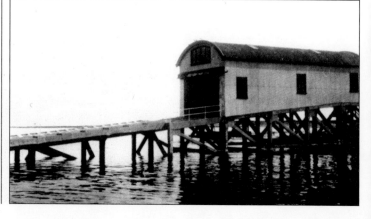

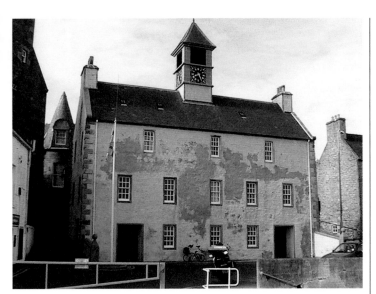

Key dates

Opened	1930
RNLI	1930
Motor lifeboat	1930
Fast lifeboat	1978

Current lifeboats

ALB 17m Severn
ON.1221 (17-10) Michael and Jane Vernon
Built 1997
Donor The Lerwick Lifeboat Appeal; bequests
 from Miss Eleanor Rennie, Glasgow, and
 Ronal Fee, Cirencester; a gift from J. Young,
 and various other legacies and donations
On station 2.6.1997
Launch Afloat

Station honours

Framed letter of thanks	4
Thanks inscribed on Vellum	5
Bronze medals	12
Silver medals	4
Gold medal	1

1859 At an RNLI committee of management meeting on 1 December, an application for a lifeboat from several boatmen and pilots at Lerwick was considered, but the matter was postponed and never revisited.
1878 A lifeboat for Shetland was stationed at Fair Isle; it was supplied by the Board of Trade, and maintained by the islanders. The islanders had already undertaken much outstanding rescue work, having saved 465 passengers and crew from the German ship *Lessing* in 1868; in 1876, four ships were wrecked on Fair Isle, one of which was lost with all hands.
1911 The first lifeboat was replaced by a new boat.

left The Old Tolbooth, which was renovated and restored in 2004, is used as the crew facility.

below 17m Severn Michael and Jane Vernon (ON.1221) moored in the harbour.

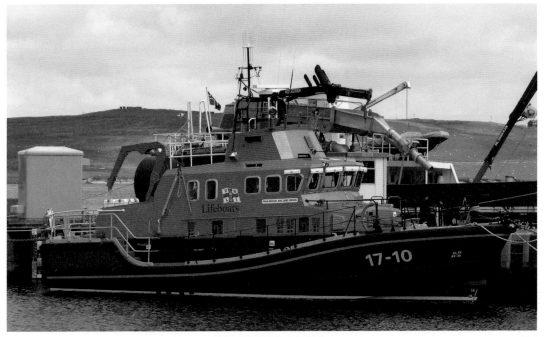

Lerwick

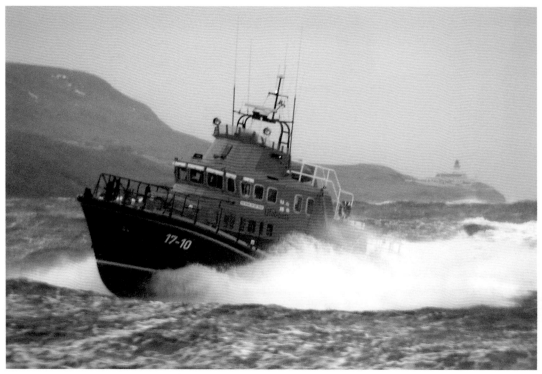

above Michael and Jane Vernon (ON.1221) in rough seas in Bressay Sound. (RNLI)

opposite 17m Severn Michael and Jane Vernon has been on station at Lerwick since June 1997. (RNLI)

below Michael and Jane Vernon at her moorings in the Small Boat Harbour.

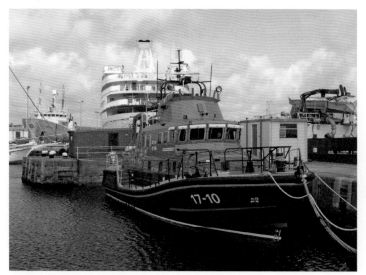

1924 A motor lifeboat was sent to Fair Isle, which served until after the Second World War by when RNLI lifeboats on the mainland could cover the area.

1930 A decision was made in 1929 to establish a new station in Shetland, made possible because a system of coast communication had recently been organised in the islands by the Board of Trade. The first lifeboat, the 51ft Barnett *Lady Jane and Martha Ryland* (ON.731), was kept afloat at moorings in the middle of the harbour, although she was brought inside harbour during winters; a crew room on the quayside used to house the gear. The lifeboat moorings were subsequently brought alongside the old breakwater.

2004 The Old Tolbooth on Commercial Street was renovated and restored at a cost of £784,617 to provide a crew facility close to the lifeboat moorings at the old harbour. The Shetland Island Amenity Trust acquired the building and granted a long lease to the RNLI. The building was refitted to provide changing and washing facilities, drying and storage facilities, a workshop for routine maintenance, a crew/training room suitable for regular exercise and instruction sessions on navigation, communications and first aid.

Lerwick

Aith

Current lifeboats

ALB 17m Severn
ON.1232 (17-14) Charles Lidbury
Built 1998
Donor Bequest of Miss Mary Lidbury, Dulverton, Somerset, together with other gifts and considerable support from local community
On station 2.5.1998
Launch Afloat

Station honours

Framed Letter of Thanks	1
Thanks Inscribed on Vellum	8
Silver medal	1

right The crew facility built in 2002-3 adjacent to the berthing pier.

opposite 17m Severn Charles Lidbury (ON.1232) heading out of Aith Voe at speed on exercise.

right 17m Severn Charles Lidbury (ON.1232) moored at the purpose-built berthing pier at Aith. The former Aberdeen lifeboat Ramsey-Dyce (ON.944), a 52ft Barnett built in 1958 and in private ownership, is also moored at the pier.

below The plaque commemorating the formal opening of Aith Lifeboat Pier on 25 July 1986.

1930 Following the tragic loss of the trawler *Ben Doran* in March, with her crew of seven also being lost, on the treacherous rocks of the Vee Skerries, the RNLI recognised the need for lifeboats to cover the seas round Shetland, and established stations at Lerwick and then Aith.

1933 The station at Aith was opened to cover the west side of Shetland and became the RNLI's most northerly lifeboat station; the first lifeboat, the 45ft 6in Watson motor *K.T.J.S.* (ON.698), was placed at moorings in Aith Voe.

1934 The station became permanent, after a twelve-month evaluation period, and a house, given the name 'Ranksville', was built for the station's full-time mechanic.

1935 The 51ft Barnett *The Rankin* (ON.776) was sent to the station in May to become the first lifeboat to be purpose-built for the station; she served until January 1961.

1985-6 A new berthing pier was constructed, at the head of which the lifeboat is moored, with the crew facilities at the landward end.

2002-3 A new larger shore building with training facilities and greatly improved crew accommodation was completed in May at a cost of £321,701.

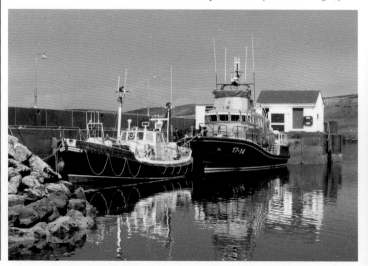

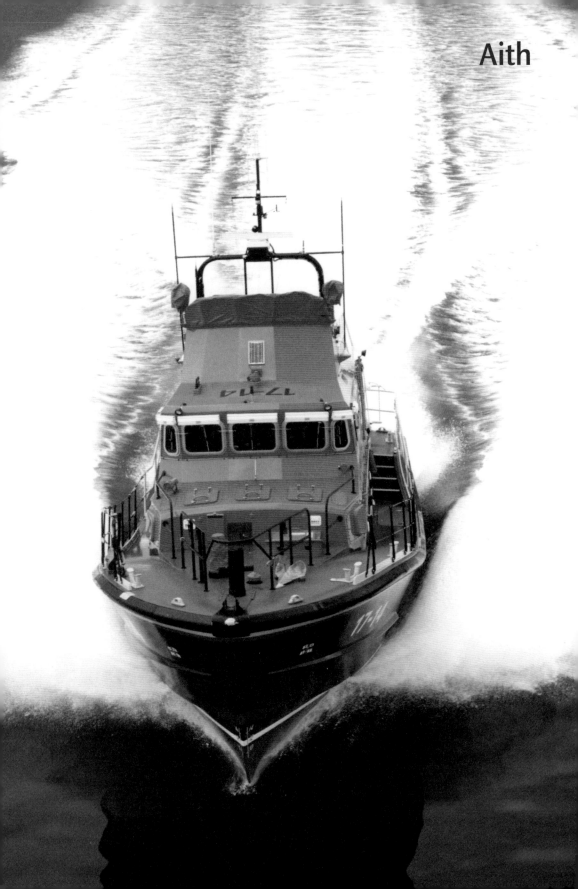

Aith

Wick

Current lifeboats

ALB 14m Trent
ON.1224 (14-20) Roy Barker II
Built 1997
Donor Bequest of Frederick Roy Barker,
St Lawrence, Jersey, Channel Islands
On station 13.2.1997
Launch Afloat

Station honours

Thanks Inscribed on Vellum	3
Bronze medal	2
Silver medal	6

right The lifeboat house and slipway built in 1916 at the Salmon Rock. It was used for the station's lifeboats from 1921 until 1995, and has been acquired by the Wick Society, a heritage organisation.

opposite 14m Trent Roy Barker II (ON.1224) on exercise off the harbour.

below 14m Trent Roy Barker II (ON.1224) leaving the harbour on exercise.

1848 A lifeboat station at Wick was established by the British Fishery Society, which was founded in 1786 and had been involved in building much of Wick harbour in 1808. The first lifeboat was 28ft non-self-righter, built by Edward Oliver, of South Shields. The Society provided three lifeboats between 1848 and 1895, placing them in the care of the Wick and Pulteneytown Harbour Trust, and they were at first kept in the open at Salmon Rock, on the south side of Wick.

1872 A lifeboat house was built close to the service bridge; it had doors at both ends and the lifeboat could be taken out through the rear doors and along the streets for a launch into the Outer Harbour, or could be launched from her carriage into the river; during the summer, because of the large number of fishing boats in the harbour, the lifeboat was kept on the Salmon Rock and launched from there.

1895 The RNLI took over the station and used the 1872 boathouse, keeping it operational until 1913; it was demolished in 1987.

1905 While attempting to assist a coble on 11 April, the lifeboat *John Avins* (ON.385) was thrown on to the rocks and wrecked; the crew were all rescued and no lives were lost.

1913 The station was temporarily closed while a new lifeboat house and slipway were built and until the new motor lifeboat was completed.

1916 A new lifeboat house with slipway, situated at the Salmon Rock, were completed at a cost of £4,000.

1921 Due to delays caused by World War II, the motor lifeboat, the 45ft Watson motor *Frederick and Emma* (ON.659), did not arrive until June, when the station was reopened.

1938 The lifeboat house was adapted for the new 46ft Watson motor lifeboat

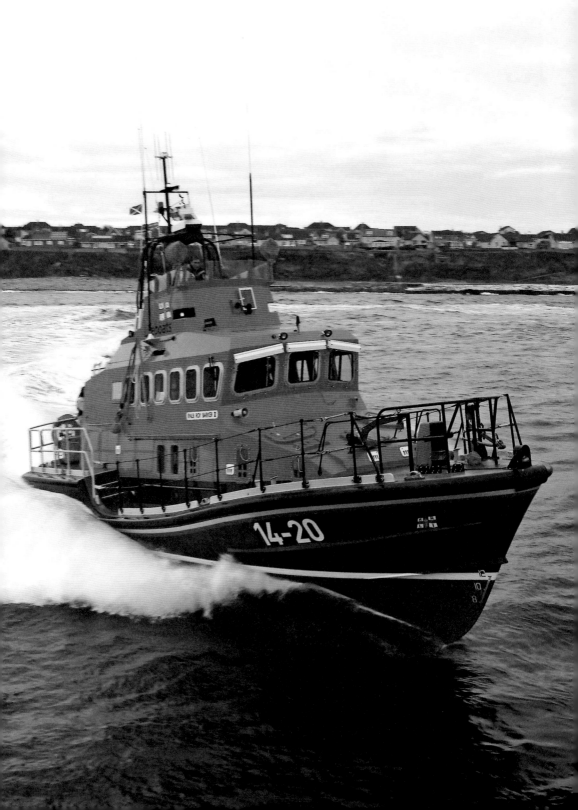

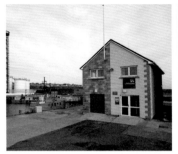

above and right The crew facility built in 1997 between the inner and outer harbours, with the lifeboat moored nearby.

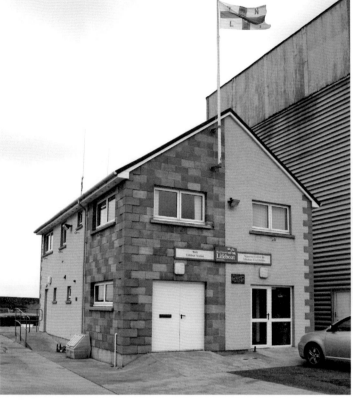

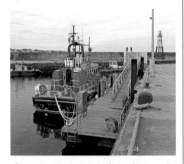

above 14m Trent Roy Barker II (ON.1224) moored alongside the boarding pontoon.

below 14m Trent Roy Barker II (ON.1224) at moorings close to the crew facility.

City of Edinburgh (ON.802), which arrived in October and served the station for thirty years.

1969 The lifeboat house was modified for the 48ft 6in Oakley class lifeboat Princess Marina (ON.1016), which was on station from 1970 to 1988.

1988 The lifeboat house was adapted to accommodate the 47ft Tyne class lifeboat Norman Salvesen (ON.1121); the boarding arrangements were modified and a new 1,000 gallon fuel storage tank was installed.

1989 Improved crew and toilet facilities were constructed in the boathouse.

1994 The lifeboat was placed on moorings in the inner harbour after problems with undermining of the slipway were experienced; a berth alongside Fishmarket Pier was found and temporary shore facilities were provided adjacent to the berth.

1997 New shore facilities were constructed adjacent to the ice plant on the jetty between the inner and outer harbours, close to the berth.

1998 A commemorative 150th anniversary vellum was awarded.

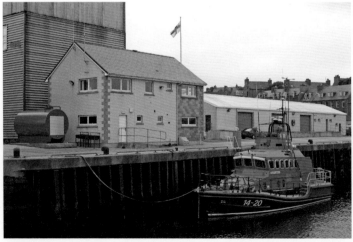

Helmsdale

left The slipway, running down to the small harbour at Helmsdale is a new one, constructed about 1970 on top of the old one; at very low tides traces of the old slipway can be seen.

below The only lifeboat to serve the station, the 28ft by 7ft self-righter Cobhar nan Mharich, had no sailing gear and was only used within the precincts of the harbour. This photo shows her in the harbour for her naming on 4 October 1909.

1906 In December, on the bar of the Helmsdale River, a boat was swamped when returning from fishing, resulted in two fishermen losing their lives.
1909 Soon after, a public meeting was held and it was agreed to provide a lifeboat. A 28ft self-righting lifeboat was ordered from Thames Ironworks. She was duly delivered and launched, being christened *Cobhar Nan Mharich* ('the mariner's help') by the Duchess of Sutherland on 4 October 1909. She was kept afloat from October to May, and in a boathouse during the rest of the year. The fishermen made up the crew.
1939 The station was closed and the lifeboat was laid up; an auxiliary rescue-boat station was set up for the War.

Dornoch Firth & Embo

1886 A lifeboat station was established to cover the Dornoch Firth area, and was based at Embo, where a lifeboat house was built at a cost of £638 6s 1d. The lifeboat, the 34ft self-righter *Daisie* (ON.89), arrived in September before the lifeboat house had been completed; the boat was launched by carriage.

1904 The RNLI decided, following the recommendations in a report from the Chief inspector of Lifeboats, to close the station and the lifeboat was withdrawn; she had been sent to the station in 1886 and had been launched only three times on service and saved six lives in less than twenty years of operations.

left The site of the Dornoch Firth lifeboat station at Embo, with the slipway running down across the beach. The site is about half a mile south of Embo, through a caravan park adjacent to Embo pier.

Cromarty/Invergordon

Key dates

Opened	1974
RNLI	1974
Motor lifeboat	1974
Inshore lifeboat	7.1976–11.1979

Current lifeboats

ALB 14m Trent
ON.1206 (14-08) Douglas Aikman Smith
Built 1995
Donor Bequest of Mr Aikman Smith, owner
 of Shortridge Ltd, Launderers and
 Cleaners, Dumfries
On station 4.5.1996
Launch Afloat

Station honours

Thanks Inscribed on Vellum (Cromarty)	4
Bronze medal (Cromarty)	1
Silver medals (Cromarty)	2

above and right The 45ft 6in Watson
motor lifeboat James Macfee (ON.711)
at moorings in the harbour at Cromarty.
The station at Cromarty was operational
for fifty-seven years.

opposite 14m Trent Douglas Aikman
Smith (ON.1206) on exercise, passing one
of the many oil rigs that are a common
sight in the Cromarty Firth.

below 14m Trent Douglas Aikman Smith
(ON.1206) at moorings alongside the
pontoon berth in the West Harbour.

1911 The lifeboat station at Nairn was
closed, and so to cover the waters of
the Cromarty Firth a new station was
established at Cromarty, where the
lifeboat was kept afloat at the pier. The
43ft Watson sailing lifeboat *Brothers*
(ON.315) was placed on station in
March and was the first of two similar
lifeboats, which had a greater range
than standard pulling lifeboats.

1928 The station's first motor lifeboat,
the 45ft 6in Watson motor *James
Macfee* (ON.711), arrived in October,
and served for twenty-seven years.

1968 The station at Cromarty was
closed due to a decline in coastal traffic
and a lack of men in the small village
able to form a crew.

1974 A station to cover the Firth was
established at Invergordon; the lifeboat,
the 52ft Barnett *Hilton Briggs* (ON.889),
was kept afloat at moorings in the West
Harbour. The station was established
as part of the RNLI policy of providing
more intensive lifeboat coverage off the
north-east of Scotland; other stations
established at the same time were
Kirkwall in 1972 and Macduff in 1974.

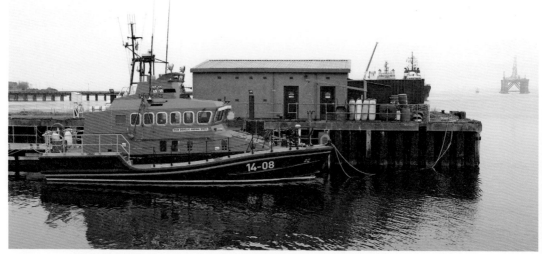

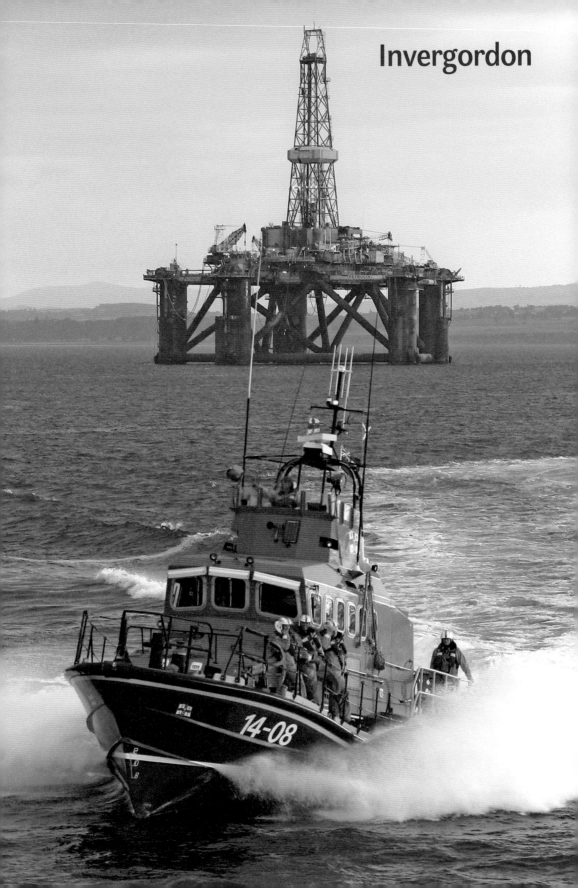

Invergordon

right The crew facility building at the West Harbour built in 1991-2 in the harbour, close to the lifeboat's moorings.

1976 The 18ft 6in McLachlan rigid-hulled inshore lifeboat A-508 was sent to the station on 1 July for a trial period.

1979 The McLachlan ILB was withdrawn on 1 November 1979 having carried out only one service launch; cover was maintained by the 52ft Barnett class lifeboat *James and Margaret Boyd* (ON.913).

1984 A new alongside berth was provided for the 33ft Brede class lifeboat *Nottinghamshire* (ON.1102).

1992 A new purpose-built shore facility was constructed adjacent to the pier; it provided a crewroom, changing room, office, workshop, toilet and shower.

1996 A blockwork building was built on the end of the pier in order to provide housing of a fuel storage tank for the 14m Trent class lifeboat *Douglas Aikman Smith* (ON.1206), which was placed on station in May, and also to provide workshop facilities.

2005 New pontoon berth completed at a cost of £77,000 to improve boarding arrangements.

right 14m Trent Douglas Aikman Smith (ON.1206) alongside the pontoon which was installed in 2005.

below 14m Trent Douglas Aikman Smith (ON.1206) on exercise in Cromarty Firth.

Key dates

Opened	2008
RNLI	2008
Inshore lifeboat	2008

Current lifeboats

ILB Atlantic 75
B-737 Thelma Glossop
Built 1997
Donor Gift of Mr and Mrs Roy Glossop,
Brighton
On station 13.9.2011
Launch Afloat

left The crew facility at Temple Pier, a little to the east of the harbour at Drumnadrochit on the northern shores of Loch Ness.

above and below Atlantic 75 Thelma Glossop (B-737) on the hydrohoist platform moored at Temple Pier.

1980 HM Coastguard coordinated search and rescue on Loch Ness since the early 1980s. Two auxiliary Coastguard units were stationed at Fort Augustus and Drumnadrochit. The Coastguard requested the use of private boats for rescue activities on the Loch until a dedicated rescue boat was provided. Based at Temple Pier, Drumnadrochit, the first boat was a 5.5m RIB powered by a single 74hp outboard, capable of 30 knots and equipped with VHF and rescue equipment.

1996 A Coastguard boathouse and base was established at Temple Pier.

2006 Coastguard Boat Policy was reviewed and recognised the fact that the RNLI now had a policy for operating on non-tidal waters and so were approached about taking over.

2007 An agreement was concluded for the transfer of activities to the RNLI.

2008 Atlantic 75 *Mercurius* (B-707) officially became operational, with many of the original coastguard crew retained. The Atlantic 75 was kept on a floating hydrohoist at Temple Pier, Drumnadrochit and Loch Ness became home to the first RNLI lifeboat on the inshore waters of Scotland.

Kessock

right The lifeboat house completed in September 2001 at a cost of £481,500 for Atlantic 75 and launching tractor.

opposite Atlantic 75 Moray Dolphin (B-771) on exercise near Inverness.

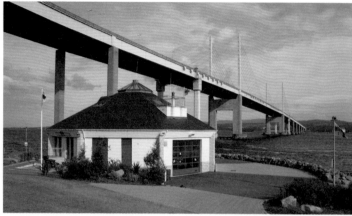

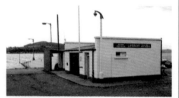

above The original ILB house, pictured in 1994. A portacabin was later provided for use as a crew -and training room.

below Atlantic 75 Moray Dolphin (B-771) launching on exercise from the ILB house.

1992 The RNLI's Committee of Management agreed in July that an ILB station be opened in the Kessock Bridge area of Inverness, at North Kessock.

1993 An inshore lifeboat station was established on 5 June for one season's evaluation with the relief D class inflatable *Starting Point* (D-396).

1994 The station was permanently established; the D class inshore lifeboat *Margaret and Fiona Wood* (D-459) was placed on station in May, housed in a small building at the old North Kessock ferry pier terminal, on the north bank of the Moray Firth, opposite Inverness.

1999 Name changed from North Kessock to Kessock lifeboat station.

2001 A new lifeboat house was built at Craigton Point, beneath Kessock Bridge carrying the A9 road, for an Atlantic 75 and launching tractor. The first Atlantic 75, the relief boat *Lucy Beryl* (B-709), arrived in October, and the D class inflatable was withdrawn.

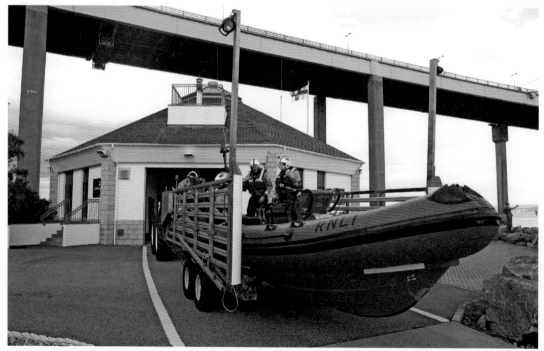

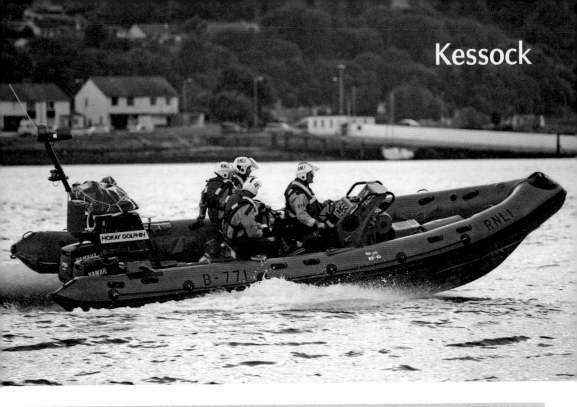

Nairn/Moray Firth

1878 A lifeboat station was established at Nairn after local residents requested a lifeboat to guard the shores of the Moray Firth. A boathouse was built for £368 and the station was formally inaugurated on 9 March.

1881 The lifeboat was launched by carriage, and the slipway had to be extended at a cost of £60.

1901 Due to encroachment by the sea, the lifeboat house was moved to another site at a cost of £600.

1902 Alterations and improvements were made to the boathouse.

1910 The RNLI decided to close the station following the placing of a motor lifeboat at Cromarty.

1911 The lifeboat was withdrawn in April and the lifeboat house was sold to the local Town Council for £50.

Key dates

Opened	1878
RNLI	1878
Closed	1911

Station honours

Bronze medal	1

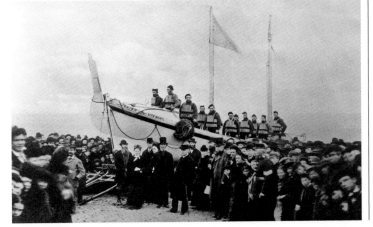

left Naming ceremony of the 34ft self-righter Caulfield and Ann (ON.267) at Nairn in March 1878; the lifeboat was christened by Lady Dunbar. This lifeboat was on station from 1878 to 1892 and saved fourteen lives. The station was known as Moray Firth until 1892 and was then renamed Nairn until its closure in April 1911. No trace exists of the lifeboat house used throughout the life of the station. (By courtesy of RNLI)

Lossiemouth

Station honours

Silver medal (shoreboat rescue)	1

right The lifeboat house built in 1859, which was used until 1898, is still standing and in use as a store.

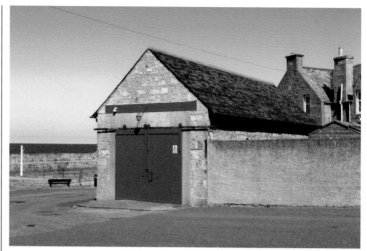

above and below The second lifeboat house built at Lossiemouth was completed in 1899 and remains largely unaltered, situated at the head of the slipway down which the lifeboat was launched. It has been used as a workshop principally for the maintenance of small boats.

1859 A lifeboat station was established at Lossiemouth and a lifeboat house was built to house the un-named 30ft Peake self-righting type lifeboat that was placed on station in June. The boat was provided to improve the safety of the many local fishing boats.

1864 During a service on 28 October several crew members were washed out of the lifeboat, but all were recovered.

1874 Posts and chains were placed in position to prevent the launching path of the lifeboat being blocked by boats.

1898-9 A new and larger lifeboat house was built at a cost of £660 8s 9d. The building was used until 1923.

1923 The station was closed after a motor lifeboat was placed at Buckie.

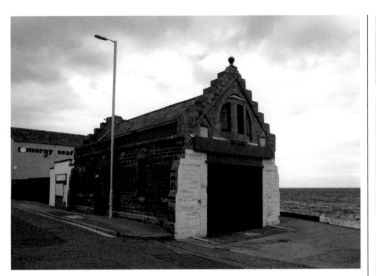

Key dates

Opened	1860
RNLI	1860
Motor lifeboat	1922
Fast lifeboat	1984

Current lifeboats

ALB 17m Severn
ON.1268 (17-37) William Blannin
Built 2003
Donor Legacies of Kenneth Maurice Williams, of Salisbury, Jean M Lamont, together with other legacies and gifts
On station 27.5.2003
Launch Afloat

Station honours

Framed Letters of Thanks	1
Thanks Inscribed on Vellum	2
Bronze medals	1
Silver medals	2

1860 In February the Inspector of Coastguard wrote to the RNLI stating the need for a lifeboat station, and this was approved in April. A lifeboat house was built along what is now the harbourside wall and the first lifeboat, the 30ft Peake self-righter *Miriam*, arrived in November.

1884 A new lifeboat house was built and the original boathouse was demolished to make way for a railway line extension; the new house was used until 1922, and was later used by a local garage.

1890 Gas was laid on to the boathouse and a lantern was provided to illuminate the barometer, which was mounted on the outside of the building for the use of the fishermen.

1921 A new lifeboat house was built inside the West Pier of the harbour for the station's first motor lifeboat, the 40ft Watson motor *K.B M* (ON 681); as there was not room for a conventional slipway into the harbour, the new house had an internal platform, or cradle, for the lifeboat which was lowered into the water by hoists and the boat floated off or slid into the water depending on the

left The house built in 1885 by the harbour wall at a cost of £448. In 1907 it was altered to take a larger 38ft Watson class lifeboat. This building remains largely unaltered externally, and has been used by a car repair garage company.

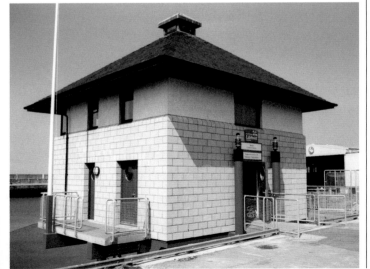

left The In crew room and shore facility built in 1994-5 on Commercial Road on the same site as the previous shed.

below The unusual lifeboat house, which had an internal launching cradle, built close to the harbour entrance in 1922 for the station's first motor lifeboat. It was used until 1961, housing two lifeboats and has since been demolished. (By courtesy of the RNLI)

Buckie

right The mooring berth and crew facility in the harbour, with 17m Severn William Blannin (ON.1268) on station.

opposite 17m Severn William Blannin (ON.1268) approaching the harbour when returning from exercise.

below Buckie lifeboat crew and station personnel on William Blannin (ON.1268).

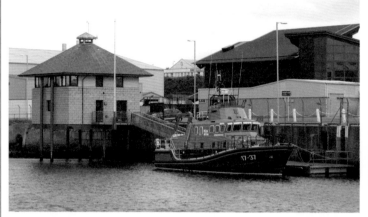

below 17m Severn William Blannin (ON.1268) on exercise.

state of the tide; this system was used between 1921 and 1961; the house has since been demolished.

1960 Centenary Vellum awarded

1961 Moorings were taken up in the Inner Harbour, with a small workshop located on the quayside above the mooring berth, and the 47ft Watson motor *Laura Moncur* (ON.958) was placed on station in June.

1994-5 A new pontoon berth was installed to improve boarding arrangements and a new shore facility was built on the adjacent quayside to replace the previous building; it includes a changing room, workshop, toilets, fuel store, crewroom and office, as well as a resuscitation area.

2009 The RNLI awarded a 150th anniversary vellum to the station.

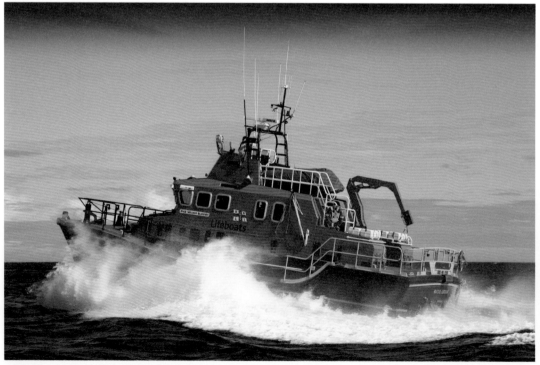

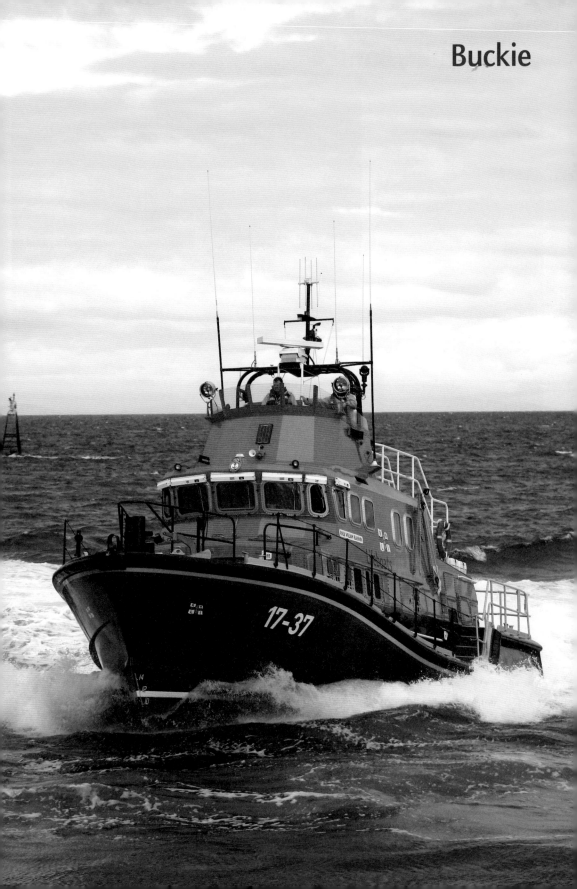

Whitehills/Banff

Key dates

BANFF	
Opened	1860
RNLI	1960
Closed	1924
WHITEHILLS	
Opened	1924
RNLI	1924
Motor lifeboat	1943
Closed	1969

Station honours

Silver medals (shoreboat rescues)	2

right and below The lifeboat house built at Banff in 1877 overlooks the beach and lies to the east of the river Deveron. It was used until the 1920s, and then became a village store before being converted into a private residence.

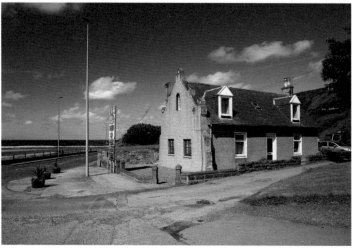

1860 A lifeboat station was established at Banff after four wrecks had occurred in three years up to 1859. A lifeboat house was built at Banff Harbour at a cost of £138 1s od and a 30ft Peake self-righting lifeboat was sent in August.

1867 The lifeboat house was moved to a new site halfway between Banff and Macduff at a cost of £67.

1876 Encroachment by the sea made the house dangerous as it had been erected on a shingle beach.

1877 A new lifeboat house was built at a cost of £227 10s od on a site given by Viscount Macduff MP. The house was used until 1924, and is still standing, to the east of the town.

1913 Alterations were made to the

lifeboat house for £355 10s 10d.

1922 The station was moved to Whitehills and the existing Banff lifeboat *George and Mary Berrey* (ON.479) was transferred there in January. A new lifeboat house was built at Whitehills.

1933 A new lifeboat house with a slipway was built in the harbour to improve launching arrangements.

1959 41ft Watson motor lifeboat *St Andrew (Civil Service No.10)* (ON.897) damaged on service on 18 November.

1961 The boathouse was adapted for the 47ft Watson motor lifeboat *Helen Wycherley* (ON.959).

1969 The station was closed and the lifeboat was withdrawn on 11 May.

right The lifeboat house with slipway built at Whitehills harbour in 1933 was converted into a private house between 2008 and 2010, with as much as possible of the original interior retained.

below The 1933 boathouse and slipway pictured in 1994 when used as a store.

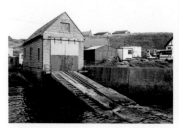

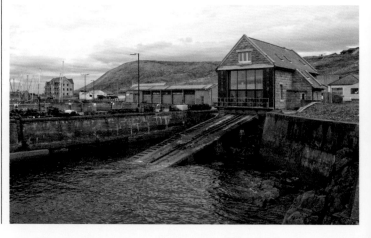

Macduff

Key dates

Opened	1974-84 and 1985
RNLI	1974
Motor lifeboat	1974-84
Inshore lifeboat	1985

Current lifeboats

ALB Atlantic 85
B-804 Lydia MacDonald
Built 2001
Donor Gift of the R. S. Macdonald
Charitable Trust
On station 7.6.2006
Launch Mobile rig and davit

1974 An all weather lifeboat station was established in March; the lifeboat was kept afloat at moorings in the harbour, and was withdrawn in September 1984.

1973 In September the Committee of Management decided to station a lifeboat at Macduff for a year's trial.

1974 The first lifeboat, the 52ft Barnett *James and Margaret Boyd* (ON.913), was sent to the station on 28 March.

1975 The permanent establishment of the station was approved by the Committee of Management in March and the 48ft 6in Solent class *Douglas Currie* (ON.1021) was sent to the station on 30 September.

1984 On 8 September the lifeboat was withdrawn and the station was closed.

1985 An inshore lifeboat station was established in September; a building provided by the council on the road to the Eastern Pier was converted to house the Atlantic 21 and launching vehicle.

1999 A new ILB house was built at Bankhead, closer to the harbour than the previous house, for the Atlantic and purpose-built Scania launching rig.

left The lifeboat house built in 1999 for the Scania launch rig and Atlantic ILB. The system of launching employed at Macduff is unique; because no site adjacent to a quay for a boathouse is available, the ILB has to be launched by mobile crane. Between 1985 and 1999 a crane towed the ILB on a road-going trailer to a suitable quay, usually in Macduff harbour but it could go further afield, from where a launch could be undertaken. The crane would lift the Atlantic 21 off the trolley, and lower it into the water. In 1999 a new purpose-built rig was built, operating on the same principle as the mobile crane, but with greater flexibility and crew comfort.

left Atlantic 85 Lydia MacDonald (B-804) being launched at the harbour by the Scania launching rig. (Courtesy of RNLI)

below Atlantic 85 Lydia MacDonald on exercise off Macduff; B-804 was the first Atlantic 85 to go on station. (Bill Bain)

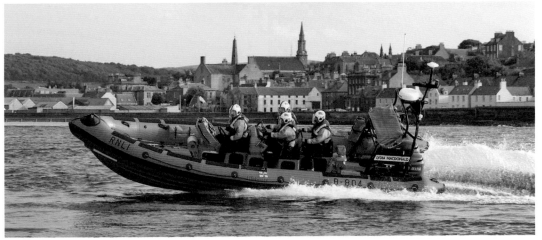

Fraserburgh

Key dates

Opened	1806
RNLI	1858
Motor lifeboat	1915
Temporary closure	1970-79
Fast lifeboat	1985

Current lifeboats

ALB 14m Trent
ON.1259 (14-34) Willie and May Gall
Built 2002
Donor Bequest of Mrs May Crombie Gall, named after the donor and her late husband, as well as other associated gifts
On station 8.5.2002
Launch Afloat

Station honours

Framed Letter of Thanks	1
Thanks inscribed on Vellum	1
Bronze medals	7
Silver medals	6
Gold medals	2

right The crew facility built in 2006-7 close to the North Pier on the site of the lifeboat house and slipway of 1913-6 , which was demolished as part of the harbour redevelopment. It was completed in April 2007 at a cost of £326,906.

opposite 14m Trent Willie and May Gall (ON.1259) on exercise off the harbour.

below left The first lifeboat house built by the RNLI in 1858 was used until 1883, later becoming a store, prior to demolition in the 1990s.

below right The lifeboat house of 1883 on a site adjacent to the 1858 house. This was used until 1916 and was demolished in the 1990s when the harbour was developed.

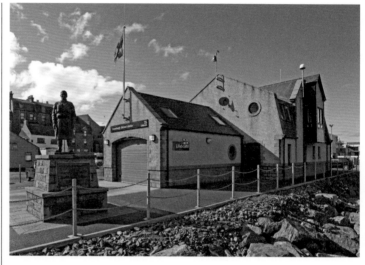

1806 The first lifeboat, built by Henry Greathead of South Shields, was supplied to the town. Organised by the Harbour Commissioners, it was funded by a 6d per man toll on all vessels entering the harbour.

1824 The RNIPLS, forerunner of the RNLI, supplied a life-saving apparatus.

1831 A new lifeboat, on similar lines to the first boat and funded in the same way, replaced the original boat; this second boat was broken up during the early 1850s and the station lapsed.

1858 The RNLI reopened the station, after a request in 1857 from Lewis Chalmers, Chief Magistrate of Fraserburgh, stating the need for a lifeboat; a 30ft Peake self-righter was supplied, and this became the first RNLI lifeboat in Scotland; a lifeboat house was built by the Harbour Commissioners in the harbour.

1875 The boathouse was re-roofed; it was used until 1883 and was then taken over by a firm of marine engineers, but was demolished during the mid-1990s.

1883 A new lifeboat house was built on a site adjacent to the 1858 house; it was used until 1917, then became a store and was demolished during the mid-1990s during harbour redevelopment.

1894 The boathouse was lengthened by the Harbour Commissioners in October.

1913-6 A new lifeboat house and slipway were constructed for the station's first motor lifeboat, situated in front of the previous house.

1915 The new motor lifeboat, *Lady*

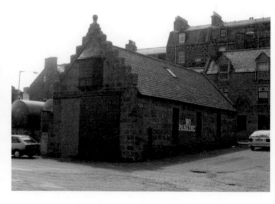

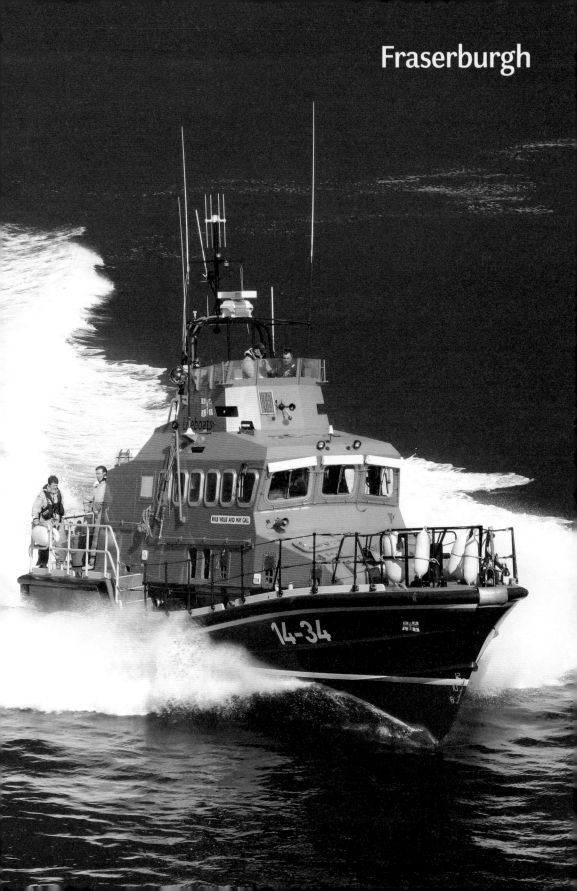

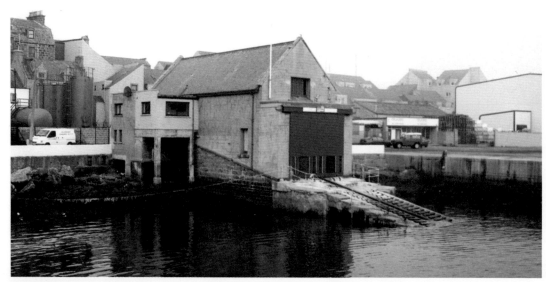

above and below The lifeboat house and slipway completed in 1916 at a cost of £3,200 and used for the lifeboat until 1997. It was then used as a crew facility, as pictured here, until being demolished in 2005 to make way for a new crew facility.

Rothes (ON.641), arrived in July; she was funded from the gift of Mr T. Dyer Edwardes to commemorate the saving of his daughter, the Countess of Rothes, from the wreck of the liner *Titanic*.
1918 In lowering the lifeboat down the slipway on 12 January, the chain holding her broke and, with only the motor mechanic on board, she shot down the slipway. The mechanic managed to control the lifeboat which then proceeded on service to HM trawler *William Ashton*.

1919 The lifeboat was launched on 28 April in a heavy northerly gale to HM Drifter *Eminent* and when about one mile from land was caught broadside and overturned. Most of the crew were thrown overboard, the engines stopped and the boat went ashore. Coxswain Andrew Noble and the second coxswain Andrew Farquhar were drowned.
1953 On 9 February the lifeboat *John and Charles Kennedy* (ON.790) was launched to escort fishing boats into the harbour. While off the North Pier

right 14m Trent Willie and May Gall (ON.1259) putting out on exercise, with the crew facility in the background.

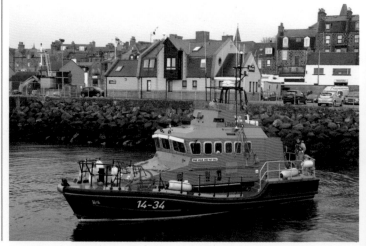

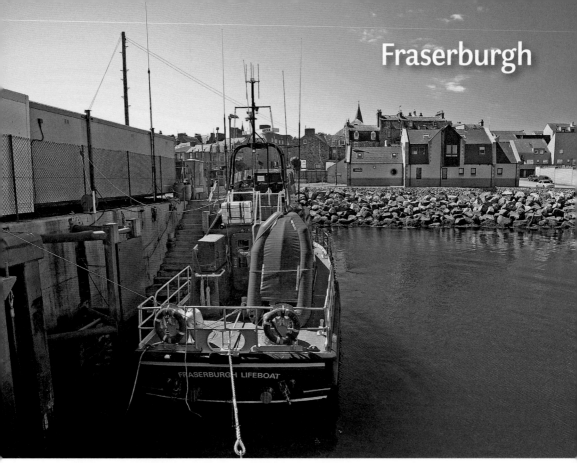

two exceptionally heavy swells capsized her. The coxswain was flung out and the other six were trapped under the canopy. Second Coxswain Charles Tait Jnr, managed to force himself down sufficiently to be able to get clear of the canopy and got ashore alive, but six men were lost, Coxswain Andrew Ritchie, Mechanic George Duthie, Bowman Charles Tait Snr, Assistant Mechanic James Noble and crew members John Crawford and John Buchan.

1954 The boathouse was altered for a new lifeboat, the 46ft 9in Watson motor *The Duchess of Kent* (ON.908).

1970 On 21 January, while on service to the Danish fishing vessel *Opal*, *The Duchess of Kent* capsized with the loss of five of her crew of six. The five men lost were Coxswain John Stephen, Mechanic Frederick Kirkness and crew members William Hadden, James R.S. Buchan and James Buchan. Assistant Mechanic John (Jackson) Buchan was flung clear when the lifeboat capsized

and was saved by a Russian trawler. Following the tragedy, the station was temporarily closed

1978 The station was reopened in June and, after a period of crew training, the station became operational on 29 April 1979 operating the 48ft 6in Solent class lifeboat *R. Hope Roberts* (ON.1011).

1981-2 The boathouse was extended to provide toilet facilities and crew room.

1985 Major adaptation of the station to accommodate the Tyne class lifeboat *City of Edinburgh* (ON.1109) were undertaken in conjunction with routine maintenance work.

1997 A new berth was completed in October and the lifeboat was placed at moorings in the harbour, near the boathouse on the north side of North Pier.

2006-7 The lifeboat house and slipway were demolished to make way for a new crew facility on the same site; the new facilities included a changing room, crew/training room, workshop, storage rooms and office.

above 14m Trent Willie and May Gall (ON.1259) at moorings in the Balaclava Outer Harbour, alongside the old North Pier, close to the crew facility.

below The life-size bronze lifeboatman statue outside the lifeboat station, which was unveiled in August 2010, was erected to remember those who lost their lives in the station's three lifeboat disasters.

Whitelink Bay

Key dates

Opened	1878
RNLI	1878
Closed	1905

below The very few remains of the Whitelink Bay lifeboat house can be seen on the Inverallochy Golf Course.

1877 At a Committee of Management meeting in June, the RNLI decided to form a station in the neighbourhood of St Coombs, a fishing village, to cover Whitelink Bay, between the fishing harbours of Fraserburgh and Peterhead. The boat was crewed by men from the small villages of St Coombs, Inverallochy and Cairnbulg.

1878 The lifeboat house was built on the sandlinks, behind the protection of the dunes, between St Coombs and Inverallochy on a site granted by Colonel Fraser. The boathouse cost £284 and was built by Buchan and Jenkins. The new station was formally inaugurated on 5 March when the first lifeboat, the 33ft ten-oared self-righter *Robert Adamson*, was christened. She was launched by carriage south of Inverallochy; two carriages were needed, one with sandplates to cross the soft dunes, and the other to cross the hard sand on the beach.

1897 Pushing poles were supplied to make launching easier.

1905 The station was closed and the last lifeboat, the 34ft self-righter *Three Brothers* (ON.241), was withdrawn in May; the remains of the boathouse, which was demolished after the First World War, can be seen about 100 yards from the seventh tee in line with the seventh hole of Inverallochy Golf Course.

Peterhead

Key dates

Opened	1865
RNLI	1865
Motor lifeboat	1912
Fast lifeboat	1988

Current lifeboats

ALB 16m Tamar
ON.1282 (16-03) The Misses Robertson of Kintail
Built 2006
Donor Gift from The Robertson Trust, founded by the Misses Robertson off Robertson and Baxter Ltd, Scotch Whisky Blenders, Glasgow
On station 29.4.2006
Launch Afloat

Station honours

Thanks Inscribed on Vellum	2
Bronze medals	9
Silver medals	11
Gold medal	1

right The crew facility located in the harbour was completed in 1999.

opposite 16m Tamar The Misses Robertson of Kintail (ON.1282) moored in the harbour.

1865 Recommendations were made to form a station as Peterhead had a 'large shipping trade and 400 fishing boats . . . [and] there had been several shipwrecks in the past eighteen months'. A first lifeboat house was built in Greenhill Road on the east side of the North Harbour for the first lifeboat, the 33ft ten-oared self-righter *Peoples Journal No.1* (ON.240), which served until 1893.

The pulling lifeboats were launched by carriage, but tugs were available for use in towing the boats to rescues.

1900-1 The boathouse was rebuilt and enlarged, and was used until 1908; it has since been demolished.

1908 The slipway into the South Harbour used for launching was removed and so the lifeboat was kept afloat on moorings in the harbour.

Peterhead

above The lifeboat house and slipway built in 1911-2 for the first motor lifeboat. This photo, dating from 1997, shows the building after it had been renovated.

right The lifeboat house and slipway, built in 1911-2 in the South Harbour, pictured in 1994 with the 47ft Tyne Babs and Agnes Robertson (ON.1127) inside. The house was used until 1998 and has since been demolished, with the site built over.

opposite 16m Tamar The Misses Robertson of Kintail (ON.1282) on the day she arrived on station.

below 16m Tamar The Misses Robertson of Kintail (ON.1282) moored in her pen in the harbour close to the pilot boat.

1911-2 A new lifeboat house and roller slipway were built on a site to the west of the South Harbour for the station's first motor lifeboat, *Alexander Tulloch* (ON.622), which became the No.2 lifeboat; five tenement houses had to be bought, at a cost of £445, and demolished to make room for the new boathouse. The pulling lifeboat, which was moored afloat, was designated the No.1 lifeboat and remained on station. **1914** The No.2 lifeboat *Alexander Tulloch* (ON.622) was totally wrecked during a south-easterly gale on 26 December when on service to the minelayer *Tom Tit*. Three of the crew of twelve were drowned; they were

Second Coxswain James Geddes, Thomas Geddes and David Strachan. **1920** A fire broke out in the lifeboat house, but there was little damage. **1928** The pulling lifeboat, the 37ft 6in self-righter *Civil Service No.3* (ON.437), kept at moorings was withdrawn. **1933** Coxswain John Strachan was washed out of lifeboat while on service but was recovered. **1938** The lifeboat house was altered for a new lifeboat, the 46ft Watson motor *Julia Park Barry, of Glasgow* (ON.819). The house was further altered in 1964, 1969 and 1978 for subsequent lifeboats. **1980-1** The boathouse was extended to provide toilet facilities for the crew. **1998** The lifeboat was placed in a berth to the west of the South Harbour where she took up moorings on 22 July; temporary shore facilities were installed on the quayside, after agreement with the harbour commissioners. The site of the slipway station was made available to facilitate development of the port. **1999** A new floating pontoon berth was provided adjacent to the harbour offices and control tower for ALB and the port's pilot boat, and permanent crew facilities were constructed on the quayside, providing workshop, office and training room. The berth and new shore facility were completed in May.

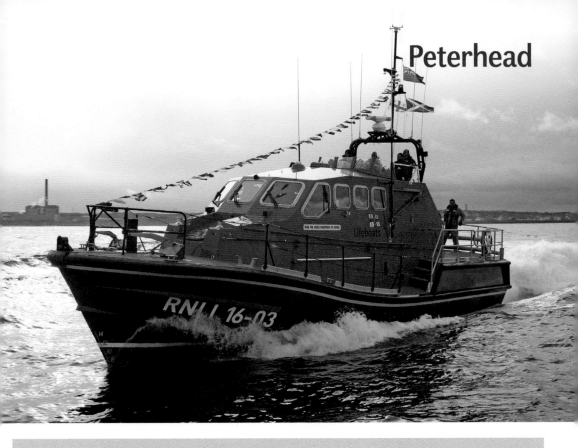

Peterhead

Port Errol

1877 A lifeboat station was established at the time the Earl of Errol was building a fishing harbour at Cruden and a lifeboat house was built at Port Errol, a small harbour to the south of the village, for £503 10s 0d. The site for the lifeboat house was described as the lower end of a small ravine. The station was formally inaugurated on 30 October 1877 with the first lifeboat, the 33ft self-righter *Peep O'Day* arriving at the station the previous month.

1903-4 The lifeboat house was enlarged at a cost of £338 to accommodate the larger 38ft Watson sailing lifeboat *John Fortune* (ON.523).

1913 One of the crew was hit by the winch handle when rehousing the lifeboat after an exercise, and received fatal injuries.

1914 The station was temporarily closed in March, and the lifeboat was removed to be altered and improved

1915 The station was reopened and *John Fortune* (ON.523) returned.

1921 The station was permanently closed, the lifeboat was withdrawn and the lifeboat house was sold; a wall was subsequently built across the slip to keep the seas back from the cliff. By the early 1970s the house was in ruins, and the site was built on during the 2000s.

Key dates

Opened	1877
RNLI	1877
Closed	1921

below The site of the lifeboat house built at Port Errol in 1877 for the Cruden Bay lifeboat station. Any remains of the house have been long disappeared.

Newburgh

below and right The boathouse built in 1877 and used for the lifeboat until 1965. It remains largely unaltered externally.

below The last Newburgh lifeboat, the 32ft Surf motor John Ryburn (ON.837), on her launching carriage on the beach with the lifeboat crew and launching tractor, on the day the boat first arrived, June 1941. (By courtesy of RNLI)

1826 Commander Knight, CG, stated that a lifeboat was necessary to augment the station at Aberdeen.
1827 The RNIPLS, forerunner of the RNLI, agreed with this recommendation and offered to pay for the conversion of a local boat or coble along the lines of Palmer's plans.
1828 A Coastguard boat was altered to Palmer's plans for use as a lifeboat; £25 was given by the RNIPLS, and a further £52 was raised locally. The boat was apparently out of use by the time of the Northumberland Report of 1851.

1877 The RNLI established a station on the recommendation of the Inspecting Commander of HM Coastguard and the Inspector of Lifeboats, and a lifeboat house was built among the sand dunes about a mile south of Newburgh, at the mouth of the river Ytham. The station was officially inaugurated on 18 November when the first lifeboat, a 30ft eight-oared self-righter, was named *Alexander Charles and William Aird*.
1910 Improvements were made to the boathouse at a cost of £238.
1924 A corrugated iron tractor house was built, about 100 yards to the rear of the boathouse, for the station's first motorised launch vehicle, the Clayton tractor number T2.
1930 Centenary vellum was presented to the station.
1941 The station's first and only motor lifeboat, the 32ft Surf type *John Ryburn* (ON.837), was placed on station in June.
1942 *John Ryburn* capsized 26 January 1942 and two crew members were drowned while on service to the steamship *Lesrix*, of London.
1965 The station was closed and the lifeboat was withdrawn on 30 September. The boathouse has since been used as a store, while the tractor house remains standing.

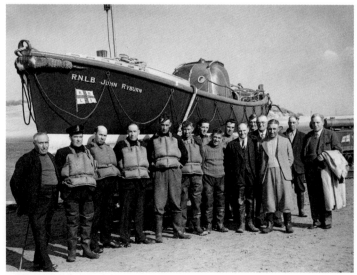

Aberdeen

Key dates

Opened	1802
RNLI	1925
Motor lifeboat	1926
Inshore lifeboat	1968
Fast lifeboats	1976
RNLI No.2 station	1925-62

Current lifeboats

ALB 17m Severn
ON.1248 (17-24) Bon Accord
Built 2000
Donor Local Appeal together with other
donations and legacies, named after City
of Aberdeen's motto.
On station 20.7.2000
Launch Afloat

ILB D class inflatable
D-694 James Bissett Simpson
Donor Bequest of Miss Eileen Simpson,
formerly of Peterhead, named in memory
of her late brother
On station 17.4.2008
Launch Davit

Station honours

Thanks inscribed on Vellum	11
Bronze medals	6
Silver medals	7
Gold medal	1

1802 The first lifeboat, funded by Alexander Baxter (Consul General for Russia), was stationed at the North Pier and was operated under the auspices of the Aberdeen Shipmasters' Society.

1810 A boathouse was built at the North Pier, located to the north of the Round House, and control of the lifeboat was passed to the Aberdeen Harbour Commissioners.

1811 A slipway was built on the North Pier between the Inner (Shelter) Jetty and Abercrombie Jetty, to improve launching; a new slipway was built in 1872 at the same location.

1820 The lifeboat was badly damaged on service on 2 March, and so was broken up; the boathouse was let to a local steamship company until 1841, and the station ceased operations.

1841 The station was re-established and a new 26ft North Country type lifeboat

left above The ILB house and crew facility on the quayside at Dock Island, facing Victoria Dock, with the davit for launching the D class inflatable inshore lifeboat.

left 17m Severn Bon Accord (ON.1248) alongside the pontoon to the north of the entrance to Victoria Dock. The pontoon is also shared by the local pilots.

below The site at Footdee, the village to the north of the entrance to the river Don, from where the lifeboats were operated until the 1960s. No trace remains of the various lifeboat houses built at this site.

Aberdeen

Above The combined shore facility and ILB house constructed at Dock Island in 1997 to provide improved crew facilities.

below The ILB house and shore facility, at the northern side of the entrance to Victoria Dock. The crew facility built in 1980 and used until 1997 is the single-storey building on the right; this has since been demolished.

was supplied, built in Sunderland; the boathouse was renovated and a launching carriage was supplied which could be used to transport the lifeboat further afield if necessary; the house was used until 1853, and was then converted into a storehouse.

1853 Two new lifeboat houses were built, one on the road to the North Pier, on the harbour side of Pilot's Square, and the other near the Broad Hill. A new lifeboat, the 30ft Peake self-righter *Bon Accord No.1*, was also built for the station by Forrestt at Limehouse; she arrived in August, and was kept in the North Pier boathouse.

1874 The lifeboat house was moved to a new site at the north-east corner of North Footdee Square, at the edge of the beach; the boat operated from here was known as the beach lifeboat.

1875 A second lifeboat, named *Bon Accord No.2*, was bought for the station, and a new lifeboat house was built over the water at Pocra Quay, so the lifeboat was afloat, but inside her own house

1877 As the lifeboat banged about inside this house, a new house was built on Pocra Jetty near the Aberdeen, Leith and Clyde Shipping Company's wharf; this was known as the harbour lifeboat.

1890 The 1877 lifeboat house was moved to Shelter Jetty in the lower harbour basin; the lifeboat was launched from a carriage into the channel down the slipway below the Lower Jetty.

1891 A hoisting apparatus with a hand-operated windlass was built, in the 1890 house, which was used to lift the boat out of the water when she was not being used; this house and the hoisting gear were dismantled when the RNLI took over the station.

1925 The RNLI took over the station, at the request of the Harbour Commissioners, who agreed to contribute £500 a year towards their upkeep; the lifeboats were credited with saving 589 lives up to that time. The RNLI also assumed control of the rocket life-saving apparatus at Torry and the North Pier. Two temporary

Aberdeen

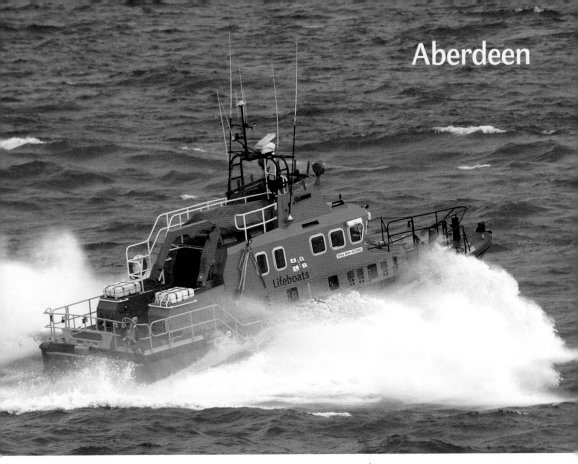

lifeboats were supplied immediately by the RNLI while a new motor lifeboat was under construction, and a Clayton launching tractor arrived in January to launch the No.2 lifeboat.

1926 The first motor lifeboat, the 60ft Barnett *Emma Constance* (ON.693), arrived on 3 October and was placed afloat at Pocra Jetty; moorings were

later moved to St Clement's Bridge Jetty; the No.2 lifeboat was kept on a carriage in the house at Footdee.

1937 During a twelve-day period of gales in January the river Dee flooded causing widespread damage. The No.2 lifeboat *Robert and Ellen Robson* (ON.669) was called out to rescue a woman and two men from

above 17m Severn Bon Accord (ON.1248) setting out from Aberdeen, which is one of Scotland's busiest ports.

left D class inflatable D-694 James Bissett Simpson outside the ILB house on the quayside of Victoria Dock.

below D-694 James Bissett Simpson on her trolley close to the davit used for launching, adjacent to the shore facility.

Aberdeen

right 17m Severn Bon Accord (ON.1248) returning to Aberdeen harbour.

above and below 17m Severn Bon Accord (ON.1248) at her moorings in Aberdeen harbour. This area of the harbour has been the location of the lifeboat moorings since 1973, although the exact position has moved as the harbour, one of the busiest in the country, has developed.

a farmhouse; the coxswain took the lifeboat stern first through the house's front door to reach the three people.

1939 The 35ft 6in Liverpool motor *George and Elizabeth Gow* (ON.827), was sent to the No.2 station in February.

1952 Commemorative 150th anniversary vellum awarded to station.

1962 The No.2 station was closed on 30 June and the lifeboat was withdrawn; the house at Footdee has since been demolished. The life-saving apparatus at North Pier and Torry, operated by the RNLI, was also removed.

1963 The station's new 52ft Barnett lifeboat *Ramsay-Dyce* (ON.944) was exhibited at Leith, Edinburgh, for the 9th International Lifeboat Conference between 4 and 6 June.

1968 An inshore lifeboat station was established in August; the first ILB, D-168, was housed in a shed near the Roundhouse, and was launched from the old Footdee Ferry Slipway nearby.

1973 The lifeboat was moved to the north side of Victoria Dock and moored on the inner side of the approach jetty to St Clement's Bridge; a wooden hut was built for the gear.

1980 A purpose-built crew facility was built near the old dock gates to house the crew's gear as well as the ILB, with a pontoon berth provided for the lifeboat; a single-arm davit from a scrapped trawler was installed to launch the ILB, meaning it could be easily got afloat and recovered at any state of the tide.

1994 A new Schat davit was installed on the quay for launching and recovering the inshore lifeboat.

1997 A new combined shore facility and ILB house were constructed at Dock Island; the new building provided housing for the D class inflatable ILB and improved crew facilities.

2001 On 28 November the RNLI's Committee of Management voted the award of a Vellum to commemorate 200 years as a lifeboat station in 2002.

Key dates

Opened	1854-1934
RNLI	1868, 1967 and 2013
Closed	1934
Inshore lifeboat	1967-84 and 2013

Current lifeboats

ILB Atlantic 75
B-740 Alexander Cattanach
Donor Anonymous gift
On station 8.2013
Launch Davit

left The lifeboat house built by the RNLI in 1868 on the south side of the pier. It was used until 1890 and later became a store in use by a small local business.

1854 New lifeboats were presented to Stonehaven and Aberdeen, funded by Miss Lydie A. Barclay, both of which were built at Aberdeen. The non-self-righting type at Stonehaven was under the auspices of the Independent Kincardineshire Lifeboat Society.
1867 Sheriff Dove Wilson wrote to the RNLI saying that the Committee of the Kincardineshire Lifeboat Association wanted the RNLI to take over the station, and it was reported that the boatmen had 'entirely lost confidence in the boat already on station.'
1868 The RNLI established a station and a 33ft self-righter pulling six oars

below The lifeboat house, built in 1889 at the south end of the harbour, was used until 1934, when the station closed and then became home to the local yacht club; the old ILB house can be seen to the right.

above The inshore lifeboat house used for the two D class inflatables which served the station between 1967 and 1984. They are credited with saving thirty-eight lives.

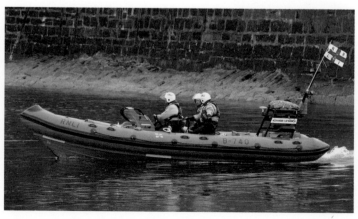

above The memorial in Stonehaven Churchyard to the four lifeboatmen lost when the lifeboat was wrecked in 1874.

right Atlantic 75 Alexander Cattanach (B-740) leaving Stonehaven harbour on exercise in July 2013 as volunteer crew members trained on the ILB prior to the station becoming operational. (By courtesy of Stonehaven RNLI)

double-banked, named *St George*, was supplied. A new lifeboat house was built at a site on the south side of the pier at a cost of £203 10s 0d. The station was inaugurated on 12 March when a 'very grand demonstration' took place.

1874 The lifeboat *St George* capsized on service on 27 February to the barque *Grace Darling*, of Blyth, with the loss of the Coxswain, James Leiper, and three of the crew; the RNLI voted £250 to a local fund. The lifeboat was so badly damaged she could not be repaired, so a replacement was built for the station.

1889-90 A new lifeboat house was built for £327 15s 9d at the south end of the harbour, enabling the lifeboat to be

launched over the beach.

1913 Alterations were made to the lifeboat house at a cost of £756 1s 0d.

1934 At a meeting of the RNLI's committee of management on 11 January it was decided to close the station. The last launch had been on 1 January 1933 to a schooner at Tod Head, but the lifeboat, the 35ft Rubie self-righter *Joseph Ridgway*, could not round Downie in the weather conditions. The motor lifeboats at Aberdeen and Montrose could cover the area.

1967 An inshore lifeboat station was established and the D class inflatable D-211 was sent to Stonehaven in April.

1984 The ILB station was closed and the D class inflatable D-234 was withdrawn on 31 October.

2013 The RNLI reopened the station after the local Maritime Rescue Institute (MRI), an independent sea rescue and training charity, closed. MRI operated various rigid-inflatables which were used for training and rescue purposes, but, after severe damage to its premises and boats during flooding in Stonehaven in December 2012, could not afford the necessary repairs and so closed. The RNLI stepped in to establish a station, receiving considerable support from the community, and an Atlantic 75, the relief boat *Alexander Cattanach* (B-740), was sent to the station in July for crew training.

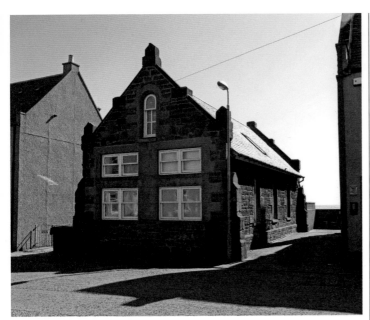

Key dates

Opened	1878
RNLI	1878
Motor	1936
Closed	1969

Station honours

Thanks inscribed on Vellum	1

left The ornate lifeboat house built in 1878 was used throughout the life of the station until 1969. It has since been converted into a private residence but retains many of its original features.

1878 Local residents asked for a lifeboat station to be established as shipwrecks in the area were increasing, and the fishing fleets of Gourdon, Bervie and Johnshaven also needed protecting. A station was established by the RNLI and a lifeboat house was built at a cost of £303 10s 0d on a site given by James Farquhar, of Hallgreen. The station was formally inaugurated on 12 October.

1890 A small surf boat, named *Maggie Law*, was built for service at Gourdon having been funded by local fishermen. It was built locally by James (Jeems) Mowat and was named after the daughter of local fish curer Tom Law.

below The last Gourdon lifeboat, the 35ft 6in Liverpool motor Edith Clauson-Thue (ON.895), returns to harbour. She was on station from 1952 to 1969, launching fourteen times on service. (By courtesy of the RNLI)

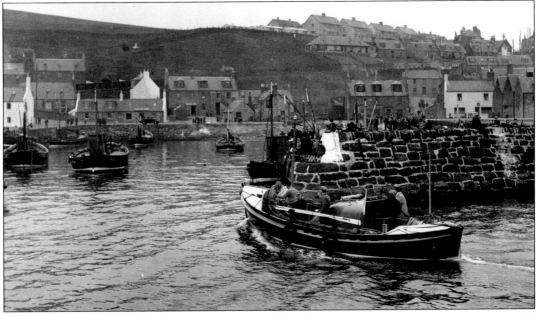

Gourdon

right The Maritime Museum in the centre of Gourdon which has, as its main exhibit, the Surf boat Maggie Law. The boat was paid for by the local fishermen, with every fisherman in the village donating his share. The upkeep of Maggie Law was also the fishermen's responsibility, with each man giving a penny out of every pound of his gross earnings. In 1997 the Maggie Law Museum was opened to the public; it was later improved and the refurbished Museum was officially reopened to the public on 12 April 2013 by Dame Anne Begg MP, after sponsorship from Aberdeenshire Council.

below The small locally-built surf lifeboat Maggie Law has been restored and is on display as part of a small museum in Gourdon. She undertook her first rescue in 1892 and remained in operation until 1930, during which time she is credited with saving thirty-six lives.

It was believed that a shallow-draught boat, which could be launched quickly, was needed. The boat was rowed by six oars and was intended largely for inshore rescue work.

1936 A motor lifeboat, the 35ft 6in Liverpool *Margaret Dawson* (ON.782) was sent to the station in February.

1950 A Case LA type launching tractor, T43, was sent to the station in January to improve launching arrangements.

1959 The lifeboat house was altered to accommodate a new launching carriage.

1969 The station was closed and the 35ft 6in Liverpool motor lifeboat *Edith Clauson-Thue* (ON.895), which had been on station since April 1952, was withdrawn in May.

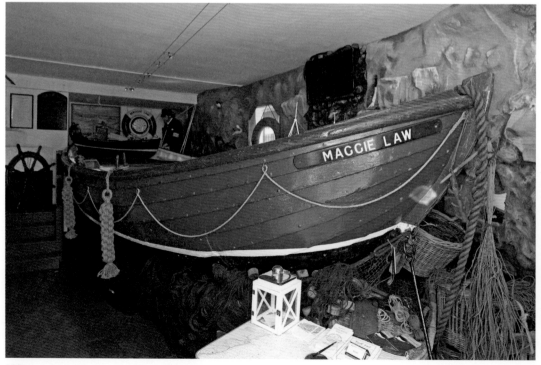

Johnshaven

Key dates

Opened	1891
RNLI	1891
Closed	1928

Station honours

Thanks inscribed on Vellum	2
Silver medals	1

left The lifeboat house built in 1891 remains standing in Fore Street, facing the entrance to the harbour. Four lifeboats were operated from here, and they launched a total of forty-eight times on service, saving thirty-five lives. The house is now a grade B listed building and a key site within the centre of the village.

1890 The RNLI decided to provide a lifeboat to help when fishing boats got into difficulty making for the harbour.
1891 A lifeboat house was built for £627 10s 10d on a site given by Hercules Scott, Brotherton Castle, with a launching slipway. The first lifeboat, the 31ft self-righter *Meanwell of Glenbervie* (ON.320), arrived in August and the new station was inaugurated on 3 October.
1920 The lifeboat *James Marsh* (ON.639) capsized on 12 December when returning from service to the schooner *Fredensborg*. The crew were washed out, but all regained the boat except James McBay, Acting Second Coxswain, who was drowned, as were two of the men who had been rescued.
1928 The station was closed and the last lifeboat *James Stevens No.11* (ON.438) was withdrawn; motor lifeboats at adjacent stations could cover the area and the fishing industry was declining. One of the two service boards is displayed in the Village Hall, but the other was destroyed in a fire.

below The lifeboat house built in 1891, with the slipway into the harbour; the building was refurbished during 2013 to become a local heritage centre.

Montrose

Current lifeboats

ALB 47ft Tyne
ON.1152 (47-034) Moonbeam
Built 1989
Donor Gift of Mr and Mrs Roland Sutton, of
 Grampian
On station 28.5.1989
Launch Afloat

ILB D class inflatable
D-626 David Leslie Wilson
Donor Legacy of David Leslie Wilson
On station 12.8.2004
Launch Davit

Station honours

Framed Letter of Thanks	1
Silver Medals	14

above right The RNLI lifeboat houses
on the north bank of the river Southesk.
The No.1 house is on the right and the
No.2 house, used for the carriage-launched
lifeboat, on the left. This unique double
boathouse was constructed in 1901-2 but
was demolished in April 1998.

below The early lifeboat house on the
north bank of the river dates from the first
half of the 19th century and was taken
over by the RNLI in 1869. (Tony Denton)

1800 The first lifeboat was built by
Henry Greathead of South Shields and
operated by a local committee. Local
subscriptions, the town council and
Lloyds of London contributed the initial
funds to pay for the boat; a launching
carriage was built locally by Robert
Gibb of Lochside.

1807 A second lifeboat was built by
Greathead, which was lighter than the
first boat. In November a site at the
south-west corner of the town was
granted on which a boathouse was built
at a cost of £63.

1818 The Town Council took over the
running of the station and a lifeboat
house was built by the Harbour Lights
Committee, close to the lower leading
light, on the north side of the river Esk;
from this time, the lifeboat was funded
from a tax levied on vessels entering
the harbour. In December the running
of the lifeboat was taken over by the
Harbour Lights Committee.

1837 The Harbour Trust took over
the running of the station, which was
overseen by an annually elected lifeboat
committee made up of local shipowners
and ship masters.

1869-70 The RNLI took over the
stations and a new lifeboat house was
built on the North Side of the river,

close to the old lifeboat house, on a
site given by the Town Council, with a
slipway constructed at a cost of £100;
the 33ft self-righter *Mincing Lane* was
the first RNLI lifeboat, and she was
publicly launched on 7 August. The
second lifeboat was taken over from the
Harbour Trust by the RNLI, and was
named *Roman Governor of Caer Hun* in
1871; she served until 1874.

1874 The no.2 boathouse was improved
ad a new No.2 lifeboat, also named
Roman Governor of Caer Hun, was sent
to the station.

1878 Five life-belts were presented to
the crew of the steam tug that was used
free of charge to tow the lifeboat to the
bar on service.

1885 A No.3 station was established and
a boathouse was built about three miles
north of Montrose, a little to the west
of Kirkside Salmon Fishing station, at a
cost of £312 6s 5d. The house, built by
James Ford & Sons, was on the north
side of the old mouth of the river Esk.

1892 The No.3 station was short-lived
and the lifeboat, the 34ft self-righter
Resolute (ON.90), was withdrawn.

1900 The 38ft self-righter *Robert
Henderson* (ON.367) was wrecked on
exercise on 22 March, fortunately with
no loss of life.

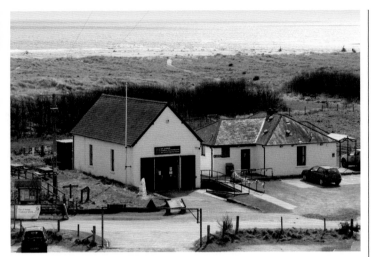

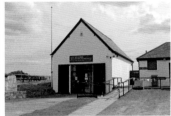

above and left The lifeboat houses built in 1885 at Kirkside, four miles north of Montrose at a fairly remote site among the sand, was used for the lifeboat for just seven years. It was converted into an information centre for the St Cyrus Nature Reserve in 1989.

1900-1 The lifeboat house was improved and enlarged, and a new house was built on the site so the station was operating from a double boathouse; the 1818 boathouse was handed over to the Harbour Board.
1926 The lifeboat house was enlarged, slip lengthened and a trolley way on rails was provided for the station's first motor lifeboat, the single-screw 45ft 6in Watson motor *John Russell* (ON.699); a tractor and carriage was used for the No.2 lifeboat.
1938 The boathouse was altered for the new lifeboat, the 46ft Watson motor

The Good Hope (ON.821), which arrived on station in October 1939.
1940 A motor lifeboat, the 32ft Surf *Norman Nasmyth* (ON.836), was sent to the No.2 station; she served for ten years, but never saved any lives. When she was withdrawn in May 1950, the station only had one lifeboat.
1964 The house was adapted for the lifeboat after it had been fitted with wheelhouse; it was used by the RNLI until 1981, and in 1984 was leased to Southesk Boats; in April 1998 it was demolished by Glaxo Wellcome, despite being a listed building.

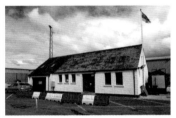

above The crew facility and ILB house built in 1989 at Piggins Quay within the confines of the port. The extension to the left for the ILB was added in 1996-7 This building was used until 2013 and is pictured when in use by the RNLI.

below The shore facility, ILB house and all-weather lifeboat mooring pontoon constructed in 2012-13 on Wharf Street to the west of the main port area.

Montrose

above The crew facility and ILB house constructed in 2012-13 on Wharf Street to the west of the port area, with a piled boarding jetty and purpose-built pontoon for the all-weather lifeboat.

below The crew facility and ILB house used from 1989 to 2013, pictured after being vacated by the RNLI, was located at the eastern end of the port on the north side of the river South Esk.

1972 The new 48ft 6in Solent lifeboat *Lady MacRobert* (ON.1019) was placed on moorings in the river, just off the lifeboat house, in December.

1981 Following harbour developments, a new berth was provided at the end of Piggins Quay, comprising three piles and a floating fender extending from the Pier, upstream of the lifeboat house; a portable building was installed for use as a crew room and gear store.

1989 A new crew facility and assembly building was constructed to replace the portable building; it provided a crew changing room, a workshop, toilet and shower facilities and a general room.

1994 An inshore lifeboat station was established on 2 February; the ILB, *Victory Wheelers* (D-398), was kept in temporary shelter on quay adjacent to the shore facility, and a Schat davit was installed for launch and recovery

right Launching D class inflatable David Leslie Wilson (D-626) using the davit on the piled jetty by the lifeboat station.

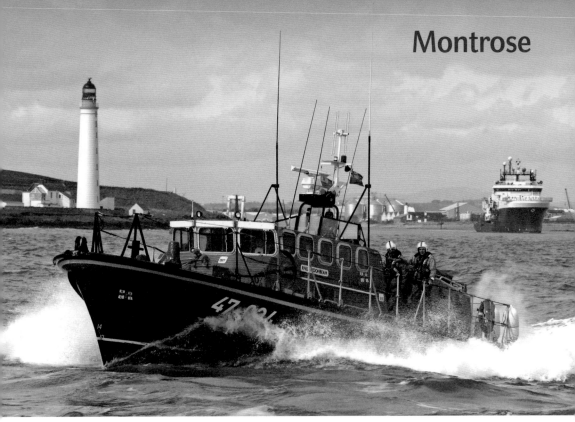

1995 The ILB station was permanently established and a new ILB, *Holme Team 3* (D-481), was placed on station in July.
1996-7 A permanent building to house the ILB was completed, adjoining the existing shore facility.
1999 A new pontoon was installed at the berth to improve boarding.
2000 Bicentenary Vellum presented.
2002 Siltation continued to be a problem in the harbour, so dredging work was undertaken.
2012-13 New shore facilities were constructed at a new site to the west of the main port, accessible by public roads, to provide considerably improved crew accommodation and housing for the D class ILB; the ALB berth was also relocated to the same site and a pontoon was installed.

above 47ft Tyne Moonbeam (ON.1152) leaves the harbour, passing Scurdie Ness lighthouse which was first lit in 1870.

above 47ft Tyne Moonbeam (ON.1152) moored alongside the pontoon, which was installed in 2012-13 as part of the new lifeboat station on Wharf Street.

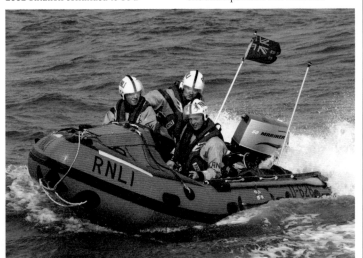

left D class inflatable David Leslie Wilson (D-626) on exercise off Montrose.

Arbroath

Current lifeboats

ALB 12m Mersey
ON.1194 (12-35) Inchcape
Built 1993
Donor Named after the Inchcape Rock which lies off Arbroath, and funded from a local appeal and other gifts and legacies
On station 26.8.1993
Launch Slipway

ILB D class inflatable
D-759 Robert Fergusson
Donor Gift from Andrew Ferguson, and named after a famous Scottish poet
On station 20.6.2013
Launch Trolley

Station honours

Framed Letters of Thanks	1
Bronze medals	2
Gold medal	1

right The lifeboat house and slipway built in 1932 for the station's first motor lifeboat, and since altered and extended for subsequent lifeboats.

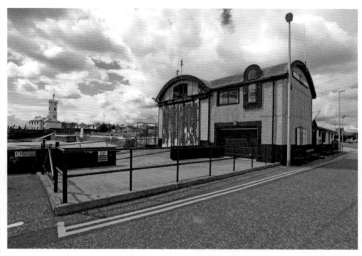

1803 The first lifeboat, a North Country type built by Henry Greathead at South Shields, was provided by public subscriptions including a grant from Lloyd's; it was operated by a local committee and kept in a house near the harbour, built on a site provided by the council; this house was used until the RNLI took over the station in 1865.

1854 A new lifeboat, similar in design to the first, was built in Sunderland and operated by the local committee.

1865 The RNLI took over the station and completely renovated it. A new lifeboat house was built by the town authorities on the site of the old house, by the side of the road leading to the harbour, known as East Grimsby; this house was used until 1932 and remains standing, having been used as a marine engineers garage at one time.

1928 Centenary Vellum awarded.

1932 A new lifeboat house and roller slipway were built on the south side of the Inner Dock for the station's first motor lifeboat, the 35ft 6in self-righting type *John and William Mudie* (ON.752), which served for eighteen years.

1953 The 35ft 6in Liverpool class lifeboat *Robert Lindsay* (ON.874)

above 12m Mersey Inchcape (ON.1194) being launched down the slipway from the lifeboat house built in 1932.

right The lifeboat house built in 1865 at East Grimsby and used until 1932.

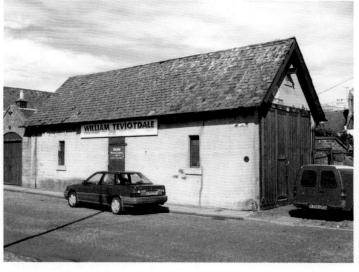

Arbroath

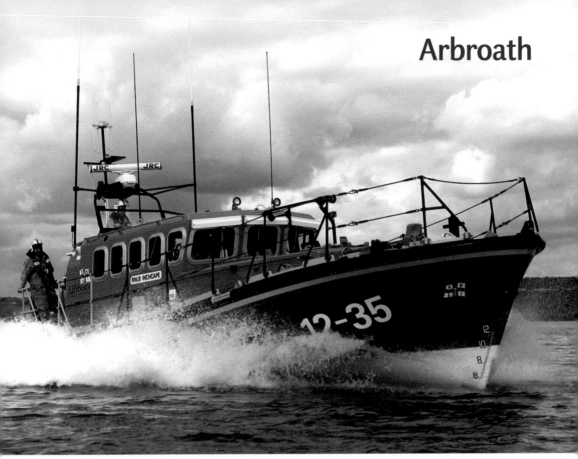

capsized when crossing the harbour bar after launching to reported flares on 27 October, with the loss of six of her crew of seven. The men who lost their lives were Coxswain David Bruce and crew members Thomas Adams, Charlie Cargill, David Cargill, Harry Swankie and William Swankie (Jnr).

Following the disaster, more than £35,000 was raised by a local fund, including a contribution of £500 from the RNLI. A 150th anniversary vellum was also awarded during the year, and a commemorative bronze plaque was unveiled, mounted on the storm wall of the Fish Quay close to the light tower,

above 12m Mersey Inchcape (ON.1194) on exercise off Arbroath. She is named after the reef on which the famous Bell Rock lighthouse was built.

left D class inflatable Robert Fergusson (D-759) on exercise. (Dave Mallinson)

below Recovery of D class inflatable Robert Fergusson (D-759) after exercise into the ILB house adjoining the lifeboat house. (Dave Mallinson)

Arbroath

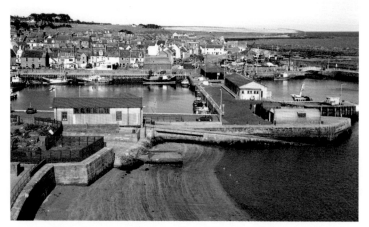

above View over the harbour showing the lifeboat house and slipway built in 1932. Just above the foot of the slipway is the boathouse used for the inshore lifeboats from 1968 to 1986.

below The lifeboat house and slipway built in 1932 facing the harbour entrance

in memory of those who lost their lives in the disaster. In addition, a stained glass window was placed in St John's Methodist Church to the memory of Coxswain David Bruce, gifted by his widow, and a memorial plaque in the Old Church to the six men, gifted by Mr and Mrs Cargill who lost two sons.

1956 The lifeboat house was altered for a new lifeboat, the 42ft Watson motor *The Duke of Montrose* (ON.934).

1962 The commemorative bronze plaque on the storm wall of the Fish Quay was moved to an outside wall of

the lifeboat house.

1963 *The Duke of Montrose* (ON.934) was exhibited at the International Lifeboat Conference held in Edinburgh from 4 to 6 June.

1968 An inshore lifeboat station was established in August; the ILB was kept in a 'Nissan' type hut on the quayside near the lifeboat house until 1986.

1969 The first ILB, D-16, was replaced by a new ILB, D-170.

1982 The lifeboat house was altered for the new lifeboat, the 37ft 6in Rother class *Shoreline* (ON.1054).

1986 An extension to the lifeboat house was built , providing accommodation for the ILB with a crewroom above, as well as toilets and an office area.

1993 The lifeboat house and slipway were modified to accommodate the 12m Mersey lifeboat *Inchcape* (ON.1194).

1997 Following a build-up of silt around the slipway, remedial dredging was carried out to make launching easier and safer. A ten-metre extension to the slipway was also built to ease launching, and dredging continued.

2003 The station was awarded a Vellum to commemorate 200 years of service.

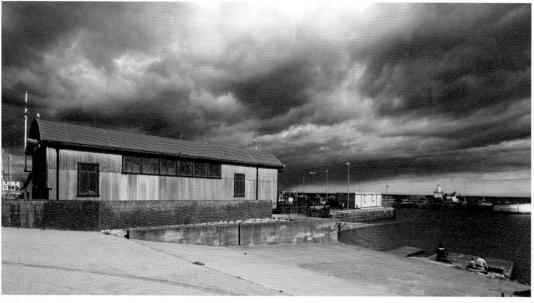

1829 Following a series of wrecks in and around the river Tay, a local committee opened a subscription in December to fund a lifeboat to be placed at Buddon Ness, on the north shore of the entrance to the Tay. The River Tay Lifeboat Society was formed to administer the lifeboat.

1830 A lifeboat was ordered from the boatbuilder Robson, of South Shields, and in November she was in her boathouse, which was 'South of the Lights of Tay', ready for service. The keys to the boathouse were held by the lighthouse keepers, and the station was supported by a tax on vessels entering the Tay. However, problems with manning were considerable, as the station was situated in the dunes, three miles from Westhaven and six miles from Broughty Ferry, places where crew could be found.

1839 To speed up launching, it was decided to keep the lifeboat afloat and two small boarding boats were kept in the boathouse at the lighthouse.

1859 A new lifeboat was built by the River Tay Lifeboat and Humane Society was kept at Broughty Castle; but the boat, built at Calman and Martin's Dundee shipyard, was poorly designed and proved to be a failure.

1861 The River Tay Lifeboat and Humane Society contacted the RNLI and requested the Institution take over the stations at Buddon and the others in the river Tay.

1863 The lifeboat house was damaged by very heavy seas in August and in December the lifeboat, while on her moorings, was hit by a passing steamer. The boat was holed and driven from her moorings, eventually sinking about a mile east of the Gaa Sands; she was recovered but was found to be so badly damaged she was condemned.

1867 The station was re-opened in March; Buddon was a better location than Broughty Ferry as most ships got into difficulty at the mouth of the Tay and so a lifeboat there was well placed for working the banks. A 33ft ten-oared iron-hulled self-righter, named *Eleanora*, was placed on station, having been built by Hepworth of Millwall in 1863. She had been built of iron to withstand lying at mooring in all weathers. The old boathouse was demolished, and was replaced by a smaller house which was built as a store in a position sheltered by the dunes. Two boarding boats were kept in the boathouse along with lifejackets and other gear.

1870 A new lifeboat, with a the hull coated in copper, was supplied to the station as the iron-hulled lifeboat's hull was being fouled by weeds. The new boat, the 33ft self-righter *Eleanora*, was sent to the station in October.

1879 The station was temporarily closed in January as floating ice in the river made it too dangerous to leave the lifeboat at her moorings.

1893 The RNLI decided to close the station as no service calls had been performed since 1881.

1894 The lifeboat *May* (ON.196), which had been on station since July 1888, was removed from Buddon on 21 February and the station was closed.

Key dates

Opened	1830
RNLI	1861
Closed	1893

Station honours

Silver medal	1
Gold medal	1

below The building that was used as the Buddon Ness lifeboat house, although exact details of its usage are not known.

Broughty Ferry

Key dates

Opened	1859
RNLI	1861
Motor lifeboat	1910
Inshore lifeboat	1964
Fast lifeboat	1978

Current lifeboats

ALB 14m Trent
ON.1252 (14-31) Elizabeth of Glamis
Built 2001
Donor Broughty Ferry Lifeboat Appeal, and
the legacies of Dr Ian Campbell Low and
Dr Ronald Bonar, named in honour of
HM The Queen Mother
On station 14.4.2001
Launch Afloat

ILB D class inflatable
D-698 Sheila Barrie
Donor The Misses Barrie Charitable Trust
On station 23.8.2008
Launch Trolley down slipway

Station honours

Bronze medals	3
Silver medals	3
Gold medals	1

opposite 14m Trent Elizabeth of Glamis
(ON.1252) at moorings in the specially
constructed berthing pen.

below The lifeboat house and slipway
built in 1909-10 but altered subsequently
for new lifeboats and the ILB.

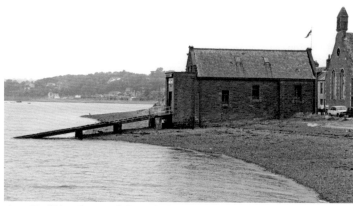

above The lifeboat house and slipway built in 1909-10 for the first motor lifeboat.

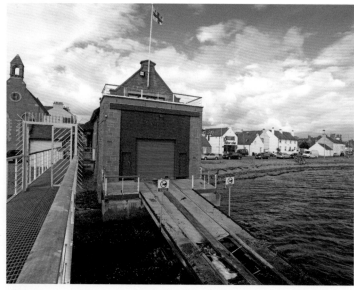

1833 A lifeboat was placed at Ferry Port-
on-Craig (now known as Tayport) by
the Dundee Humane Society. This boat,
a 30ft non-self-righting design, lasted
until the 1850s but by 1860 it was no
longer in use.

1851 A lifeboat was stationed on a
slipway at Magdalen Green, '. . . for
bathers and boating parties who get
into distress.' The slipway was situated
on Buckingham Point, a rocky outcrop
later to become the northern landfall
for the Tay Rail Bridge.

1861 In December the RNLI agreed to
take over the station.

1862-3 A new lifeboat house was built
by the RNLI at the foot of Fore Street,
in Fisher Street, at a cost of £203; the
lifeboat was launched from a carriage
into the river Tay. It was thought
advisable to station the new RNLI boat
near her crew at Broughty Ferry, rather
than at Buddon Ness, as there were by
then several steam tugs available to tow
the lifeboat downriver to a casualty. The
new lifeboat, a standard 32ft self-righter
named Mary Hartley, was placed on
station in May 1862.

1889 A slipway was built at a cost of
£130 to improve launching.

1908 Plans for a new boathouse and
slipway to house a motor lifeboat were
submitted to Broughty Ferry Burgh
Council on 6 July. After a year of debate,
councillors passed the plans.

1909-11 The new lifeboat house and
roller slipway were built for the
station's first motor lifeboat, the 40ft
Watson motor Maria (ON.560); this
house, on the same site as the previous
house,was used for the all-weather
lifeboat until 1978.

1931 Centenary vellum awarded.

1959 On 8 December the lifeboat
Mona was launched to the North

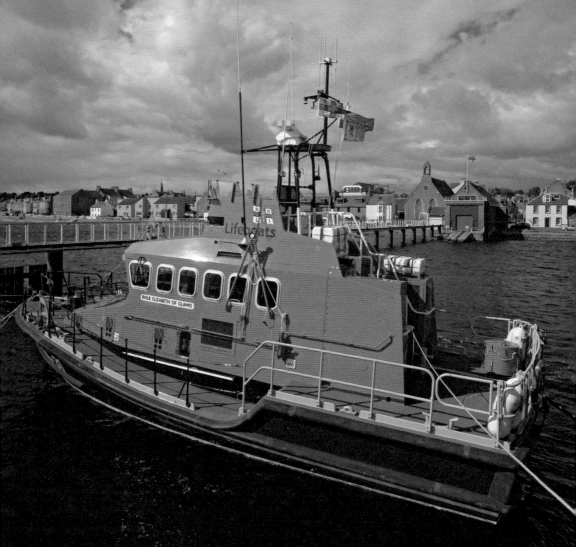

right 14m Trent Elizabeth of Glamis (ON.1252) arriving on station in March 2001, escorted by 52ft Arun Joseph Rothwell Sykes and Hilda M. (ON.1099), with Broughty Castle in the background.

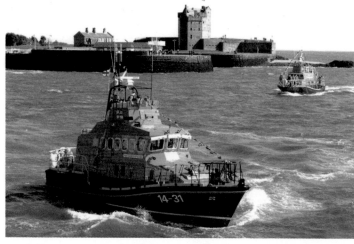

above The memorial plaque mounted on the north wall of the lifeboat house to remember those who gave their lives when the lifeboat Mona capsized in 1959.

below The D class inflatable Sheila Barrie (D-698) inside the lifeboat house on the launching cradle that runs down the slip.

Carr lightvessel which had reportedly broken adrift in exceptionally severe in the river Tay. In the early hours of the morning the lifeboat capsized and her crew of eight were drowned; they were David G. Anderson, James Ferrier, Alexander S. Gall, Ronald Grant, Johnny Grieve, John J. Grieve, George B. Smith and George Watson. *Mona* was burnt on the foreshore at Cockenzie and a temporary lifeboat, *City of Bradford II* (ON.709), was sent to the station.

1960 The boathouse was adapted to house a new 47ft Watson class lifeboat, *The Robert* (ON.955).

1962 On 3 June Lord Provost McManus unveiled a memorial plaque on the north wall of the lifeboat house to the eight men lost in the lifeboat disaster.

1964 Extensive alterations were carried out to the slipway because of difficulties in launching at high water caused by siltation; the slipway was raised 3ft over its whole length, and its overall length was increased by 20ft. In April an inshore lifeboat station was established, the first in Scotland; the ILB, number D-17, was kept in the lifeboat house.

1978 Moorings for the lifeboat in the river Tay were taken up and the 52ft Arun *Spirit of Tayside* (ON.1056) was placed on station on 6 May; an inflatable boarding boat was used to reach the lifeboat moorings.

1980 150th anniversary vellum awarded.

1981 The slipway was altered and additional launching traversing trolleys were provided so that both ILB and boarding boat could be operated from the boathouse; the boathouse was refurbished to provide a crew room.

2000-1 A substantial piled boarding jetty was constructed, running out from the existing lifeboat house to provide a sheltered berth, boarding and refuelling facility for the Trent class lifeboat; the lifeboat house was refurbished to provide improved crew facilities, a training room and housing for the ILB.

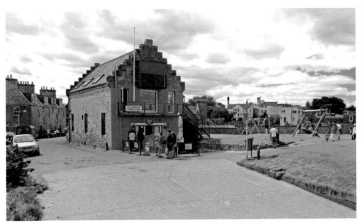

1802 Following a wreck in January 1800, efforts were made to purchase a lifeboat for the town, with local magistrate Cathcart Dempster starting a subscription to fund a boat. The station's first lifeboat was built by Henry Greathead of South Shields, and funded by local subscriptions together with a contribution from Lloyds.

1824 By 1823 the first lifeboat had fallen into disrepair and so a new 27ft lifeboat was built, similar in design. She was designed to work around the shallow West Sands, a carriage was built for her locally and a boathouse was erected near the Swilcan Burn at the west entrance to the city.

1860 By the 1850s the lifeboat had lapsed and so the RNLI reopened the station. The 32ft ten-oared Peake self-righting lifeboat *Annie* arrived in January. She remained until 1873 and was followed by three other self-righting lifeboats, all carriage launched.

1910 A new lifeboat house was built at the East Sands; it was used until 1938.

1938 The RNLI decided to close station with effect from 31 August as St Andrews was deemed unsuitable for operating a motor lifeboat, and the area could be covered by Broughty Ferry lifeboat. The last lifeboat, *John and Sarah Hatfield* (ON.600), was withdrawn but the boathouse remains standing.

above The lifeboat house built in 1910 on the East Bents site occupied by the two previous boathouses. The first was built in 1802 to house the Greathead-built lifeboat, which was known as the Cork Lifeboat, and the second was built in 1860 for the first lifeboat supplied by the RNLI. The house of 1910 was used until the station closed in August 1938, and remains in use by the St Andrews Sailing Club having been little altered externally.

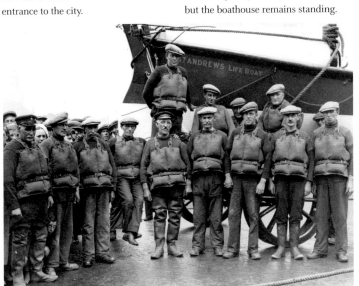

left St Andrews lifeboat crew in kapok life-jackets stand next to the station's last lifeboat, John and Sarah Hatfield (ON.600).

below John and Sarah Hatfield (ON.600) being rowed through the small harbour at St Andrews in 1938 shortly before being withdrawn from the station.

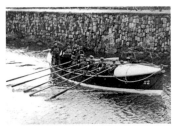

Boarhills

Key dates

Opened	1865
Closed	1919

1866 The boathouse built in 1824 at St Andrews was moved to Boarhills and used to house the independently operated lifeboat.
1881 The boathouse was enlarged and the floor concreted for a new lifeboat.

1919 The station was closed, but the boathouse remains standing with the launch channel still evident; a corrugated roof has been added and the building has been used for agricultural purposes for many years.

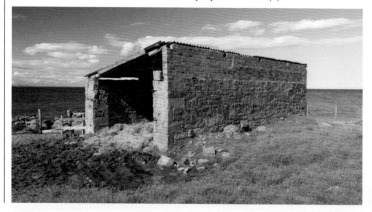

right The remains of the lifeboat house at Boarhills; the building was moved to this location from St Andrews in the 1860s and used until 1919 by the carriage-launched independent lifeboat.

Crail

Key dates

Opened	1884
RNLI	1884
Closed	1923

Station honours

Silver medals	1

right and below The lifeboat house built in 1884 and now used as a store by the Balcomie Golf Club.

1884 After a public meeting in January, a lifeboat station was founded by the RNLI. A lifeboat house was built at a cost of £760, two miles north east of the village of Crail. A 34ft self-righting lifeboat *George Patterson* (ON.91) was provided at a cost of £356, and on 6 November the station was inaugurated.
1887 Stables were built at the side of the lifeboat house at a cost of £240 for horses after they had been used for the launch, while they waited for the lifeboat to return and be recovered
1923 The station was closed; the 1884 boathouse had been used throughout the life of the station to house the two self-righting lifeboats that were operated. This house, located to the south of Fife Ness at Balcomie Links, is still standing, unaltered externally, and used as a store by Balcomie Golf Club on whose land it stands.

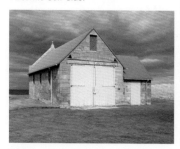

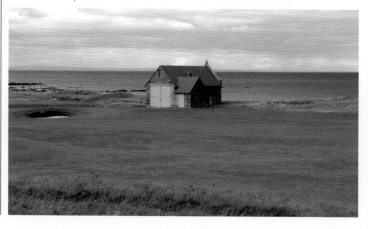

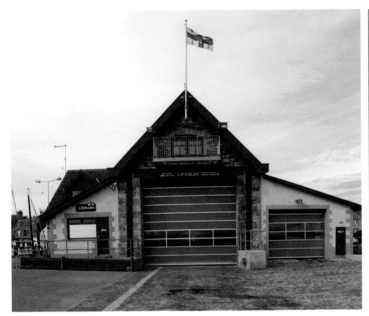

Opened	1865
RNLI	1865
Motor lifeboat	1933
Inshore lifeboat	5.2003
Fast lifeboat	1991

Current lifeboats

ALB 12m Mersey
ON.1174 (12-17) Kingdom of Fife
Built 1991
Donor Anstruther Appeal, The Cotton Trust, The Doctors Appeal, Bequest of Dr Nora Allan and other gifts and legacies
On station 16.10.1991
Launch Tractor and carriage

ILB D class inflatable
D-667 The Rotary Centennial Queen
Donor The
On station 30.11.2006
Launch Trolley

Station honours

Silver medal	4
Gold medal	1

left The lifeboat house built in 1904 in the harbour and extensively modified and rebuilt in 1965, 1991 and 2009.

below left The lifeboat house as modernised and extended in 2008-9.

below 12m Mersey Kingdom of Fife (ON.1174) on her launching carriage outside the lifeboat house.

1865 The lifeboat station was established at the request of the local fishermen, who subscribed £60 themselves towards the cost of the station; a lifeboat house was built at a cost of £165 on land given by the Harbour Board at the head of the old East Pier, enabling a launch into the harbour or over the beach; this house was used until 1904.

1887 A slipway was built at a cost of £80 to improve launching.

1904 A new lifeboat house and launchway were constructed on the site of the previous house, on the Middle Pier, for a launch into the outer harbour; this house, built at a cost of £1,583, is still in use today, although considerably altered and extended for subsequent lifeboats.

1965 The lifeboat house was adapted for a 37ft Oakley lifeboat; a Centenary Vellum was awarded to the station.

1991 The lifeboat house and slipway was extended, modernised and refurbished for the Mersey class

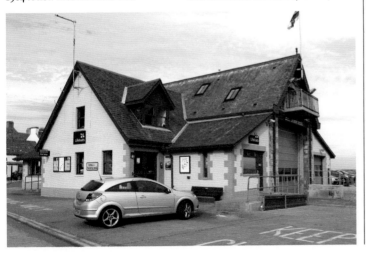

Anstruther

above D class inflatable Rotary Centenary Queen (D-667) leaving the harbour.

right 12m Mersey Kingdom of Fife (ON.1174) afloat in Anstruther harbour during the station's annual lifeboat day.

opposite Kingdom of Fife (ON.1174) being launched into the harbour from her carriage outside the boathouse.

below 12m Mersey Kingdom of Fife (ON.1174) on her carriage outside the lifeboat house.

lifeboat; the floor of the house was lowered by 2ft, an extension was built at the north end and the launching slipway was restructured.

1995 A two-storey extension to the starboard side of the boathouse was constructed; it provided a drying/changing room for the crew, shower and toilet, a crew room and galley, and a souvenir sales outlet.

2003 A D class inflatable ILB was sent to the station in May for a twelve-month evaluation trial.

2004 The ILB station was fully established alongside the all weather lifeboat and in 2006 a new ILB was allocated to the station, launched down the slipway into the harbour.

2008-9 The lifeboat house was extensively rebuilt and enlarged to provide a new ILB house, new doors for both ALB and ILB houses, a retail sales extension, a new crew training room, and a new visitors' gallery. The contractors were Clachan Construction and the RNLI completed the shop fit-out and the visitors' gallery before the house was reopened for Easter 2009.

Buckhaven

1898 Following a request from local residents, the RNLI decided to establish a lifeboat station at Buckhaven, on the north side of the Firth of Forth, at a meeting of the Committee of Management on 8 December. The Committee noted that there were plenty of fishermen available to crew the lifeboat and that a considerable number of vessels pass the area each year.

1900 A suitable site at Buckhaven was found and leased to the RNLI at a nominal annual rent, and a lifeboat house and launching slipway were built on the site at a cost of £282. The first lifeboat, specially built for this station at the request of the local fishermen, was a non-self-righting Liverpool type measuring 35ft by 10ft, and was named *Isabella* (ON.441) after the donor, the late Mrs Isabella Haxton, of Kickcaldy, who bequeathed money to provide a lifeboat for the Fifeshire coast. The launching carriage was fitted with Tipping's plates as the harbour dried out to the South Pier head, and the ground was soft; pushing poles were also supplied to help get the boat afloat.

1932 With the harbour gradually silting up, by the early 1930s launching had become more difficult and by 1932 the lifeboat could only be safely launched around high tide; with a motor lifeboat on station at Anstruther, the station at Buckhaven was closed and on 30 September the lifeboat was withdrawn.

Key dates	
Opened	1900
RNLI	1900
Closed	1932

Kinghorn

Key dates

Opened	1965
RNLI	1965
Inshore lifeboat	6.1965

Current lifeboats

ILB Atlantic 85
B-836 Tommy Niven
Donor Legacy of Tommy Niven, of Carlisle
On station 22.10.2009
Launch Tractor and do-do carriage

right Atlantic 85 Tommy Niven (B-836) on her do-do carriage outside the ILB house.

below Atlantic 85 Tommy Niven being launched across the beach by Talus MB764 County tractor TW40.

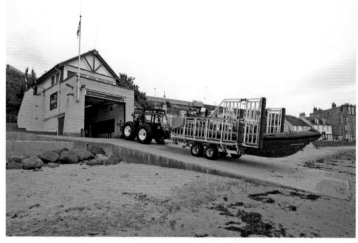

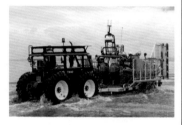

below The Marley type ILB house of 1982 which was moved to this site in the small harbour in 1991 and used until 1995.

below right The ILB house built in 1995 for Atlantic ILB and its launch vehicle.

1965 An inshore lifeboat station was established in June on the banks of the Firth of Forth; the ILB was kept in a small Hardun boathouse behind the sailing club overlooking the bay, and the ILB was launched over the beach.

1982 A new Marley pre-cast ILB house was built in the harbour replacing the Hardun boathouse.

1985 The D class inflatable ILB was withdrawn and replaced by a twin-engined C class inflatable on 10 June.

1987 The ILB house was extended so that the launching trolley could be housed with the ILB.

1991 The ILB house was moved to a new site in the harbour to allow

work to be done by the local drainage authority. The house was used until 1995 and remains in existence, being used as a store.

1995 The C class ILB was withdrawn and an Atlantic 21 rigid-inflatable ILB was placed on temporary duty on 29 June. A new two-storey ILB house and launching ramp were built on the beach to accommodate the Atlantic and its launching tractor coupled in line, with a souvenir sales outlet, workshop, and improved crew facilities also included.

2005 The lifeboat station celebrated forty years; the launch on service on 14 July to a yacht in Aberdour was recorded as its 800th service.

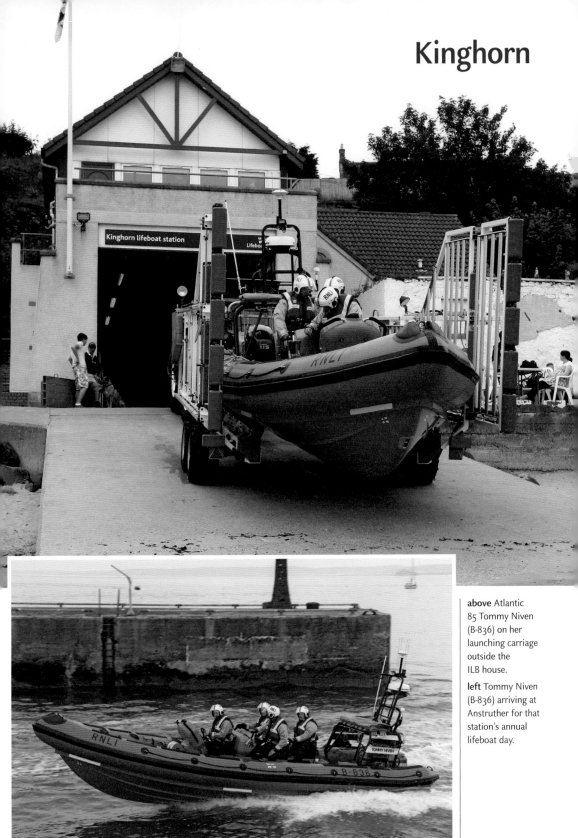

Kinghorn

above Atlantic 85 Tommy Niven (B-836) on her launching carriage outside the ILB house.

left Tommy Niven (B-836) arriving at Anstruther for that station's annual lifeboat day.

Queensferry

Key dates

Opened	1967
RNLI	1967
Inshore lifeboat	1967

Current lifeboats

ILB Atlantic 85
B-851 Jimmie Cairncross
Donor Bequest of Jimmie Cairncross
On station 6.9.2012
Launch Trolley and tractor

Station honours

Framed Letters of Thanks	1

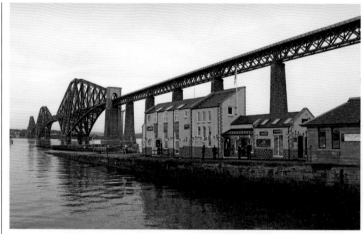

right and below The lifeboat house at Hawes Pier, beneath the famous Forth railway bridge, built in 2012 for Atlantic 85.

below Atlantic 85 Jimmie Cairncross (B-851) on exercise off South Queensferry.

1967 An inshore lifeboat station was established in July; the ILB was housed in the old Toll House, which was converted to house the boat; it was situated at Hawes Pier, South Queensferry, beneath the Forth Rail Bridge, the southern terminal of the old Forth ferry crossing.

1969 On 1 January the name of station was changed to Queensferry, having been South Queensferry, at the request of the station branch.

1989 A new ILB house was built at Hawes Pier, on the site of the previous house; the new house includes a crew/instruction room, a changing room, store and toilet facilities; it was extended in 1998 for an Atlantic 75; the boat is launched down the old ferry slipway into the Firth of Forth.

2011-12 A new two-storey ILB house built at Hawes Pier, on the site of the old house which was demolished. The new building gave direct access to the pier for a faster launch, changing rooms, washing and storage facilities, mechanic's workshop, training and presentation room and a souvenir outlet. The house was officially opened on 24 November 2012.

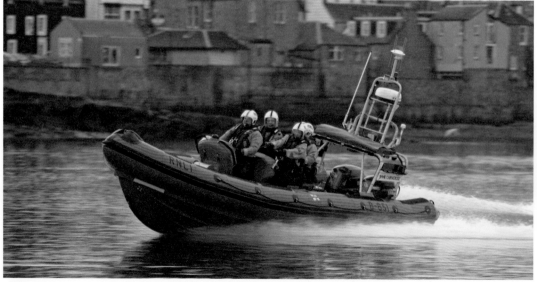

Queensferry

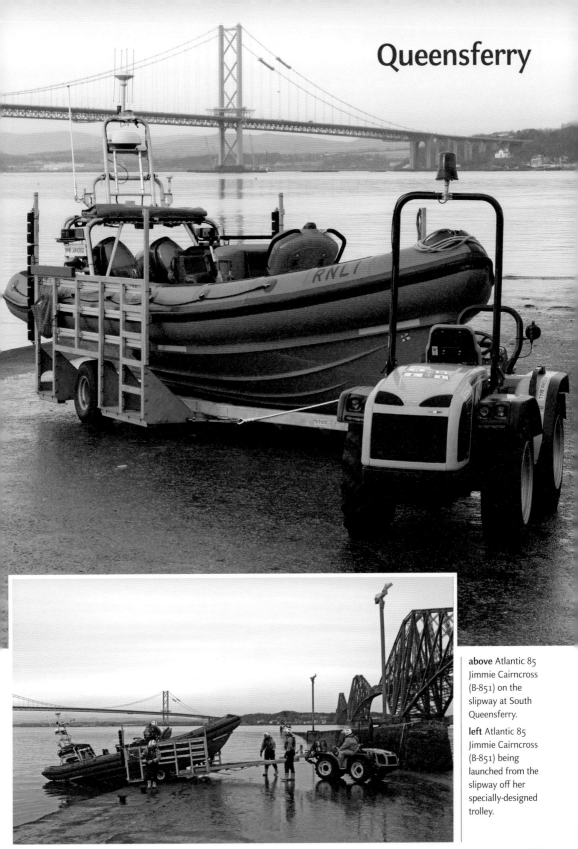

above Atlantic 85 Jimmie Cairncross (B-851) on the slipway at South Queensferry.

left Atlantic 85 Jimmie Cairncross (B-851) being launched from the slipway off her specially-designed trolley.

North Berwick

right D class inflatable Evelyn M (D-758) returning to the lifeboat house using New Holland TC450 tractor TA71. (Dave Mallinson)

opposite and below Blue Peter III (D-619, on station July 2004 to 2013) on exercise off North Berwick.

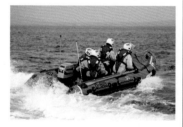

right The lifeboat house built in 1904 with the crew facility built in 1997 adjacent to the launching slipway.

below The lifeboat house built in 1904 was converted to house the D class ILB and launch vehicle in 1991.

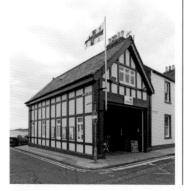

1860 The RNLI established a lifeboat station and a lifeboat house was built to the east of the town.

1871 A slipway was constructed from the house to the beach to improve launching; the house and slipway were used until 1904.

1880 The lifeboat was not launched because all the horses used for towing the carriage were engaged in agricultural work.

1904 A new lifeboat house was built on the site of the previous house, situated on the corner of Victoria Road overlooking the beach on the road to the harbour.

1925 The station was closed and the boathouse was sold; it became the

Victoria Café for a number of years.

1967 An inshore lifeboat station was established in April and the ILBs were kept in a small garage at the basement of the Harbour Terrace buildings, adjoining the harbour, until 1991. The station was one adopted by the BBC TV programme Blue Peter.

1991 The 1904 boathouse was purchased by the RNLI and refurbished to house the ILB and launch vehicle.

1997 The boathouse was extended to house the D class inshore lifeboat and tractor in line; separate crew facilities were built on an adjacent site overlooking the launching slipway and beach.

2001 Centenary Vellum awarded to mark a total of 100 years of service.

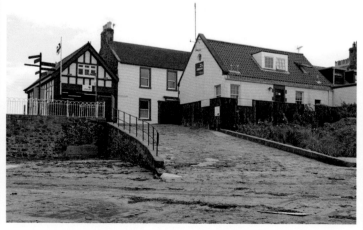

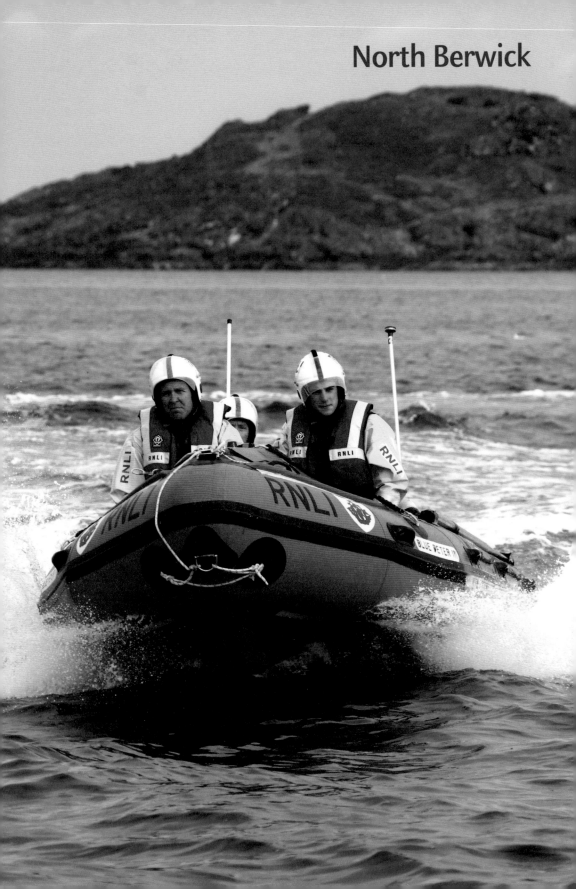

Dunbar

Current lifeboats

ALB 14m Trent
ON.1266 (14-35) John Neville Taylor
Built 2003
Donor Bequest from the estate of Mr John
Neville Taylor, Westcliffe on Sea, Essex
On station 8.5.2008
Launch Mooed afloat

ILB D class inflatable
D-708 Jimmy Miff
Donor Gift of James Hall, of Edinburgh
On station 8.1.2009
Launch Trolley

Station honours

Framed Letters of Thanks	5
Thanks Inscribed on Vellum	2
Bronze medal	1
Silver medal	4

opposite 14m Trent John Neville Taylor
(ON.1266) on exercise off St Abbs Head.

opposite inset The extension to the
boathouse for the D class inflatable Jimmy
Miff (D-708) and its launch vehicle.

below 14m Trent Sir Ronald Pechell Bt,
which was on station from 1995 to 2008,
on exercise in rough seas off Torness.

above The lifeboat house built in 1901 in Dunbar harbour, with the house for the D class ILB to the right.

1808 The first lifeboat was built, funded by public subscriptions; this boat saved forty-five men from HMS *Pallas* in two trips but, after putting out for a third time, was capsized.

1821 Few details of the first lifeboat survive, but by 1821 she had fallen into a state of disrepair and was sold at auction in October 1829.

1827 The old boathouse was being used as a committee room.

1864-5 The station was re-established by the RNLI and a new lifeboat house was constructed on the harbour quay at a cost of £165; this house was used until 1901 and was then demolished.

1901 A new lifeboat house was built on the same site in the harbour at a cost of £633; it was used until 1931.

1909 The last horse-drawn launch was carried out.

1931 The lifeboat was placed afloat at moorings on the south side of Victoria Harbour, close to the lifeboat house; the

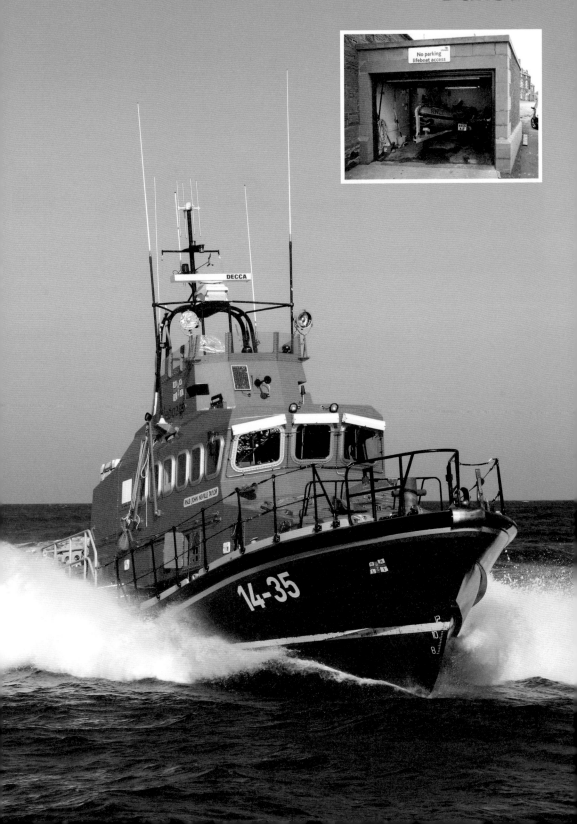

DECCA

RNLB JOHN NEVILLE TAYLOR

14-35

12
10
8

Dunbar

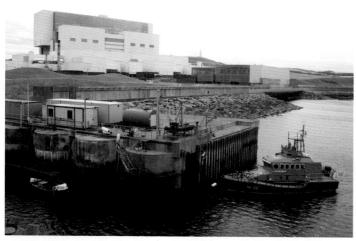

above 14m Trent John Neville Taylor (ON.1266) going alongside the pier at Torness, where crew facilities and a fuel store have been installed.

water mooring berth for the lifeboat was provided at Torness harbour, approximately four miles south of Dunbar and across the bay from Skateraw; to reach Torness, the crew assemble at the lifeboat house in Dunbar Harbour and travel by road to the power station.

1996 The lifeboat house was refurbished to improve the crew facilities, which include a changing/drying room, crewroom, store, souvenir sales outlet, shower and toilet; an extension to the side of the boathouse was also constructed for the ILB and its launching vehicle.

boathouse was then used as a gear store and crew room.

1968 An inshore lifeboat station was established in July; the ILB was kept adjacent to the 1901 lifeboat house.

1993 Following problems with silting of the harbour entrance, a low

2008 During the early hours of 23 March the lifeboat *Sir Ronald Pechell Bt* (ON.1207) broke from her moorings at Torness and was damaged so badly that she was beyond economic repair; as a result a Trent lifeboat from the relief fleet was reallocated to the station.

Skateraw

1906 The RNLI decided that a lifeboat should be placed at Skateraw, to the south of Dunbar.

1907 The station was established in March, a lifeboat house was built; the boat was manned from Dunbar.

1943 The lifeboat, *Sarah Kay* (ON.569), was withdrawn having saved fifty-seven lives in thirty-six years and the station was closed; in the 1960s the lifeboat house was demolished, with just the foundations still visible.

right The site of the lifeboat station at Skateraw, with just the base of the boathouse and the launchway visible.

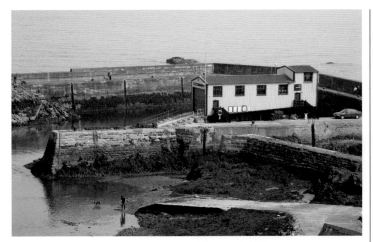

Key dates

Opened	4.1911
RNLI	1911
Motor lifeboat	1911-74
Inshore lifeboat	6.1974

Current lifeboats

ILB Atlantic 75
B-783 Dorothy and Katherine Barr II
Donor The Barr Charitable Trust.
On station 2.10.2002
Launch Trolley down slipway

Station honours

Framed Letter of Thanks	2
Silver medal	4

1907 On 17 October, during a storm and in dense fog, the cargo vessel *Alfred Erlandsen* struck the Ebb Carr rocks. Lifeboats from Eyemouth and Dunbar attempted to rescue the seventeen sailors on board but they all died. A local appeal was set up by Miss Jane Hay, who had witnessed the loss of the entire crew and she repeatedly impressed upon the authorities the urgent need for a lifeboat at St Abbs.

1908 At a meeting of the RNLI Committee of Management on 9 January it was decided to establish a lifeboat station at St Abbs.

1909-11 A slipway was built in the harbour with the lifeboat being kept in the open at the top of it. In recognition of her efforts, Miss Jane Hay became the honorary secretary of the new station, and the first lifeboat, the 38ft Watson motor Helen Smitton (ON.603), arrived on 25 April.

1914-5 A lifeboat house was built at the top of the slipway.

1964 The lifeboat house was adapted for the 37ft Oakley class lifeboat.

1974 The offshore lifeboat *Jane Hay*

left The lifeboat house of 1915 and slipway of 1911 in St Abbs harbour, subsequently adapted and extended.

below Atlantic 75 Dorothy and Katherine Barr II (B-783) in front of the lifeboat house and launching cradle.

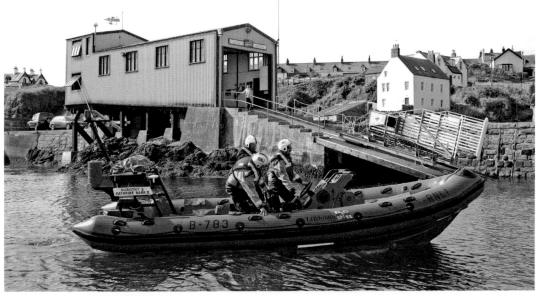

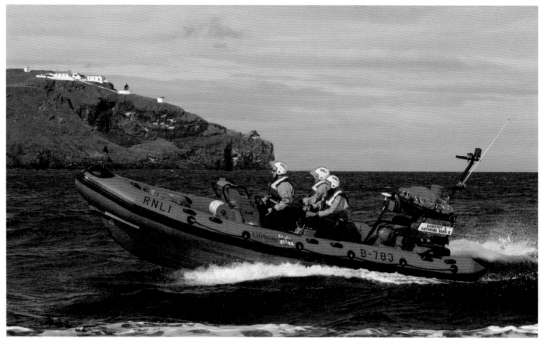

above and below Atlantic 75 Dorothy and Katherine Barr II (B-783) on exercise off At Abbs Head.

(ON.974) was withdrawn from service following the placing of a 44ft Waveney at the neighbouring station of Eyemouth, and a D class inshore lifeboat D-110 was sent to the station.

1980-1 The lifeboat house was re-sheeted and converted to house a larger inshore lifeboat.

1979 The D class inflatable was replaced by the twin-engined C class 17ft 6in Zodiac Mk.IV type ILB C-505.

1982 An electric winch was installed for recovery of the inshore lifeboat.

1985 The station was adapted to operate an Atlantic 21 rigid-inflatable ILB, B-537, which was launched from a cradle lowered down the slipway.

1987 Modifications were carried out to the launching trolley and slipway to improve low water launching.

1998 The lifeboat house was extended and modified to improve crew facilities.

2002 The slipway was refurbished and a new winch was installed.

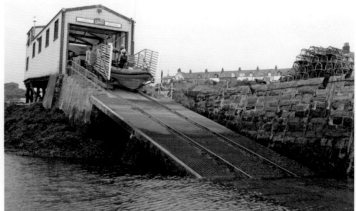

right Atlantic 75 Dorothy and Katherine Barr II launching on exercise from the cradle down the slipway.

above The single-storey crew facility on Gunsgreen Quay built in 1992.

Key dates

Opened	1876
RNLI	1876
Motor lifeboat	1937
Fast lifeboat	1974

Current lifeboats

ALB 14m Trent
ON.1209 (14-11) Barclaycard Crusader
Built 1996
Donor Barclaycard and their Profiles points
holders, the bequests of Charles Beeby
and Mrs E.I. Aston, together with other
legacies and gifts
On station 31.3.1996
Launch Afloat

Station honours

Thanks Inscribed on Vellum	7
Bronze medal	1
Silver medal	1

1876 The RNLI established a lifeboat station at Eyemouth and a lifeboat house was built on the East Pier, at the southern side of the harbour entrance, with a curved launchway into the mouth of the harbour; this house was used until 1909 and the foundations remained intact until the redevlopment of the harbour in the 1990s.

1909 A new lifeboat house and launchway were built, in front of the previous house but at ninety degrees to

below 14m Trent Barclaycard Crusader (ON.1209) at moorings in the harbour alongside the purpose-built pontoon.

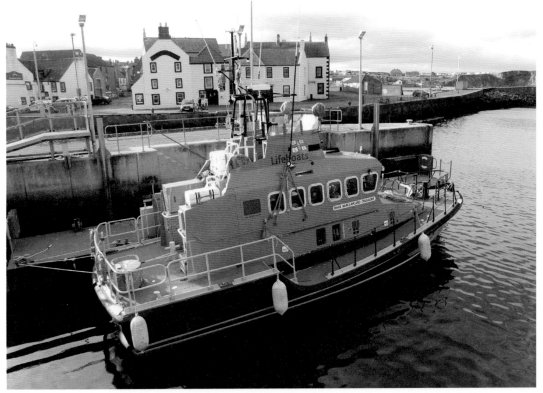

Eyemouth

opposite 14m Trent Barclaycard Crusader (ON.1209) on exercise off Eyemouth.

right and below The lifeboat house built in 1909 and used until 1963 for carriage-launched lifeboats. A tractor house was built at the back, but the whole building was demolished in the 1990s during the redevelopment of the harbour.

it, affording a launch into the river at the harbour entrance; this house was used until 1963; it was demolished in 1997 during harbour improvements.

1963 The station was temporarily closed in August for harbour works.

1964 The station was reopened on 17 November and the lifeboat was placed afloat on the south side of the harbour in a specially-built mooring berth.

1992 A new single-storey shore facility was constructed on Gunsgreen Quay, which provided a training room and office, changing facilities, a workshop, toilet, shower and fuel store.

1998-9 A new alongside mooring berth was provided in Gunsgreen Basin, constructed during the enlargement and improvement of the harbour; a pontoon was later installed.

below 14m Trent Barclaycard Crusader leaving Eyemouth harbour on exercise.

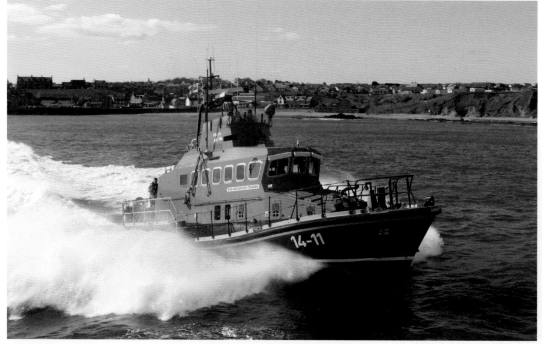

14-11

Bibliography

Anderson, Andrew D (1990): Huna Lifeboat (1877-1930), in *The Scottish Lifeboat*, pages 23-26.

Bruce, George (1884): *Wrecks and Reminiscences of St Andrews Bay* (John Leng & Co, Dundee).

Davies, Joan (1985): Rugged in the Extreme: Caithness Lifeboat Stations Thurso and Wick, in *The Lifeboat*, No.494, Winter 85/86, pages 263-268.

Duthie, J. (1983): *To the Rescue: Life-Saving at Aberdeen, 1802-1924* (Rainbow Books, Aberdeen).

Guild, William J. (1973): Links with the past 4: Buddon Ness, in *The Scottish Lifeboat*, pages 63-67.

— (1974): Links with the past 5: Port Logan, in *The Scottish Lifeboat*, pages 43-48.

— (1975): Links with the past 6: Johnshaven, in *The Scottish Lifeboat*, pages 53-57.

— (1978): Links with the past 9: Ardrossan, in *The Scottish Lifeboat*, pages 50-55.

Jeffrey, Andrew (1996): *Standing into Danger: Two Hundred Years of Lifeboat Service in the River Tay and St Andrews Branch* (Dundee Branch, RNLI).

Leach, Nicholas (1998): Rescue by mobile crane . . . Or launching the Macduff lifeboat (in Lifeboat Enthusiasts' Society *Newsletter*, No.116, pp.8-9).

— (2001): Stronsay Lifeboat Station (in Lifeboat Enthusiasts' Society *Newsletter*, No.125, p.15).

— (2007): *Orkney's Lifeboat Heritage* (Tempus Publishing Ltd, Stroud).

— (2009): *Longhope Lifeboats: An Illustrated History* (Foxglove Publishing, Lichfield).

— (2010): *Buckie Lifeboats: 150 Years of Gallantry* (Foxglove Publishing, Lichfield).

Leith, George (1993): *A Lerwick Lifeboatman's Story* (The Shetland Times Ltd, Lerwick, Shetland).

McPhillips, Ivor B. (1997): The Dunbar Lifeboat History.

Morris, Jeff (1993): *The History of the Wick and Ackergill Lifeboats*.

— (1996): *The History of the Eyemouth Lifeboats*.

— (2003): *The Story of the Fraserburgh Lifeboats*.

— (2006): *The Story of the Thurso Lifeboats*.

Morrison, Dorothy (2000): *Montrose Lifeboat: 200 years of service* (Lifeboat Committee, Montrose Branch).

Nash, George (1970): Links with the past 1: Crail, in *The Scottish Lifeboat*, pages 40-42.

Ralston, Thomas (1996): *To The Edge: Confessions of a Lifeboat Coxswain* (Scottish Cultural Press, Aberdeen).

Rankin, Sandy (1996): Mallaig's Lifeboats, in *The Scottish Lifeboat*, pages 43-47.

Rutherford, R.N. and Collin, T.R. (1992): *The Story of Kirkcudbright Lifeboat Station 1862-1991*.

Smith, David (1988): St Andrews Lifeboat, in *The Scottish Lifeboat*, pages 13-16.

Trewren, Norman (1985): *The Lifeline: A history of the Aberdeen Lifeboat Station 1925-1985*.

Tuck, Bob (2001): Saved by a Scania, in *Truck & Driver*, October, pages 30-33.

Welch, Michael (1999): *Anstruther Lifeboat Station: A History - Part II 1985-1998* (RNLI Anstruther station).

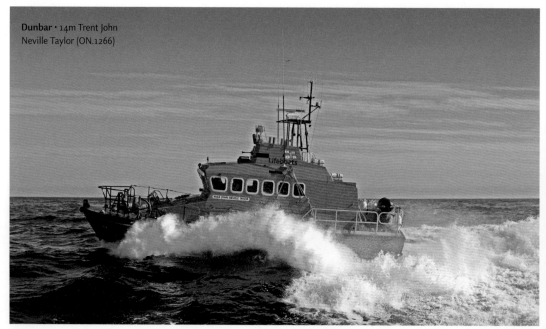

Dunbar • 14m Trent John Neville Taylor (ON.1266)

Lifeboat types serving in Scotland

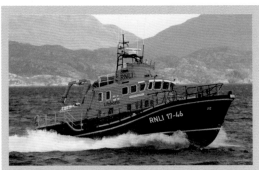

Severn

Introduced 1991, last built 2004, 46 built
Dimensions 17.3m (55ft 9in) x 5.5m (18ft) x 1.68m (5ft 6in)
Engines Twin 1,200hp Caterpillar, or twin 1,500hp MTU diesels
Stationed Aberdeen, Aith, Barra Island, Buckie, Campbeltown, Lochinver, Mallaig, Islay, Kirkwall, Lerwick, Stornoway, Stromness, Thurso, Tobermory

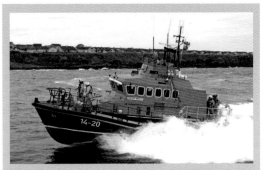

Trent

Introduced 1991, last built 2004, 38 built
Dimensions 14.26m (46ft 9in) x 4.53m (14ft 10in) x 2.5m (8ft 4in)
Engines Twin 808bhp MAN D2840LXE diesels, speed 25 knots
Stationed Broughty Ferry, Dunbar, Eyemouth, Fraserburgh, Invergordon, Oban, Portree, Troon, Wick

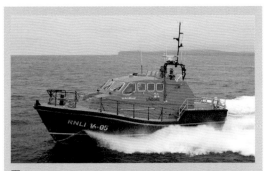

Tamar

Introduced 2005, last built 2013, 27 built
Dimensions 16m (45ft 11in) x 5m (14ft 10in) x 1.35m (4ft 3in),
Engines Twin 1,015bhp (746bkW) Cat C18 diesels, 25 knots
Stationed Longhope, Peterhead and Portpatrick

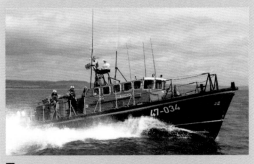

Tyne

Introduced 1982, last built 1990, 40 built
Dimensions 47ft (14.3m) x 15ft (4.6m) x 4ft 2in (1.27m)
Engines Twin 425hp G 8V-71, or twin 565hp DDEC diesels, 17 knots
Stationed Montrose (due to be replaced by 13m Shannon in 2015)

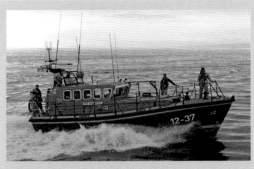

Mersey

Introduced 1986, last built 1993, 38 built
Dimensions 38ft (11.57m) x 12ft 6in (3.81m) x 6ft (1.86m)
Engines Twin 285hp Caterpillar 3208T diesels, 16 knots
Stationed Anstruther, Arbroath, Girvan and Leverburgh

Inshore lifeboats

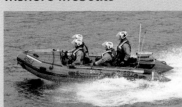

D class inflatable Introduced in 1963, size 5m by 2m, single 50hp outboard engine, three or four crew

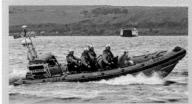

Atlantic 75/85 Atlantic 75 introduced in 1993, Atlantic 85 in 2004, twin outboard engines, three or four crew

Index